D1467014

BMW Art Guide by Independent Collectors—the global guide to private collections of contemporary art.

Revised edition with thirty-one additional collections.

HATJE
CANTZ

Around the World in 256 Collections

Discovering art in private settings

—

How does a museum visit differ from visiting a private collection? After all, art can be found in both places. Whereas museums devote space to art with historical significance, private collections showcase the individual, subjective tastes of the collector. However, you don't necessarily need to embrace the collector's point of view. It's really more a matter of seeing things in a fresh light—like trying on a new pair of glasses. This shift in perspective often leads to unexpected revelations. Although this guide will at times point you toward art you are already familiar with, once perceived in the context of a private collection, it can seem re-energized, invigorated. Each collection is unique and its variety reflects the collector's individual history and passions, often supplemented with personal anecdotes. We are asked to question our familiar assumptions and thus to remain constantly flexible. Once again the expanded search for contemporary art in hidden places is also what drives the fourth edition of the *BMW Art Guide by Independent Collectors*. In this edition, we've added four new countries: Lebanon, Romania, Serbia, and South Korea. From cosmopolitan Hong Kong to Appenzell in Switzerland—from pulsating urban centers to tranquil provinces—the entire range is represented. It is our aim to provide you many hours of enjoyment and inspiration with this publication. We would like to extend our gratitude to the 256 collections for their active support of a project whose purpose is for art to be experienced in unique environments. Continually updated information on new discoveries and interviews, as well as background information on art and collecting, can be found on our blog at www.bmw-art-guide.com.

Hildegard Wortmann
Senior Vice President Brand BMW

Karoline Pfeiffer
Director,
Independent Collectors

BMW Art Guide by Independent Collectors
256 private collections of contemporary art.

A —

B

C

D

E

F

G

H

I

J

K

L

M

N

O

P

Q

R

S

T

U

V

W

X

Y

Z

— **A**

1 Colección de Arte
 Amalia Lacroze de Fortabat
 *Argentina's wealthiest woman presents six
 centuries of art-treasure collecting*

Collector:
Amalia Lacroze de Fortabat

Address:
Olga Cossettini 141
Puerto Madero Este
C1107CCC Buenos Aires
Argentina
Tel +54 11 43106600
info@coleccionfortabat.org.ar
www.coleccionfortabat.org.ar

Opening Hours:
Tues–Sun: 12–8pm

The Colección de Arte Amalia Lacroze de Fortabat lies in the middle of Puerto Madero, the trendy quarter of the Argentine capital. Until the end of the 1990s, this neighborhood was still a no-go area of rundown houses ringing the harbor. It's been heavily restored and added to over the past few years by world-class architects like Sir Norman Foster, Philippe Starck, and Santiago Calatrava. The architect of the Colección Fortabat, which opened in fall 2008, is the Uruguay-born New Yorker Rafael Viñoly. He built a modern, light-filled house for the art collection of Argentina's wealthiest woman: 1 000 works ranging from Pieter Bruegel to Andy Warhol, who made a portrait of her in 1980. The socially critical artist Antonio Berni has a gallery all to himself.

A *2* MACBA—Museum Art Center
Buenos Aires
*An art center with a focus on international
geometric art*

MAMBA, MALBA, MACBA. Anyone flaneuring through
Buenos Aires on a museum tour could get them mixed up.
While the first two have been around for a long time, the
MACBA arrived on the scene in 2012. The Museum Art
Center Buenos Aires was founded by native Aldo Rubino,
who now lives in Miami and is a frequent guest on the collec-
tors' panel at Art Basel Miami Beach. Rubino's private
collection concentrates on geometric abstraction: Op Art,
Hard Edge, and Neo-Geo, from Manuel Álvarez Bravo and
Victor Vasarely, all the way to the American Sarah Morris.
Special exhibitions feature all varieties of current art. Shows
take place in the 2 400-square-meter translucent building
brought to life by local architect duo Vila Sebastián. The
location is great: the MACBA, which sits adjacent to the
MAMBA, is in the lively flea-market quarter of San Telmo.

Collector:
Aldo Rubino

Address:
Avenida San Juan 328
C1147AAO Buenos Aires
Argentina
info@macba.com.ar
www.macba.com.ar

Please check the website
for the most current information
on opening hours.

3 Fundación Costantini/MALBA—
Museo de Arte Latinoamericano
de Buenos Aires
*An ambitious overview of a century
of Latin American art*

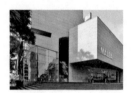

Unsuspecting "gringos" come across places in South
America that they couldn't have imagined in their wildest
dreams. The Museo de Arte Latinoamericano de Buenos
Aires (MALBA) is one such place. The museum of art fea-
tures work from the Caribbean to Tierra del Fuego and
is located in the posh district of Palermo Chico. It looks
like an outpost of New York's Museum of Modern Art
(MOMA). Here, too, people know how to erect elegant
structures; here modernism is self-consciously defined—
naturally, from a Latin-American perspective. Nearly
300 key works from businessman Eduardo F. Costantini's
collection are on permanent display: politically charged
Conceptual Art by Léon Ferrari; the Chilean surrealist
Roberto Matta is also well represented, as is the Brazilian
Lygia Clark, whose fragile metal objects have leapt to
premium prices internationally.

Collector:
Eduardo F. Costantini

Address:
Avenida Figueroa Alcorta 3415
C1425CLA Buenos Aires
Argentina
Tel +54 11 48086500
info@malba.org.ar
www.malba.org.ar

Opening Hours:
Thurs–Mon: 12–8pm
Fri: 12–9pm

There is no shortage of museums, galleries, and other exciting art venues in Buenos Aires, the bustling metropolis on the Río de la Plata. Too bad, then, that they are spread across so many different quarters, with melodious names like Recoleta, Retiro, Palermo, and Belgrano. Carefully planning your art sojourn, therefore, is crucial. The comparatively cheap black-and-yellow taxis and their friendly drivers will do the rest. Aside from the private museums presented in this guide, one should definitely visit the Museo Nacional de Bellas Artes (MNBA), with its extensive collections of European and predominantly Argentine art through the twenty-first century. More closely affiliated with international art discourse is the private Fundación Proa, located in the colorful harbor district of La Boca. Whether Jeremy Deller, Mona Hatoum, or the young Argentine rising star Eduardo Basualdo—all have had a big show in this gleaming white building. Casa Cavia, housed in a newly renovated 1920s-era villa in Palermo Chico, directly behind the Museo de Arte Latinoamericano de Buenos Aires (MALBA), features an unconventional mix of restaurant, bookstore, perfume lab, and florist. Located in the districts of Retiro and Recoleta, the galleries Ruth Benzacar and Jorge Mara-La Ruche, both regular exhibitors at Art Basel Miami Beach, offer primarily Argentine avant garde at the highest level. Whoever wishes to discover both the younger Argentine and international scene is in good hands at Miau Miau, in Palermo. Each year, in late May, in the middle of Argentina's fall season, the fair ArteBA takes place. Also located in Palermo, the fair initially specialized in Latin American art but has become increasingly international. In October, friends of photography will discover fine works at the fair Buenos Aires Photo. It's located in the communal Centro Cultural Recoleta, which exhibits the work of international greats like August Sander or Roger Ballen, in addition to Argentine artists. There are also off-spaces, but here they have a rather nomadic character. It's best to pay attention to local flyers to discover what's going on.

Nicole Büsing & Heiko Klaas

4 Museo James Turrell— **A**
 The Hess Art Collection, Colomé

*Turrell's largest Skyspace and additional light rooms
in breathtaking surroundings*

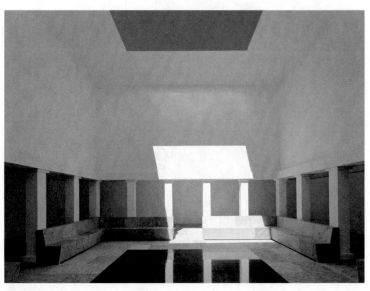

Collector:
Donald M. Hess

Address:
Ruta Provincial 53
km 20 Molinos 4419
Salta
Argentina
Tel +54 3868 494200
museo@bodegacolome.com
www.bodegacolome.com

Opening Hours:
Tues–Sun: 2–6pm
And by appointment.
Reservations encouraged.

Additional exhibition locations:
Klapmuts, South Africa, p. 182
Napa, United States of America,
p. 224

Far away from all the art metropolises, in a majestic
location beneath the bright blue sky of the Argentine
Andes, lies the world's first James Turrell Museum, open-
ed in 2009. Here the light-and-land artist from Arizona
completed the biggest *Skyspace* at his collector and friend
Donald M. Hess's vineyard, Colomé: 2 300 meters up a
mountainside sits a Turrell observatory with an open roof,
joined by an orchestration of subtle light. Eight more
light rooms, works acquired by Hess over the past forty
years, are grouped around the spectacular centerpiece.
Here you experience pure meditative inwardness. The
Museo James Turrell, which Hess maintains along with
his collections in South Africa and North America, is a
truly magical space in a fascinating location.

A ━━━

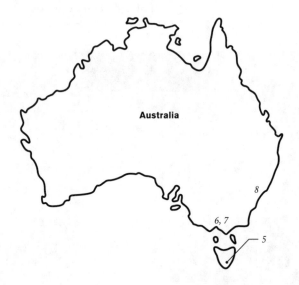

Australia

8

6, 7

5

5 Museum of Old and New Art (MONA)
 A collection that places personal predilection
 over speculative intention

Small gestures are not his thing: Australian millionaire David Walsh owns one of the largest museums in the southern hemisphere. This building without daylight is burrowed deep into the Tasmanian bedrock. Aside from contemporary art, the museum also houses Egyptian mummies and Greek coins. Walsh, who made his fortune developing complex winning-systems for gambling, combines antique treasures with Australian contemporary art, as well as works by internationally renowned artists like Jannis Kounellis, Hans Bellmer, Anselm Kiefer, the Viennese group Gelitin, or Wim Delvoye's excrement machine, *Cloaca*. Walsh prefers works that confront viewers immediately with subjects like sex and death. He views his Museum of Old and New Art, opened in 2011, as a kind of secular temple in which visitors are made keenly aware of humanity's existential conditions.

Collector:
David Walsh

Address:
655 Main Road
Berriedale TAS 7011
Hobart
Australia
Tel +61 3 62779900
info@mona.net.au
www.mona.net.au

Opening Hours:
May–September
Wed–Mon: 10am–5pm
October–April
Wed–Mon: 10am–6pm

6 Lyon Housemuseum **A**
The private house as museum: living with art and showing it

Collectors:
Corbett & Yueji Lyon

Address:
219 Cotham Road
Kew VIC 3101
Melbourne
Australia
Tel +61 3 98172300
museum@lyonhousemuseum.com.au
www.lyonhousemuseum.com.au

By appointment only. To arrange an appointment, send an e-mail, or call on Mondays or Tuesdays between 9:30–11:30am.

If you want to visit Corbett and Yueji Lyon, you first have to make an appointment. For good reason: the architect built a house for his family that also functions as a museum. In the cavernous rooms the artworks are re-hung biannually. Lyon draws on a long tradition, such as Peggy Guggenheim's Venetian home, where her private collection was shown. The Australian pair has specialized in the artists of their own country, collecting paintings from the likes of Tim Maguire, sculptures by Peter Hennessey, or large C-print photographs by Anne Zahalka. Two decades ago the Lyons decided to collect the work of a new generation, such as that by Peter Atkins, Callum Morton, and Patricia Piccinini, who have since become established internationally. The couple has remained true to their pioneering spirit.

7 Ten Cubed
Spotlight on artists from Australia and New Zealand

Collectors:
Dianne Gringlas & Ada Moshinsky

Address:
1489 Malvern Road
Glen Iris VIC 3146
Melbourne
Australia
Tel +61 3 98220833
info@tencubed.com.au
www.tencubed.com.au

Opening Hours:
Tues–Sat: 10am–4pm

Most art collections don't open their doors with a pre-determined closing date, but Ten Cubed is one that did. Established in 2010, the original idea was to collect ten works by ten artists over ten years, hence the name. Once enough works by a single artist—from painting to photography, to sculpture and video art—had been purchased, they would be given a solo show in the airy, custom-built gallery space in Glen Iris. The original focus was on Australian and New Zealand artists, from sculptors Alexander Knox and Anne-Marie May to photographers such as David Rosetzky and Pat Brassington. Aesthetic appeal and collectability were the main criteria. Surprised by the success of their experiment—within five years ten artists had already been selected—collector Dianne Gringlas and her curatorial advisor Ada Moshinsky, who is also her sister-in-law, announced Ten Cubed 2, which will now include international artists for the project.

A *8* White Rabbit—
Contemporary Chinese Art Collection
*One of the largest collections of contemporary
Chinese art*

Judith and Kerr Neilson have chosen to limit them-
selves: they only collect Chinese art, and only works crea-
ted after the year 2000. When Judith Neilson traveled to
Beijing in 2001 she realized that her understanding of
Chinese art was based on an outdated cliché. When she
returned, she restructured their existing collection and,
together with her husband, she bought an old factory in
Sydney's industrial district. There she began to systemati-
cally acquire contemporary work by artists like Ai Weiwei,
Huang Zhen, Qi Zhilong, or Huang Yan. The age of the
artist did not matter, rather Neilsen was after "creativity
and quality." Instead of buying at art auctions, the couple
buys directly in China from gallerists and artists' studios.
Featuring only a handful of Chinese works in 2000, it is
now considered one of the world's most important and
focused collections.

Collector:
Judith Neilson

Address:
30 Balfour Street
Chippendale NSW 2008
Sydney
Australia
Tel +61 2 83992867
info@whiterabbitcollection.org
www.whiterabbitcollection.org

Opening Hours:
Wed–Sun: 10am–5pm

Sydney has long battled it out with Melbourne for top billing on the Australian cultural calendar. But, while the latter boasts an equally if not more active gallery and museum scene, Sydney's harborside arts festival, the Biennale of Sydney, places it a cut above, particularly on the international art world stage. Having attracted top-notch curators for its past editions—Documenta 13 artistic director Carolyn Christov-Bakargiev and Fondazione Prada director Germano Celant, and others—the 20th Biennale of Sydney in spring 2016 was helmed by Stephanie Rosenthal, chief curator of London-based Hayward Gallery, and focused on the boundaries between our virtual and physical lives. For those headed Down Under during biennale off-months, there's still plenty left to see. The Art Gallery of New South Wales (Art Gallery NSW) leads off Sydney's museum scene. The institution's John Kaldor Family Collection is of particular note here for its breadth of American and European postwar and contemporary masters. The Museum of Contemporary Art Australia (MCA)'s waterfront building, which previously housed the Maritime Services Board, was renovated in 2012 to offer increased exhibition space and a more modern vibe. More experimental is Artspace, a contemporary art venue in the city's Woolloomooloo district, which was founded by artists in 1983 and moved to its current venue, a historic building known as The Gunnery, in 1992. The much younger Carriageworks opened in 2007 in the disused Eveleigh Rail Yards, and hosts a multi-disciplinary program of contemporary art, theater, and performance—as well as the city's biggest art fair, Sydney Contemporary, which is held every two years in September. Australia's relative isolation from the art market power-centers of Europe, America, and Asia translates into fewer commercial galleries than some cities of similar global standing, but a trip here wouldn't be complete without a stop at Roslyn Oxley9 Gallery, which has helped launch the careers of Tracey Moffatt and Fiona Hall, among others.

Alexander Forbes

— **A**

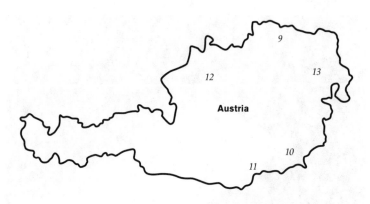

9 Kunstraum Buchberg
*Permanent contemporary installations
and projects in the park*

Collectors:
Gertraud & Dieter Bogner

Address:
Buchberg am Kamp 1
3571 Gars am Kamp
Austria
Tel +43 1 5128577
office@bogner-cc.at
www.bogner-cc.at/projekte/
kunstraum

By appointment only.

Gertraud and Dieter Bogner are museum experts. The couple runs an international agency for museum planning, cultural and strategic museum concepts, and exhibition management in Vienna. Some of their prestige projects in recent years include the New Museum in New York City or the new Bauhaus Museum in Dessau. Of course, with this type of background, the Bogners also have a strong interest in living with art. This is done at a location far away from Vienna at Buchberg, their twelfth-century castle located in lower Austria, where since 1979 they have invited artists to modify its rooms. Thus far there have been twenty-two permanent room alterations: color interventions, wall works, and sculptures. And in the green surrounds of the castle, stars like Dan Graham or Heimo Zobernig have executed distinctive works relating to the architecture.

A *10* Schlosspark Eybesfeld
*Carefully executed art projects in a
palace-garden setting*

A palace, a garden, and an enthusiastic couple. Christine and Bertrand Conrad-Eybesfeld do not buy their art off the rack. It originates on site, sometimes in a few weeks, sometimes over a period of years. The owners of a cultural management agency do not consider themselves collectors or patrons, but rather artists' partners for these outdoor projects. Indeed, the couple has enough space: the palace is located in the sparsely populated state of Styria, in southeastern Austria. It all started with the artist Heimo Zobernig, who in 1989 made his mark on the palace's former tennis court with a fifteen-centimeter-thick concrete plate. Sol LeWitt executed a large-scale work shortly before his death, in 2007. For the Conrad-Eybesfelds, at least as important as the end result is getting people involved in the whole process, including the local community.

Collectors:
Christine & Bertrand
Conrad-Eybesfeld

Address:
Jöss 1
8403 Lebring
Austria
Tel +43 3182 240812
Tel +43 3182 240818
cce@eybesfeld.at
bce@eybesfeld.at
www.eybesfeld.at

Only guided tours by appointment.

11 Museum Liaunig **A**
*Austrian art after 1945 and prominent works
by international artists*

Collector:
Herbert W. Liaunig

Address:
Neuhaus 41
9155 Neuhaus
Austria
Tel +43 4356 21115
office@museumliaunig.at
www.museumliaunig.at

Opening Hours:
May–October
Wed–Sun: 10am–6pm

Guided tours by appointment.

With its slim, slightly rounded form, the Museum Liaunig resembles a gigantic USB-stick plugged into green hills. Carinthian businessman Herbert W. Liaunig opened this radically modern-looking museum far away from the urban hustle and bustle in the summer of 2008, and had it greatly expanded in 2014. The building was masterminded by the Viennese architects Querkraft, who lean toward understatement: 90 percent of the rooms are located underground. Liaunig collected "what resulted from personal encounters and predilections." The more than 3 000 works include key pieces of Austrian postwar art by figures like Arnulf Rainer or Maria Lassnig, but also undiscovered or overlooked works, as well as young positions. Since the museum was founded, Liaunig has collected with more focus and closed some previous gaps, such as his acquisition of several Viennese Actionists. His goal is to bring Austrian art since 1945 alive for the visitor.

12 Museum Angerlehner
*The unique collection of an entrepreneur fascinated
by art and artists*

Collector:
Heinz J. Angerlehner

Address:
Ascheter Strasse 54
4600 Thalheim bei Wels
Austria
Tel +43 7242 2244220
office@museum-angerlehner.at
www.museum-angerlehner.at

Opening Hours:
Fri–Sun: 10am–6pm
And by appointment.

The Upper Austrian entrepreneur Heinz J. Angerlehner describes himself as "a collector with heart and soul." Over a thirty-year period he acquired more than 2 500 works of art. They have either attracted him emotionally or spontaneously—without regard for any art-historical classification, but with a high regard for quality. This is how his collection grew over the years to include many famous names from his homeland, such as Arnulf Rainer, Gunter Damisch, Hubert Schmalix, or Andreas Leikauf. In September 2013 the Museum Angerlehner opened in Thalheim, near Wels. It is housed in a former assembly hall covered with iridescent black metal panels, which in addition to showing the collection also hosts temporary exhibitions in its roughly 2 000-square-meter space. An added highlight is the fifty-meter-long display storeroom with retractable walls.

A *13* TBA21—Augarten
*Worldwide support of art projects and exhibitions
in a Viennese park*

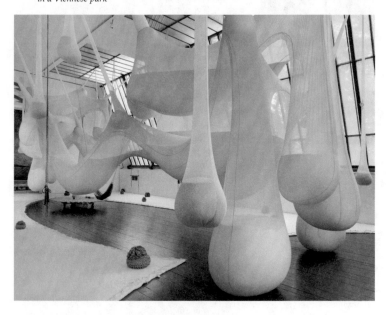

Since 2012, the Augarten in Vienna has hosted a think tank
for art projects situated at the interface of art, architec-
ture, and sustainability. The private foundation Thyssen-
Bornemisza Art Contemporary (TBA21) develops exhibi-
tions here in dialogue with its own collection. Especially
appealing in summer: the open-air stage designed by
British architect David Adjaye, which serves as a platform
for lectures, performances, and concerts. But that's not
all they do: the mission of the globally active foundation
is to work closely with international artists, from Vienna
to Reykjavík to New Delhi. Chairwoman Francesca von
Habsburg, daughter of the super-collector Baron Hans
Heinrich Thyssen-Bornemisza, grew up with art, and has
become one of the most experimental-friendly and socially
engaged patrons of contemporary art since the foundation
was established in 2002.

Collector:
Francesca von Habsburg

Address:
Scherzergasse 1A
1020 Vienna
Austria
Tel +43 1 51398560
augarten@tba21.org
www.tba21.org

Opening Hours:
Wed–Thurs: 12–5pm
Fri–Sun: 12–7pm

No other city in the German-speaking world presides over such a dense network of museums and galleries like Vienna, the Austrian metropolis of 1.8 million inhabitants. The best place to begin a tour is MuseumsQuartier Wien (MQ), where you'll find three institutions of international standing: the Museum Moderner Kunst Stiftung Ludwig Wien (MuMoK), founded in 1962, featuring the largest collection of twentieth- and twenty-first-century art in central Europe, the Kunsthalle Wien, focusing on contemporary discourse, and the Leopold Museum, boasting the largest Egon Schiele collection in the world. Other highlights on the Vienna tour include the Belvedere, with Austrian art from 1900 onwards, and its annex for contemporary art, the 21er Haus. Art Nouveau enthusiasts should not miss the Vienna Secession. Every October, Viennafair, an art fair for international contemporary art, draws visitors to the trade fair center's Hall A, designed by renowned Viennese architect Gustav Peichl. This is also the perfect opportunity to get to know the local gallery scene of experienced protagonists who have set the tone with committed international and avant-garde programs. In the city's first municipal district, Rosemarie Schwarzwälder has shown abstract and Conceptual Art at her gallery Galerie nächst St. Stephan, on Grünangergasse, since 1984. Located just a stone's throw away are the exhibition spaces of Ursula Krinzinger, the grande dame of Vienna's galleries. Since 1971 Krinzinger has been synonymous with performance and body art, as well as the Viennese Actionism of Hermann Nitsch and Rudolf Schwarzkogler. Further to the southwest, Georg Kargl Fine Arts, on Schleifmühlgasse, has made a name for itself since the late 1990s with artists like Gerwald Rockenschaub, Clegg & Guttmann, or Mark Dion. Next door you'll find the galleries of Christine König and Kerstin Engholm, also well worth a visit. As the day draws to a close, the Viennese art scene enjoys meeting up for schnitzel, goulash, and Czech beer at the legendary Viennese Beisl Café Anzengruber. *Wohl bekomms!* Cheers!

Nicole Büsing & Heiko Klaas

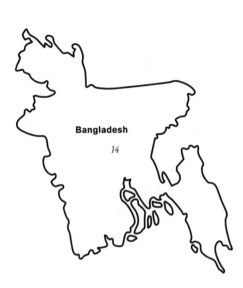

Bangladesh

14

14 Samdani Art Foundation
*A discovery of modern and contemporary art
from Bangladesh*

Collectors:
Nadia & Rajeeb Samdani

Address:
Level 5, Suite 501 & 502
Shanta Western Tower
186 Gulshan–Tejgaon Link Road
Tejgaon I/A, Dhaka-1208
Bangladesh
Tel +8802 8878784-7
info@samdani.com.bd
www.samdani.com.bd

By e-mail appointment only.

Globalization has put previously ignored countries on the art map—Bangladesh, for example. Bangladeshi industrialist Rajeeb Samdani and his wife, Nadia, are well aware of this, so their aim is to acquaint an international audience with art from their country. In April 2011 they opened a foundation to promote local art via exhibitions, film screenings, and events like the Dhaka Art Summit. Their collection, spread over three floors of their private home, includes local artists such as Shumon Ahmed, Tayeba Begum Lipi, and Mahbubur Rahman, alongside international artists such as Dominique Gonzalez-Foerster, Tony Oursler, Tracey Emin, Anish Kapoor, Philippe Parreno, and Prabhavathi Meppayil. Samdani, who is also a founding member of the South Asian Acquisitions Committee of the London Tate, has an additional project: a sprawling sculpture park in the country's northeast.

B

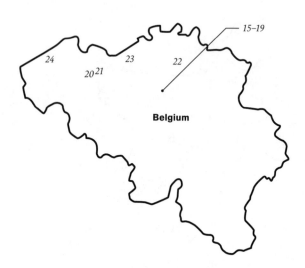

15–19

24 23 22

20 21

Belgium

15 Frédéric de Goldschmidt Collection
*Reduced aesthetics and humble materials in
three locations in the center of Brussels*

He had always purchased art, but it wasn't until 2009 that
Frenchman Frédéric de Goldschmidt began thinking
of himself as a collector. That's when he first acquired
works that vastly exceeded the dimensions of his loft
apartment, located in a seventeenth-century building
in central Brussels. Today he owns two additional show-
rooms measuring seventy and 160 square meters, respec-
tively. His collection revolves conceptually around the
group Zero and their associates, with works by Günther
Uecker, Heinz Mack, or Piero Manzoni. In the meantime,
de Goldschmidt, who works as a film producer, has begun
collecting mostly younger artists, such as the Berliner Stef
Heidhues, or Joël Andrianomearisoa, from Madagascar. The
collection's common thread is a reduced aesthetic and great
sensitivity to rather humble materials. De Goldschmidt
rehangs his collection each year in time for Art Brussels.

Collector:
Frédéric de Goldschmidt

Address:
Brussels, Belgium
fdegoldschmidtcollection@gmail.com

Visitation permitted only
occasionally. Please inquire
by e-mail.

16 Maison Particulière
*Exhibitions in a private home curated by collectors,
artists, and scholars*

B

Collectors:
Amaury & Myriam de Solages

Address:
Rue du Châtelain 49
1050 Brussels
Belgium
Tel +32 2 6498178
info@maisonparticuliere.be
www.maisonparticuliere.be

Opening Hours:
Tues–Wed: 11am–6pm
Fri–Sun: 11am–6pm

It would be hard to be more innovative. The Brussels-based French couple Amaury and Myriam de Solages put together a monothematic exhibition several times a year with collector friends and art experts. Shows on themes of pairs, taboos, or icons, for instance, have been presented at Maison Particulière. The location is as unique as the idea: an uninhabited aristocratic domicile in the lively district of Châtelain. Three stories, dark hardwood floors, high ceilings, lots of light, and chock-full of first-rate furniture by Ludwig Mies van der Rohe, Arne Jacobsen, and young designers. The whole project has been well-received in Brussels: since its opening, in April 2011, Maison Particulière has turned into an absolute hotspot of the city. Works as varied as those by Cindy Sherman, Kiki Smith, and Hans Bellmer can be seen alongside young Belgian artists, African sculptures, and porcelain objects. Eclecticism with style.

B

17 Charles Riva Collection
*Charming presentation of contemporary art
in two locations in Brussels*

The Frenchman Charles Riva is co-owner of galleries in Brussels, Paris, and London. He views his Charles Riva Collection, in Brussels, as a nonprofit space. Here he lives with his collection in a centrally located luxurious nineteenth-century townhouse. In the spring of 2009, Riva started organizing two to four exhibitions a year featuring works of artists from the collection, including Leipzig painter and printmaker Christoph Ruckhäberle, Californian performance artist and pop-culture antagonist Paul McCarthy, or the fictional New York artist Reena Spaulings. Going to galleries is a serious thing, Riva says, almost on par with attending church. Whoever visits his collection should get a sense of the novel ways in which art unfolds when viewed in private rooms. And located just two kilometers away is Riva Project, a new space specializing exclusively in contemporary sculpture.

Collector:
Charles Riva

Address:
Rue de la Concorde 21
1050 Brussels
Belgium
Tel +32 2 5030498
info@charlesrivacollection.com
www.charlesrivacollection.com

Opening Hours:
Wed–Sat: 12–6:30pm
And by appointment.

18 Servais Family Collection
*Art that poses questions, in a converted factory loft
in the north of Brussels*

Alain Servais is omnipresent in the art world. He is occasionally part of the expert panel for the collection of new media at Art Basel. At other times he can be seen during Berlin Art Week rushing from gallery to gallery on a rented Vespa. He is also an avid Twitter user. The extremely well-connected Frenchman, who lives in Brussels, is hungry for art. In his opinion, good art should question certainties: "It should teach me something that I don't know about myself or my environment." Servais converted an old factory into a 900-square-meter loft in the multicultural district of Schaerbeek. Here he shows his collection, which includes established names such as Gilbert & George and Barbara Kruger as well as younger positions, like video works by Mexican artist Arturo Hernández Alcázar. Once a year he rearranges 80 percent of his collection's holdings.

Collector:
Alain Servais

Address:
Brussels, Belgium
collection.servais@gmail.com

By e-mail appointment only.

"Brussels is booming, when it comes to culture and the arts," says Katerina Gregos, the artistic director of Art Brussels. April 2016 marked a double premiere: Art Brussels was held in its new location inside the historic halls of Tour & Taxis, and the New York fair Independent installed its European offshoot at the Dexia Art Center, a centrally located, former furniture department store from the 1930s. During such events Brussels really comes alive: open houses hosted by scores of private collectors, gallery nights and parties set the program. For young artists and international collectors, this European capital—with both its charm and rough edges—is the new Mecca: studios, galleries, and institutions congregate here en masse. The Palais des Beaux-Arts (for short: Bozar) lures visitors with exhibitions ranging from Jeff Wall to Daniel Buren. Art-goers interested in current positions such as Edith Dekyndt are in good hands at the Wiels—Centre d'Art Contemporain, in the Forest district. Nine artists' studios for international newcomers are available for residencies at this art center, which opened in 2007 in an old brewery. If you want to explore the Brussels gallery scene, it's best to take a tour of the Ixelles district, or the Lower Town, also known as Downtown. Situated here are the spaces of the long-established Galerie Greta Meert and the gallery Dépendance, run by Michael Callies who originally hails from Germany. Walking in the direction of Ixelles you'll also pass the flagship gallery Jan Mot, Galerie Micheline Szwajcer, recently relocated from Antwerp, as well as the New York blue-chip gallery Barbara Gladstone. Upon arriving in the elegant Ixelles district, you'll find Almine Rech, Xavier Hufkens, and Levy.Delval. Anyone wishing to stock up on art books in otherwise comics-enthusiast Belgium should head straight to the magnificent Galeries Royales Saint-Hubert Passage, near the Grand Place. Here the bookshop Tropismes provides an opportunity for endless hours of browsing.

Nicole Büsing & Heiko Klaas

19 Vanhaerents Art Collection
*Art and film since the 1970s: Warhol, Naumann,
and subsequent trends*

B

Collector:
Walter Vanhaerents

Address:
Rue Anneessens 29
1000 Brussels
Belgium
Tel +32 2 5115077
www.vanhaerentsartcollection.com

Online registration required.

Walter Vanhaerents's family has been in the construction business for eighty years, so naturally he went into the business too. But as a young man he studied film. He was so impressed with Andy Warhol's five-hour-long film *Sleep* that he wanted to see other works by the Pop icon. No surprise, then, that Warhol, along with Bruce Naumann, is one of the anchors of the Vanhaerents Art Collection. But the reactions of subsequent generations of artists to these seminal figures interests Vanhaerents as well, whose collection also features works ranging from Cindy Sherman, Matthew Barney, and Ugo Rondinone, to the provocative, neo-Pop Art, business-minded artist Takashi Murakami. The collection is housed in a charmingly remodeled 1926 industrial building on the outskirts of the hip fashion and gallery district of Dansaert. Starting in 2007, new exhibitions have been shown biannually on three floors.

B

20 Museum Dhondt-Dhaenens

In the middle of Flanders, international art stars shown in quick succession

The Flanders industrialist couple Jules and Irma Dhondt-Dhaenens began collecting art in the 1920s. Belgium was just as divided then as it is today, which is why the couple focused almost exclusively on Flemish artists from 1880 to 1950, including James Ensor and Frits Van den Berghe. Later the collector couple decided to have a museum built to house their collection. Not in Brussels or Ghent, but in the countryside at Deurle, a beautifully located village on the river Leie and close to the artist colony Sint-Martens-Latem. The bright white, flatroofed modernistic structure was opened in 1968. Today the museum continues to sharpen its contemporary profile with around eight annual exhibitions devoted to such international artists as Thomas Hirschhorn, Wade Guyton, and Monika Sosnowska.

Collectors:
Jules & Irma Dhondt-Dhaenens

Address:
Museumlaan 14
9831 Deurle
Belgium
Tel +32 9 2825123
info@museumdd.be
www.museumdd.be

Opening Hours:
Tues–Sun: 10am–5pm

21 Herbert Foundation

A highly intellectual private collection in an industrial complex in Ghent

To utopia and back. The collection of the Ghent-based couple Annick and Anton Herbert focuses on art produced between 1968 and 1989. In a former steam-engine factory near the center of the Flemish city they present in temporary exhibitions works by concept and avant-garde artists such as Bruce Nauman, Marcel Broodthaers, Carl Andre, Robert Barry, and Lawrence Weiner as well as Martin Kippenberger, Franz West, and Thomas Schütte. What connects them all is their critical reflection upon social and artistic issues. What makes the collection so unique is its profound archive of artist books, letters, postcards, posters, invitations, and other documents, which show the friendly ties and decades of intellectual debate between the Herberts and "their" artists.

Collectors:
Anton & Annick Herbert

Address:
Coupure Links 627 A
9000 Ghent
Belgium
Tel +32 9 2690300
contact@herbertfoundation.org
www.herbertfoundation.org

Opening hours vary depending on exhibition. Please check the website for the most current information.

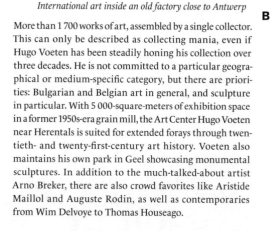

B

22 Art Center Hugo Voeten
International art inside an old factory close to Antwerp

Collector:
Hugo Voeten

Addresses:
Vennen 23
2200 Herentals
Belgium

Sculpture Park:
Hazenhout 17-19
2440 Geel
Belgium

Tel +32 475 555125
info@artcenterhugovoeten.org
www.artcenter.hugovoeten.org

Please check the website
for the most current information
on opening hours.

More than 1 700 works of art, assembled by a single collector. This can only be described as collecting mania, even if Hugo Voeten has been steadily honing his collection over three decades. He is not committed to a particular geographical or medium-specific category, but there are priorities: Bulgarian and Belgian art in general, and sculpture in particular. With 5 000-square-meters of exhibition space in a former 1950s-era grain mill, the Art Center Hugo Voeten near Herentals is suited for extended forays through twentieth- and twenty-first-century art history. Voeten also maintains his own park in Geel showcasing monumental sculptures. In addition to the much-talked-about artist Arno Breker, there are also crowd favorites like Aristide Maillol and Auguste Rodin, as well as contemporaries from Wim Delvoye to Thomas Houseago.

23 Verbeke Foundation
An impressive terrain for hiking and discovering unorthodox art

Collectors:
Geert & Carla Verbeke-Lens

Address:
Westakker
9190 Kemzeke, Stekene
Belgium
Tel +32 3 7892207
info@verbekefoundation.com
www.verbekefoundation.com

Opening Hours:
Thurs–Sun: 11am–6pm

Dynamic, not static. This is the motto of the Belgian collector pair Geert and Carla Verbeke-Lens. "Our exhibition space does not aim to be an oasis. Our presentation is unfinished, in motion, unpolished, contradictory, untidy, complex, inharmonious, living, and unmonumental," says Geert Verbeke. The former logistics businessman opened a twelve-hectare art park in 2007 on his company's property. Storage buildings and greenhouses offer 20 000 square meters of covered space for two enormous special exhibitions per year. The Verbekes started with collages and assemblages, but now they prefer "Bio-Art"—art that includes living animals, plants, and even scents. Visitors unable to see the whole display in a single day can even spend a night in a truly new environment: Joep van Lieshout's eccentric polyester sculpture *CasAnus*, a gigantic reconstruction of a human rectum.

B

24 Collection Vanmoerkerke
Highlights of European and American contemporary art

A good collection should have a focus, says entrepreneur Mark Vanmoerkerke who hails from the Belgian seaside resort of Ostend. His collection currently includes around 500 works of mainly European and American Post-Conceptual Art—works of artists like Ed Ruscha, Maurizio Cattelan, or Christopher Wool, for example. Vanmoerkerke regularly invites established curators, gallerists, and artists to put together exhibitions from the collection. This way things remain exciting not only for him but also for visitors. Previous guest curators have included the likes of museum directors Nicolaus Schafhausen and Dirk Snauwaert, gallerist Leo König, or artist David Claerbout. The Belgian cult curator Jan Hoet was one of the first to be allowed to mix it up in the former airplane hangar and modern extension that houses the collection.

Collector:
Mark Vanmoerkerke

Address:
Oud Vliegveld 10
8400 Ostend
Belgium
Tel +32 473 997745
info@artcollection.be
www.artcollection.be

Opening Hours:
Mon–Fri: 9am–5pm

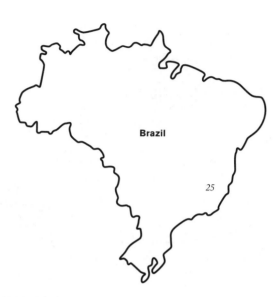

Brazil

25

Collector:
Bernardo Paz

Address:
Rua B 20
Brumadinho, MG
35460-000
Brazil
Tel +55 31 37519700
info@inhotim.org.br
www.inhotim.org.br

Opening Hours:
Tues–Fri: 9:30am–4:30pm
Sat–Sun: 9:30am–5:30pm

25 Instituto Inhotim—Centro de Arte
Contemporânea e Jardim Botânico
*The harmony of art and nature at one of the world's
most sensual locations*

Admittedly, it's hard to get here—but it's worth it. Inhotim completely redefines the production, exhibition, and experience of major outdoor-art projects. The collector, commodities magnate and philanthropist Bernardo Paz, invites well-known artists to his 1 000-hectare tropical expanse to unleash their most extravagant ideas. A team of four curators, including German Jochen Volz, supports the artists however it can. Cildo Meireles, Matthew Barney, Ólafur Elíasson, Yayoi Kusama, and Chris Burden have all left their marks. Getting to Doug Aitken's *Sonic Pavilion*, which funnels the sounds of inner earth to the surface, or to Hélio Oiticica's color-orgy *Magic Square #5*, might take a while. Best is to take one of the many golf carts available, but if you decide to walk, there are plenty of benches along the way to let your dreams fly.

C

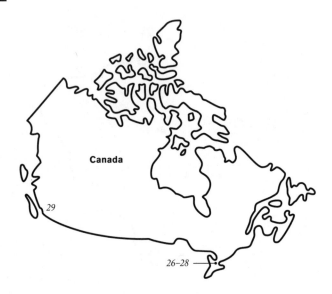

Canada

29

26–28

26 Scrap Metal
*Art focused on the relationship between word and
image in an industrial hall*

The name of the collection is bemusing: inside the former
industrial warehouse, where investor Joe Shlesinger and
his wife Samara Walbohm have presented selections from
their collection since 2011, anything other than scrap metal
is on view, as the name of the space cheekily suggests.
Rather, the focus is on Canadian and international artists
whose work is similarly humorous and ambiguous. This
includes art by General Idea, Bill Viola, Jeff Wall, Camille
Henrot, or other global players. The names Dave Dyment,
Micah Lexier, or Laurel Woodcock, however, are not so well
known. All their works examine the complex interrela-
tionship of language, text, and image. The link between
art and text also resonates at Scrapbooks—a bookshop
designed by Paul P.—where the artist currently exhibiting
work at the collection determines the reading selection.

Collectors:
Samara Walbohm &
Joe Shlesinger

Address:
11 Dublin Street, Unit E
Toronto ON M6H 1J4
Canada
Tel +1 416 5882442
info@scrapmetalgallery.com
www.scrapmetalgallery.com

Please check the website
for the most current information
on opening hours.

27 The Bradshaw Collection
The Canadian couple who profit from the bundled
synergy of their highly developed sense of art

Collectors:
Cecily & Robert Bradshaw

Address:
Toronto, Canada
robertbradshaw@me.com

Visitation permitted only
occasionally. Please inquire
by e-mail.

It was a shared love of art that brought Cecily and Robert **C**
Bradshaw together about ten years ago. Both collected art
prior to their marriage but Robert Bradshaw attributes
their current collection in large part to the influence of his
wife's tastes. Cecily Bradshaw sits on the Director's Council
of the Museum of Modern Art (MOMA) in New York, and
their collection reflects this blue-chip sensibility. Works by
Anselm Kiefer, Chiharu Shiota, William Kentridge, Tony
Cragg, and Ross Bleckner are but a few of those installed in
their Toronto home. To furnish their residence, the Brad-
shaws appointed renowned Dallas-based interior designer
Jan Showers to create spaces that generously highlight the
couple's art collection. The design also took special care
to incorporate the Bradshaws' impressive trove of *livres des
artistes,* featuring books illustrated by Pablo Picasso, Jasper
Johns, Henri Matisse, and Marcel Duchamp, among others.

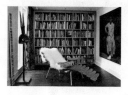

Collector:
Kenneth Montague

Address:
25 Ritchie Avenue
Toronto ON M6R 2J6
Canada
Tel +1 416 7079400
info@wedgecuratorialprojects.org
www.wedgecuratorialprojects.org

By appointment only.

28 The Wedge Collection
Contemporary art from the African diaspora

Contemporary art from Africa and the African diaspo-
ra has recently taken an increasingly prominent positi-
on in the art historical canon—and rightly so. Among
Toronto's foremost collectors helping to push that evolu-
tion forward is dentist-cum-curator Kenneth Montague.
The Wedge Collection—the name he has given his assem-
blage of works—focuses heavily on artists like Jennifer
Packer, Mickalene Thomas, and Zanele Muholi, whose
practices explore black identity. Begun in the late 1990s,
the collection is now located in Montague's David Anand
Peterson-designed home. Montague himself started col-
lecting at just ten years old and has gone on to assemble
an impressive selection of mid-century design in addition
to art. Now, the collector frequently stages programming
and exhibitions at his home that are free and open to the
public, and curates shows in Toronto and elsewhere of
artists he collects and collaborates with.

29 Rennie Collection at Wing Sang
*Continuity since 1972: from trailblazing giants
to new talents*

C

A guided tour through Chinatown's Wing Sang Building, where collector Bob Rennie presents his acquired works, takes exactly fifty minutes—not a lot of time for one of the largest collections in Canada. But Rennie focuses on central positions, like John Baldessari, Mike Kelley, Mona Hatoum, Rodney Graham, or Belgian artist David Claerbout, who takes excerpts of Hollywood classics lasting seconds and stretches them out to last an entire day. The works owned by the real-estate marketer are re-arranged annually in two to three solo or group exhibitions. Rennie, who had the oldest building in the district lavishly renovated, has been collecting for over thirty years, acquiring many pieces now considered to be trailblazing. In addition he keeps himself abreast of contemporary art trends by collecting the works of talents like Turner Prize winners Martin Creed and Simon Starling.

Collector:
Bob Rennie

Address:
51 East Pender Street
Vancouver BC V6A 1S9
Canada
www.renniecollection.org

Only guided tours with prior
online registration.

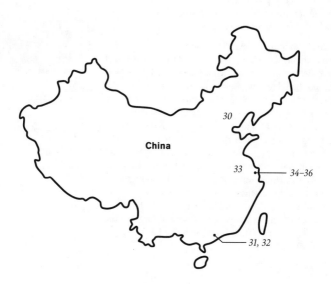

China

30

33
34–36

31, 32

30 M Woods
*Contemporary art in a former factory
in the 798 Art Zone*

Collector:
Lin Han

Address:
D-06, 798 Art Zone
No. 2, Jiuxianqiao Rd.
Chaoyang District
Beijing 100015
China
Tel +86 10 83123450
info@mwoods.org
www.mwoods.org

Opening Hours:
Tues–Sun: 11am–6pm
And by appointment.

"Art has changed me very much—in the way I think and see the world. Art is magical." Even if Lin Han only began collecting in 2013, his words show the extent to which art has impacted his life. So far, the young industrial designer, who now runs a PR agency and works at his family's investment company, has acquired more than one hundred works by renowned artists such as Tracey Emin, Zeng Fanzhi, Kader Attia, and Yoshitomo Nara. Since 2014, Lin has presented his collection in the expansive exhibition spaces of a former Bauhaus-style munitions factory located in the bustling arts district of 798 Art Zone. The name of the collection alludes to Lin's family: The "M" is the first letter of the name of his mother, who awakened his love for art. "Woods" is the English translation of his family name, "Lin."

31 Living Collection
*Contemporary art from Hong Kong in the loft
of a former industrial building*

C Since the founding of Art Basel Hong Kong, the former
British colony has become a hotspot on the international
art scene. But if you're particularly interested in its local
art, you should visit the imposing exhibition space of the
collector William Lim. In 2004, during his travels, the
architect began to acquire works by Chinese artists. Two
years later he decided to focus more exclusively on artists
from Hong Kong. Since then, he has been collecting,
among others, the works of Lee Kit, Nadim Abbas, or
Tsang Kin-Wah—young artists who deal with society and
their lives in Hong Kong. But here you'll also find inter-
national positions such as Lee Bul, Hernan Bas, or Callum
Innes in Lim's nearly 400-square-meter loft. That his studio
is a place of lively exchange is evidenced not least in the
artists' dinners that Lim hosts on a regular basis.

Collector:
William Lim

Address:
Hong Kong, China
info@cl3.com
www.livingcollection.hk

By e-mail appointment only.

32 Z Collection
*A collection of Chinese and Western contemporary art in
a private home on the Peak*

Hong Kong-based financier turned art critic, collector, and
curator William Zhao discovered his passion for art at an
early age, purchasing his first piece, a drawing by Pablo
Picasso, twenty years ago. His art collection is on display
at his home, a large house on the Peak overlooking Hong
Kong, where both Chinese and Western artists are featured
including established positions such as Carol Rama and
Joseph Beuys to younger artists such as Guan Xiao and
Cheng Ran. The passionate polo player mainly collects ar-
tists he knows personally, and whose artistic language he
finds inspiring. Zhao advises collectors on contemporary
Chinese art and curates exhibitions with major Chinese
artists such as Sun Xun and Liu Weijian for galleries and
foundations including Louis Vuitton. He is also involved
with Duddell's, a Hong Kong cultural venue, with Ai Weiwei
curating one of their first exhibitions in 2013.

Collector:
William Zhao

Address:
Hong Kong, China
Tel +852 97015650
jw@zcompanyhk.com

Visitation permitted only
occasionally. Please inquire
by e-mail.

Hong Kong is without a doubt the center of the Asian art market. In addition to the international auction houses Christie's and Sotheby's, numerous art galleries have set up shop in the skyscrapers of the Central District, Hong Kong Island's buzzing financial hub. Influential Chinese representatives like Pearl Lam Galleries are found here, in addition to Western protagonists like Gagosian, White Cube, Galerie Perrotin, or Massimo De Carlo (MDC). In 2011, Art Basel took over the local fair Art HK, completing another step on the way to Hong Kong's transformation into an art market giant. The next big event on the agenda is the planned 2019 opening of M+, a major museum for visual culture. This will host, among other treasures, the core of the collection of Uli Sigg, one of the most important collectors of Chinese contemporary art. The Herzog & de Meuron designed museum will be part of the West Kowloon Cultural District, a vibrant quarter located directly on the harbor's waterfront. This area already enjoys several major museums, including the Hong Kong Museum of Art, which holds an excellent collection of Chinese paintings and calligraphy. The Hong Kong Arts Centre (HKAC) in Wanchai plays a pivotal role in the local arts scene, bringing together exhibition spaces, theaters, a cinema, and artists' studios under one roof. Just as multidisciplinary is Tai Kwun—Centre for Heritage & Art, which is opening toward the end of 2016 in a former police station redesigned by Herzog & de Meuron. Other institutions worth visiting include Para Site, a nonprofit art space run by independent artists in the hip area of Sheung Wan, and the Asia Society Hong Kong Center in Admiralty. The trend towards contemporary art is rapidly expanding, seen in the rise of artistic hubs in Hong Kong's industrial areas. Chai Wan, for example, is now home to galleries like Platform China; and Wong Chuk Hang houses Spring, an art space dedicated to an international cross-disciplinary program of artist and curatorial residencies and exhibitions.

Silvia Anna Barrilà

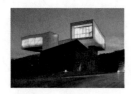

Collector:
Lu Xun

Address:
No. 9, Zhenqi Road
Pukou District
Nanjing 210031
China
Tel +86 25 58609999
contact@sifangartmuseum.org
www.sifangartmuseum.org

Opening Hours:
Wed–Sun: 10am–5pm

33 Sifang Art Museum
*Emerging and blue-chip artists in a building
by Steven Holl*

"The way art brings joy to the heart and challenges your **C**
existing perceptions is fascinating," explains Chinese
collector Lu Xun in describing the motivation behind his
collecting activity, a great passion of his since 2009. The
first works that Lu acquired were a sculpture by Yayoi
Kusama and a watercolor by Marlene Dumas. Since
then, he has collected about 200 artworks by Chinese
and international artists, such as Yang Fudong, Xu Zhen,
William Kentridge, and Luc Tuymans. But Lu is increasing-
ly interested in emerging artists, particularly from China.
His collection is housed in a spectacular building, designed
by Steven Holl, in the middle of the Laoshan National Park,
on the outskirts of Nanjing. Opened in November 2013,
the museum is part of the Sifang Parkland, a versatile area
that includes a conference center, a hotel, a recreation center,
and artist residences—the ideal space to find peace and
harmony with nature and art.

Collectors:
Liu Yiqian & Wang Wei

Address:
Lane 3398
Longteng Avenue
Xuhui District
Shanghai
China
Tel +86 21 64227636
info@thelongmuseum.org
www.thelongmuseum.org

Opening Hours:
Tues–Sun: 10am–6pm

34 Long Museum
*An overview of Chinese art history and
contemporary art*

The first collectors from Mainland China to make it onto
the 2012 *Artnews* list of the 200 top collectors were the
investor Liu Yiqian and his wife, Wang Wei. In December
of that same year, the billionaires opened their collection
to the public at the Long Museum in Shanghai. Liu's career
began in the 1980s, with the opening of the Chinese market.
First he turned his mother's small shop into a thriving
business. Then a friend introduced him to the newly
created financial sector, where he grew his fortune. For
over twenty years the couple has bought art from China
mainly at auctions, ranging from traditional art to work
by contemporary artists such as Zhou Chunya, Wang
Guangyi, Zhang Xiaogang, and Yue Minjun. Meanwhile,
the museum in Shanghai now occupies two locations: older
works remain in Pudong while current positions are pre-
sented at West Bund, since 2014. And a third venue opened
in spring 2016 in Chongqing.

35 Qiao Zhibing Collection
*An idiosyncratic presentation of new Chinese artists
amid Shanghai's nightlife*

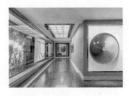

C In a nightclub called Shanghai Night, in the southwestern
part of the city, lives a modest but uniquely displayed col-
lection of Chinese and international art. The roughly thirty
works, in a variety of categories, spread over four floors
and 10 000 square meters, come courtesy of Qiao Zhibing,
who's been collecting since 2006. The collection focuses
primarily on presenting the recent generation of Chi-
nese artists, including Liu Wei, Zhang Enli, Yang Fudong,
MadeIn Company, or Qiu Xiaofei. An additional em-
phasis is on international artists like Ólafur Elíasson,
Sterling Ruby, Thomas Houseago, Michaël Borremans,
Theaster Gates, and Danh Vo. Since 2015, Qiao Space offers
a second location that can be visited by request. The ope-
ning of an additional space is planned for late 2017. For
this Qiao is converting several former oil tanks in a disused
industrial area at West Bund into what will be known as
Tank Shanghai.

Collector:
Qiao Zhibing

Address:
Shanghai Night
Caobao Road 400
Xuhui District
Shanghai
China
qiaocollection@vip.sina.com

By e-mail appointment only.

36 Yuz Museum
*Asian and Western contemporary art in a
disused airport*

For someone with a passion for large-scale installations,
there could be no better place for a private museum than
an aircraft hangar. For this purpose, the Sino-Indonesian
entrepreneur Budi Tek chose the former hangar of Shang-
hai Longhua Airport. He then commissioned Japanese
architect Sou Fujimoto to convert it into a 9 000-square-me-
ter exhibition space, which opened in 2014. Tek had already
founded a museum in Jakarta, which now serves as the
headquarters of his foundation. And although Tek began
collecting as recently as the beginning of the millennium,
he has become one of the most important collectors world-
wide. While he initially focused on Chinese contemporary
artists like Ai Weiwei, Zhang Xiaogang, or Fang Lijun, he
soon turned towards Western artists: his favorites include
Fred Sandback, Anselm Kiefer, and Adel Abdessemed.

Collector:
Budi Tek

Address:
No. 35 Feng Gu Road
Xuhui District
Shanghai
China
Tel +86 21 64261901
info@yuzmshanghai.org
www.yuzmshanghai.org

Opening hours vary depending
on exhibition. Please check
the website for the most current
information.

While Shanghai has typically been the more business-focused sibling of Beijing, the southern city's art scene has exploded over the past decade. Much of the most recent thrust of that growth has centered on the West Bund district, a riverside redevelopment, which is now home to two of the city's most-notable contemporary art institutions. This being China, they are private museums—Liu Yiqian and Wang Wei's Long Museum and Budi Tek's Yuz Museum. Energizing Shanghai's private art scene is Adrian Cheng's K11 Art Foundation (KAF)—located on People's Square inside the eponymous shopping mall also owned by his family's company—as well as the nearby Museum of Contemporary Art Shanghai (MOCA Shanghai), which features a wide-ranging exhibition program, spanning both contemporary art and design. While Asia's most significant fair remains Art Basel Hong Kong, Shanghai has seen a number of exciting new additions to the calendar of art market events. The West Bund Art & Design in September and Art021 Shanghai Contemporary Art Fair in November have managed to attract major international galleries like Pace, Sadie Coles HQ, and Gagosian Gallery to mainland China, despite both only having held their inaugural editions in 2013 and 2014. Meanwhile, Photo Shanghai attracts huge numbers of photography lovers to the city each September. Shanghai's local gallery scene is growing too, with some of the highlights including Antenna Space and Leo Xu Projects, both of which boast experimental and innovative programs and have helped bring some of China's most exciting young artists to the international stage. Foundational to Shanghai's art market, however, is the appropriately-named ShanghArt Gallery, which began exhibiting in 1996 and has since expanded to spaces in West Bund, Beijing, and Singapore. The fact that the gallery, which has fostered the careers of major figures like Zeng Fanzhi and Yang Fudong, is already celebrating its twentieth year of existence in 2016 goes to show the level of determination driving Shanghai's art world expansion. Other art world capitals would be well advised to be on the lookout.

Alexander Forbes

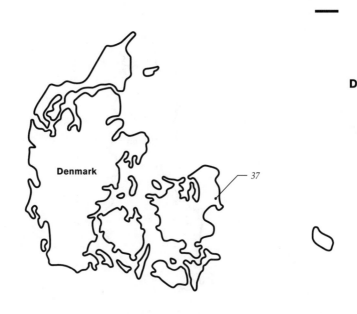

Denmark

— 37

37 Djurhuus Collection
*International contemporary art tending toward irony
and the grotesque*

Collector:
Leif Djurhuus

Address:
Copenhagen, Denmark
ldj@plesner.com
www.djurhuuscollection.com

Visitation permitted only
occasionally. Please inquire
by e-mail.

If you have reservations, don't do it! This is the maxim of
the Copenhagen lawyer and art collector Leif Djurhuus,
who has been devoid of doubt roughly 2 000 times, the
number of works in his collection. Since he does not own
a private museum, they are stored in a warehouse. A se-
lection of 200 works was exhibited from August 2011 to
January 2012 at the Aros Aarhus Art Museum. Show-
cased were pieces by the 1960s Danish avant garde,
such as Poul Gernes or Sven Dalsgaard. The collection
also includes international sky-rocketers like Robert
Kusmirowski or Kendell Geers, along with plenty
of young artists from all over the world. What interests
Djurhuus is cutting edge, border-crossing, provo-
cative young art. If you make an appointment
with him, Djurhuus will show you his collection wherever
it is being exhibited.

F

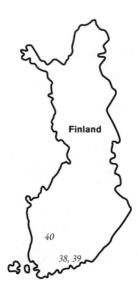

Finland

40

38, 39

38 Didrichsen Art Museum
*International and Finnish art in a once
very modern Finnish home*

A house in the elegant International Style, flooded with
light, overlooking the ocean and a garden dotted with sculp-
tures by Henry Moore. This dreamy house is not located
in Pacific Palisades, California, but rather on a bay near
Helsinki. The modernist villa, built in 1958, belonged to
the collector pair Gunnar and Marie-Louise Didrichsen.
Its architect, Viljo Revell, once an assistant to Alvar Aalto,
later added a structure that in 1965 was opened as the Did-
richsen Art Museum. Gunnar Didrichsen, a Dane who
moved to Finland in 1928 and started a lucrative business,
began collecting with his wife, Marie-Louise, and he loved
progress as much as he liked art. The comprehensive col-
lection includes classical modernist works alongside pre-
Columbian art and Chinese antiquities.

Collectors:
Gunnar & Marie-Louise Didrichsen

Address:
Kuusilahdenkuja 1
00340 Helsinki
Finland
Tel +358 10 2193970
office@didrichsenmuseum.fi
www.didrichsenmuseum.fi

Please check the website
for the most current information
on opening hours.

39 RKF Collection
Finland's finest assemblage of contemporary art stars

Collectors:
Kaj Forsblom &
Rafaela Seppälä-Forsblom

Address:
Helsinki, Finland
info@galerieforsblom.com

Visitation permitted only
occasionally. Please inquire
by e-mail.

Located on the ground floor of the building that gallerist Kaj Forsblom and his wife, Rafaela Seppälä-Forsblom, call home, the RKF Collection presents a superb selection of international greats from the couple's approximately 1 500-work collection. The selection is striking in its depth, especially considering that the couple has only been actively buying for around fifteen years—they were married in 2000 and launched their efforts in earnest thereafter. A particular focus has been placed on tracing painting in its various forms from 1980 to the present, with artists such as Jannis Kounellis, Donald Sultan, and Young British Artists like Damien Hirst among their favorites. The by-appointment private museum features a permanent installation by Scottish artist Charles Sandison—the full text of the *Encyclopedia Britannica* is projected on a seventy-seven-year-long loop in a mirrored room—but most other pieces are swapped out a couple times each year.

F

40 Sara Hildén Art Museum
One of the most important Finnish art hubs,
located on a beautiful lake

Collector:
Sara Hildén Foundation

Address:
Laiturikatu 13, Särkänniemi
33230 Tampere
Finland
Tel +358 3 56543500
sara.hilden@tampere.fi
www.tampere.fi/english/sarahilden

Opening Hours:
Tues–Sun: 10am–6pm

Typical Finland: the Sara Hildén Art Museum, in Tampere, is nestled harmoniously in an expansive sculpture park abutting a lakeshore. Sara Hildén (1905–1993) was a successful entrepreneur in the fashion industry who collected Finnish and international artists of her time. In 1962 she established a foundation. The museum was commissioned by the city of Tampere in 1979, and was designed by the local architect Pekka Ilveskoski as a two-story, low-rise building with large windows. Over 1 500 square meters serve to showcase the collection's works, some 5 000 objects. The focus remains on Finnish art: from the "Finnish Frida Kahlo," Helene Schjerfbeck (1862–1946), to very young artists. Wide-ranging special exhibitions feature internationally renowned artists like Alex Katz, Subodh Gupta, or Wilhelm Sasnal.

F

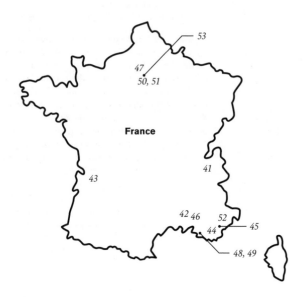

53

47
50, 51

France

41

43

42 46 52
44 45
48, 49

41 Fondation pour l'Art Contemporain—
 Claudine & Jean-Marc Salomon
 From a solitary castle to the vibrant town center:
 contemporary art seeks a public audience

In 2001, Claudine and Jean-Marc Salomon opened their con-
temporary art collection to the public in a beautiful, albeit
secluded location in the Savoyard Alps. Housed in a castle,
the Fondation Salomon opened at the time with a bang:
forty works by the eccentric artist duo Gilbert & George
caused quite a stir in the tranquil mountain valleys—and
bestowed the collection with the added attention from
which it profits today. After twenty-five exhibitions, a move
was made to the lively little town of Annecy, in 2014. The
collection has set itself the goal of presenting not only more
experimental forms of art in a municipal environment, but
also of reaching a larger audience. An art prize also serves
here as part of the new strategy, which allows francophone
artists to spend half a year in New York.

Collectors:
Claudine & Jean-Marc Salomon

Address:
34 Avenue de Loverchy
74000 Annecy
France
Tel +33 4 50028752
www.fondation-salomon.com

Please check the website
for the most current information
on opening hours.

42 Collection Lambert
*Museum-quality international contemporary art
since 1960*

Collector:
Yvon Lambert

Address:
5 Rue Violette
84000 Avignon
France
administration@collectionlambert.com
www.collectionlambert.com

Opening Hours:
Tues–Sun: 11am–6pm

Collection Lambert's register of artists reads like a Who's Who of recent art history: from Francis Alÿs to Lawrence Weiner. And then a slew of top names in between to make any museum director jealous: Louise Bourgeois, Cy Twombly, and Jenny Holzer, to name just three. Yvon Lambert was once one of the most trendsetting gallerists in all of France. In 2014, he gave up his gallery, founded in 1966, in order to devote more time to his own collection and to publishing. With Collection Lambert, opened in 2000 in Avignon, he has fulfilled a dream of bringing his collection to his hometown in southern France. It was first housed in the somewhat dimly lit Hôtel de Caumont, an eighteenth-century palace. In July 2015, the exhibition space doubled in size when the neighboring Hôtel de Montfaucon was converted into a white cube.

F

43 L'Institut Culturel Bernard Magrez
French lifestyle and art in the heart of Bordeaux

Collector:
Bernard Magrez

Address:
16 Rue de Tivoli
33000 Bordeaux
France
Tel +33 5 56817277
contact@institut-bernard-magrez.com
www.institut-bernard-magrez.com

Opening Hours:
Fri–Mon: 1–6pm
Tues: 1–9pm

Bernard Magrez may be known for his wine, which is how he made his fortune. At his Institut Culturel, in Bordeaux, he offers a broad audience access to his artistic interests. The elegant eighteenth-century townhouse Château Labottière presents parts of his collection of modern and contemporary art in temporary, thematic exhibitions. Magrez deliberately avoids the expertise of professional art consultants, instead letting his personal response to art guide his acquisitions. His eclectic taste is mirrored in a wide range of artists, from Lucio Fontana and Peter Doig to Wim Delvoye, Sam Taylor-Wood, Takashi Murakami, and Joana Vasconcelos. The patron also maintains three additional castles in the region, each dedicated to literary or musical events and to intellectual exchange.

44 Peyrassol—Parc de Sculptures

A sculpture park on a centuries-old vineyard
in Provence

Located on the historic vineyard estate Peyrassol northwest of Saint-Tropez, in the Var Département of the Provence region, is one of France's youngest private sculpture parks. In 2001 the Brussels entrepreneur Philippe Austruy and his wife, gallery owner Valérie Bach, acquired the vineyard, which dates back to the year 1256. For the Franco-Belgian couple, wine, food, and hospitality are equally as important as contemporary art. Nestled on the wooded grounds are over twenty sculptures by Jean Dubuffet, César, Jean Tinguely, and Jaume Plensa, among others—and the collection is being constantly expanded. In recent years, works by French artists like Jeanne Susplugas or Fabrice Langlade have been added. The perfect blend of art, Provençal flavors, and warm Mediterranean sun comprise the charm of this special place.

F

Collectors:
Valérie Bach & Philippe Austruy

Address:
Commanderie de Peyrassol RN 7
83340 Flassans-sur-Issole
France
Tel +33 4 94697102
contact@peyrassol.com
www.peyrassol.com

Opening Hours:
Early May–mid-September
Mon–Fri: 9am–7pm
Sat–Sun: 10am–7pm
Mid-September–end of April
Mon–Sat: 10am–6pm

45 Venet Foundation

An artist's take on collecting in the South of France

While a majority of the collections featured in this guide have been assembled by successful players in the world of business, artists have also long been smitten by the collecting bug. In the summer of 2014, French Conceptual artist Bernar Venet opened the doors to his Le Muy property, which has become widely known as The Venet Foundation, a project over twenty-five years in the making. The site was developed in conversation with Minimalist master Donald Judd. Boasting a chapel designed by Frank Stella, and numerous large pieces by Venet himself, it features around 100 works by fellow postwar and contemporary art giants: Sol Lewitt, Carl Andre, Jean Tinguely, On Kawara, and Dan Flavin among them. The collection is a personal one, with Venet often exchanging his own works for those on view by artists who shaped the practice of Conceptual Art as we know it—all friends of Venet who he met after moving to New York in 1967.

Collector:
Bernar Venet

Address:
365 Chemin du Moulin des Serres
83490 Le Muy
France
info@venetfoundation.org
www.venetfoundation.org

Only guided tours with prior online registration.

Collector:
McKillen Family

Address:
2750 Route de la Cride
13610 Le Puy-Sainte-Réparade
France
Tel +33 4 42619292
reservations@chateau-la-coste.com
www.chateau-la-coste.com

Opening Hours:
Mon–Sun: 10am–7pm

46 Château La Coste
*Exceptional art projects on a slightly different kind
of Provençal vineyard*

Here is where art, architecture, nature, and wine enter into
an excellent liaison. When the Irish businessman Paddy
McKillen acquired the idyllic winery Château La Coste,
some fifteen years ago, the idea arose to forge a creative
space that would join artists and architects in the scenic
surroundings of Luberon. Since 2011 the 125-hectare site **F**
has been open to art lovers, who should budget at least
two hours for a walking tour of the property's vineyards,
olive groves, and woods. Japanese architect Tadao Ando
designed the visitor center at the entrance, guarded by a
large Louise Bourgeois bronze spider standing in water.
Other highlights are site-specific works by Tracey Emin,
Liam Gillick, Richard Serra, and Franz West. New projects
by Carsten Höller, Renzo Piano, and Frank O. Gehry are
in development.

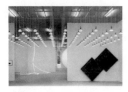

Collectors:
Jean-Philippe & Françoise Billarant

Address:
Route de Bréançon
95640 Marines
France
lesilo@billarant.com

By appointment only.

47 Le Silo
*Minimalism, Conceptual Art, and geometric abstraction
arranged perfectly in a former grain silo*

They don't consider themselves pure collectors; they're
more artists' companions and contemporaries. For over
thirty years the Parisian business couple Jean-Philippe
and Françoise Billarant have been intensely engaged with
Minimalism, Conceptual Art, and geometric abstraction.
Their friendships with artists have played a central role:
Carl Andre, Robert Barry, François Morellet, and Michel
Verjux are all pals. In Marines, northwest of Paris, the
couple had a 1948 grain silo transformed into exhibition
spaces by the young architect Xavier Prédine-Hug, a former
employee of Philippe Starck, who remodeled the simple
structure into a reductive cathedral. And the artists? They
thanked the collectors for their decades-long loyalty with
perfect site-specific installations.

48 La Fabrique—Collection Gensollen
*A psychiatrist couple collects Conceptual Art
as intellectual challenge*

"We do not just want to show art; we insist upon having a dialogue with others about it," say Marc and Josée Gensollen, who have amassed an impressive collection of Minimal and Conceptual Art since the early 1970s. The psychoanalytically trained couple from Marseille presents their collection of more than 500 key works in a stylishly converted former mill. In La Fabrique, light-filled living and exhibition rooms merge on several floors into one another. A remarkable library and an archive convey the impression of a great proximity to artists such as Lawrence Weiner, Gianni Motti, Pierre Huyghe, Dan Graham, and Jonathan Monk. Art as an intellectual challenge: the eloquent pair relishes how their collection inspires them to think about the present in more complex ways.

F

Collectors:
Marc & Josée Gensollen

Address:
11-13 Rue du Commandant Rolland
13008 Marseille
France
gensollen.la.fabrique@hotmail.fr

By e-mail appointment only.

49 Fonds M-ArCo—Le Box
*Cutting-edge art on the grounds of a former
slaughterhouse in Marseille*

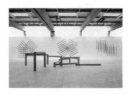

One of Marseille's former abattoirs is located on a remote harbor just outside the city limits. This is where Marc Féraud, a successful ship-outfitter, established both his company and—behind a shiny silver aluminum façade—his 1 000-square-meter exhibition space, Le Box. Here he presents works from his contemporary art collection, from François Morellet, Wade Guyton, and Kelly Walker, to Sergej Jensen, in one or two temporary exhibits a year. Together with his wife, Marie-Hélène, Féraud has been committed to young art since the late 1990s. In 2009 they founded the Fonds M-ArCo (Marseille-Art Contemporain). Le Box opened in 2011 with an exhibition of Gérard Traquandi and Alan Charlton. In addition to their own program, the Férauds work closely with the public museum collections of Marseille.

Collectors:
Marc & Marie-Hélène Féraud

Address:
Anse de Saumaty
Chemin du Littoral
13016 Marseille
France
Tel +33 4 91969002
contact@m-arco.org
www.m-arco.org

By e-mail appointment only.

50 DSLCollection
*The best of Chinese contemporary art,
available 24/7, 365*

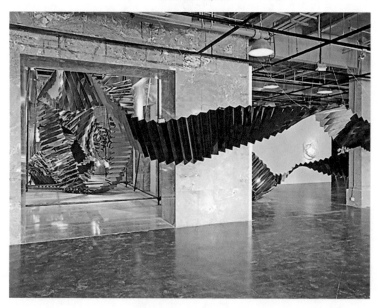

F

Collectors:
Dominique & Sylvain Levy

Address:
Paris, France
art.dslcollection@gmail.com
www.dslcollection.org

Opening Hours:
Mon–Sun: 24 hours

The DSLCollection is only ten years old but the assemblage of ninety-some Chinese contemporary artists is by no means lacking in depth. Featuring works by leading figures like Ai Weiwei and Zeng Fanzhi, alongside those of promising younger artists who carry the Chinese avant-garde tradition forward like Song Yuanyuan and Zhao Zhao, the collection demonstrates its intent to remain current with an extensive online platform-cum-virtual museum, an iPad app, and 3-D films. Spearheaded by Paris-based couple Dominique and Sylvain Levy, the DSLCollection differs from others in that it strictly limits the number of artworks it holds at any one time to 250, and a number of works are sold each year to make room for new pieces. As opposed to collections where the works reflect a timeline of particular tastes, the Levys constantly strive to collect art that is relevant to their specific profile.

51 La Maison Rouge
*Attractive guest collections in Paris and
exciting artist projects*

F

If you stroll along Boulevard de la Bastille, you will not come upon this "red house," as the name implies. The only thing red is a neon sign designating the private museum, which was opened in 2004 by the political scientist and supermarket-dynasty heir Antoine de Galbert. Once inside the 2 000-square-meter complex, however, you will find that red house after all: in the covered courtyard stands a bright red structure—housing the café. De Galbert enjoys enigmatic staging. He also plays this kind of hide-and-seek game with his collection, which is not on permanent display, but rather rotates with those of his friends. Numerous top collections, like those of Thomas Olbricht or Harald Falckenberg, have made appearances at La Maison Rouge. Thematic and monographic exhibitions also take place here, as well as projects with artists ranging from Arnulf Rainer to Gregor Schneider.

Collector:
Antoine de Galbert

Address:
10 Boulevard de la Bastille
75012 Paris
France
Tel +33 1 40010881
info@lamaisonrouge.org
www.lamaisonrouge.org

Opening Hours:
Wed: 11am–7pm
Thurs: 11am–9pm
Fri–Sun: 11am–7pm

"Paris is simply fantastic," says the Parisian artist Jeanne Susplugas. "You fall in love again and again with this city. The cultural scene is extraordinarily rich. From the museums to the opera, from the galleries and art centers to private art initiatives, like the Maison Rouge." One of the hotspots of the art scene is the Palais de Tokyo: a 22 000-square-meter laboratory for young international contemporary art—perfect for night owls, as it's open until midnight. Major exhibitions of modern and contemporary art are on show at the Centre national d'art et de culture Georges-Pompidou, the Galerie nationale du Jeu de Paume, and the Musée d'Art Moderne de la Ville de Paris, all in the city center, as well as the Fondation Cartier, which lies a bit further south. The extensive summer exhibition *Monumenta* at the Grand Palais takes place every two years. In 2016, the Chinese artist Huang Yong Ping followed in the footsteps of major art figures like Daniel Buren and Anish Kapoor. The Grand Palais is also the venue of two high-profile fall fairs: the FIAC art fair and Paris Photo. If you want to visit commercial galleries, head to the Marais district. Here, for example, you'll find the distinguished spaces of the grandes dames of the Paris gallery scene, Chantal Crousel and Nathalie Obadia. In recent years, a hip new gallery district has also popped up in the dynamic neighborhood of Belleville. And uncompromisingly contemporary galleries like Bugada & Cargnel or Balice Hertling are always worth a visit. Even among art collectors word has spread that you won't just make discoveries inside this neighborhood's trendy galleries and cool off-spaces but also in the popular restaurants and unconventional shops that lend this district its special flair. Opened in 2014 in the Bois de Boulogne, the Fondation Louis Vuitton of super-collector Bernard Arnault has become the new pilgrimage site for art enthusiasts— albeit not without some controversy. Building costs of the deconstructivist Frank O. Gehry building exceeded 100 million euros. And the art exhibited there is likely to be worth even more.

Nicole Büsing & Heiko Klaas

52 Fondation Maeght
Key figures of the twentieth-century avant garde and an extravangant sculpture park

Collectors:
Aimé & Marguerite Maeght

Address:
623 Chemin des Gardettes
06570 Saint-Paul-de-Vence
France
Tel +33 4 93328163
accueil@fondation-maeght.com
www.fondation-maeght.com

Opening Hours:
October–June
Mon–Sun: 10am–6pm
July–September
Mon–Sun: 10am–7pm

It all started in the 1920s. Aimé Maeght, a lithographer, moved from the outskirts of Lille to Cannes and opened a small printing company with his wife, Marguerite, where they also sold radios and furniture. The then-unknown painter Pierre Bonnard asked them to take a few of his paintings on commission. They sold out in an instant, leading to one of the biggest success stories of twentieth-century art dealing. In 1946 the couple opened their legendary gallery in Paris and organized shows with Henri Matisse, Marc Chagall, and Wassily Kandinsky, and with Americans like Alexander Calder. The Fondation Maeght, founded in 1964, centers on works by all these artists and acts as a gift to posterity. With aesthetic inspiration from the likes of Marc Chagall, Joan Miró, and Georges Braque, Spanish architect Josep Lluís Sert constructed a museum of Mediterranean light that attracts roughly 200 000 visitors a year.

F

53 Fondation Francès
Contemporary photography in the service of discussion

Collectors:
Estelle & Hervé Francès

Address:
27 Rue Saint-Pierre
60300 Senlis
France
www.fondationfrances.com

Opening Hours:
Tues–Sat: 11am–1pm, 2–7pm

For Estelle and Hervé Francès, the collector's mission is not just to pile up works of art, but rather to be creative in bringing diverse art positions together in order to foster dialogue. In 2009 the head of a cultural communication office and her husband, an ad agency boss, opened their collection in Senlis, a small city outside of Paris. The 300-square-meter space in an eighteenth-century building offers enough room for thematic exhibitions every half year. There are also guest studios, where artists can spend a summer. The Francès' collection aims to provoke discussion, to foster new interactions, and to unsettle the emotions. Exhibiting photographs of vulnerable or sexually charged human bodies—works by Andres Serrano, Vanessa Beecroft, Dash Snow, or Larry Clark—often does the trick.

G

54 Sammlung Fiede
Young contemporary art in very different locations

When Friedrich Gräfling was fifteen years old, he was faced
with the decision to buy a PlayStation or the work of a graf-
fiti artist. He opted for the latter, thereby laying the founda-
tion for this impressive collection of contemporary art. The
architect shows his art today in his hometown of Aschaf-
fenburg, where he converted a former slaughterhouse into
an unconventional 600-square-meter venue, featuring one
new exhibition annually. Additionally, Gräfling initiated
an independent exhibition space, called Salon Kennedy,
in a prestigious historic apartment in Frankfurt. "I am
interested in the idea of sharing works with people who
otherwise might not have the opportunity to see artists
from abroad or even this kind of art," says the collector,
who proved early on to possess a good sense for quality,
acquiring works by Taryn Simon, Yves Scherer, Katharina
Grosse, and Andy Boot.

Collector:
Friedrich Gräfling

Address:
Aschaffenburg, Germany
fiede@culturalavenue.org
www.sammlung-fiede.de

Only guided tours with prior
registration.

55 Kunstmuseum Walter
Former East meets West in a remodeled industrial monument

Collector:
Ignaz Walter

Address:
Beim Glaspalast 1
86153 Augsburg
Germany
Tel +49 821 8151163
office@kunstmuseumwalter.com
www.kunstmuseumwalter.com

Opening Hours:
Fri–Sat: 11am–8pm
Sundays and public holidays:
11am–6pm
And by appointment.

His motto: *Don't let others define your understanding of art.* Since the early 1970s, the Augsburg developer Ignaz Walter has been collecting modern and contemporary art from 1945 to today. He focuses mainly on painting and sculpture, but also the niche-medium of glass art—the latter is prominently represented in the collection via the works of the Italian Egidio Costantini. The juxtaposing of art from East and West Germany is of particular interest to Walter. **G** Painters from the former East Germany—Bernhard Heisig, Wolfgang Mattheuer, or Werner Tübke—are represented as prominently as Georg Baselitz, Sigmar Polke, or A.R. Penck, who were all born in East Germany but carved out their careers in the West. Walter exhibits his roughly 1 600 works in a 6 000-square-meter glass palace, a remodeled industrial landmark from 1909-10 in Augsburg's garment district.

56 KAT_A—Kunst am Turm_Andra
Top-notch conceptual and photographic art at the foot of the Seven Mountains

Collector:
Andra Lauffs-Wegner

Address:
Haus Hedwig
Konrad-Adenauer-Strasse 23
53604 Bad Honnef-Rhöndorf
Germany
info@kat-a.de
www.kat-a.de

By e-mail appointment only.

"Irony, intelligent wit, and thoughtfulness toward the aesthetic are very important to me," says Andra Lauffs-Wegner. The shareholder in storied juice manufacturer Haus Rabenhorst was first introduced to collecting art while still in the cradle, so to speak, with her parents being enthusiastic supporters of Pop Art, Arte Povera, and Minimal Art. Since November 2014, Lauffs-Wegner has presented her own collection with a focus on conceptual and photographic art in a carefully renovated Wilhelminian villa in Bad Honnef. Here, a subtle patina prevails rather than a sterile white cube atmosphere: the rented premises of Haus Hedwig, a former rehabilitation center for mothers, deliberately exudes the charm of imperfection. Ólafur Elíasson, Jeppe Hein, Tatiana Trouvé, Michael Sailstorfer, Annette Kelm, and Alicja Kwade are established highlights in a continuously growing collection. The extensive park grounds are also used for presenting works.

G

57 Museum Frieder Burda
High-profile classical modernism and international contemporary art

For Frieder Burda, art is the elixir of life. The entrepreneur Burda proved to have good instincts already in his early thirties: the first artwork he bought was by Lucio Fontana. Now he owns about 1 000 works: classics of German Expressionism, as well as representatives of Abstract Expressionism, like Jackson Pollock or Mark Rothko. His Picasso collection ranks among the most important in Germany, as does his collection of German postwar art, with numerous works by Georg Baselitz, Sigmar Polke, or Gerhard Richter. Driven by his lust for painting, Burda also buys current positions like Neo Rauch or Karin Kneffel. This extraordinary assembly of works demanded a suitable home: in 2004 the collector opened his private museum in the posh city of Baden-Baden—a snow-white building designed by the American star architect Richard Meier. It has already drawn over two million visitors.

Collector:
Frieder Burda

Address:
Lichtentaler Allee 8B
76530 Baden-Baden
Germany
Tel +49 7221 398980
office@museum-frieder-burda.de
www.museum-frieder-burda.de

Opening Hours:
Tues–Sun: 10am–6pm

58 Stiftung Museum Schloss Moyland

An extensive collection of Joseph Beuys's life and work meets contemporaries

Collectors:
Hans & Franz Joseph
van der Grinten

Address:
Am Schloss 4
47551 Bedburg-Hau
Germany
Tel +49 2824 951060
info@moyland.de
www.moyland.de

Opening Hours:
April–September
Tues–Fri: 11am–6pm
Sat–Sun: 10am–6pm
October–March
Tues–Sun: 11am–5pm

The art-enthusiast brothers Hans and Franz Joseph van der Grinten had a lifelong friendship with Joseph Beuys. This resulted in a vast collection of nearly 6 000 works and roughly 100 000 letters, photos, and notes by the action artist, as well as numerous works by other artists. The Schloss Moyland collection was made public in 1997, and under director Bettina Paust it has undertaken a new conceptual turn: international research on Beuys has taken center stage since **G** 2009, and the number of exhibited works was reduced by 90 percent. Furthermore, the house has shined anew since a 2011 renovation. Special exhibits featuring young artists or Beuys's students, such as Katharina Sieverding, should certainly sustain visitors to this idyllic moated castle on the Lower Rhine.

59 Galerie Bastian

Hybrid use: private-collection showroom and/or commercial gallery

Collectors:
Céline & Heiner Bastian

Address:
Am Kupfergraben 10
10117 Berlin
Germany
Tel +49 30 20673840
info@galeriebastian.com

Opening Hours:
Thurs–Fri: 11am–5:30pm
Sat: 11am–4pm

The corner building on Museum Island is a prime address: Heiner Bastian acquired the choice property on the Kupfergraben canal in 2000 and put out a call for an international architectural competition. David Chipperfield offered the most convincing design, an elegant contemporary building adapted to the historical context. Immense windows offer views of the adjacent Neues Museum and the James Simon Galerie, the new Museum Island visitor center, set to open in 2018. Bastian, a former assistant to Joseph Beuys, privately financed the project he calls a "townhouse for art." Bastian's son, Aeneas, periodically uses the second floor as a commercial gallery—but the space also shows parts of Céline, Heiner, and Aeneas Bastian's high-profile private collection at least twice a year: from Joseph Beuys's drawings and Andy Warhol's Polaroids to the works of young unknown artists.

60 Sammlung Boros
Roughly 700 works of contemporary art in an
extensively refurbished bunker

This is one of the most spectacular places for a private collection of zeitgeisty art. It took Karen and Christian Boros four years to transform a former air-raid bunker, an historic monument in Berlin-Mitte, into their private museum. On top of this colossus they built a luxurious penthouse. Ad-man Boros, who has offices in Wuppertal and Berlin, has been collecting contemporary art since the 1990s. Since 2008 the collection has exhibited groups of works by twenty contemporary artists, who have operated within a given space. Many of them, like Ólafur Elíasson, Cosima von Bonin, or Tomás Saraceno, created very tailored site-specific works. The remodeling of the Boros bunker —which was used in East Germany as a warehouse for exotic fruits, and then as a techno club after the Wall came down— took both time and money. Architect Jens Casper had to remove a number of walls to transform 120 small rooms into eighty larger ones that take up 3 000 square meters.

G

Collectors:
Christian & Karen Boros

Address:
Bunker, Reinhardtstrasse 20
10117 Berlin
Germany
Tel +49 30 27594065
info@sammlung-boros.de
www.sammlung-boros.de

Opening Hours:
Thurs: 4–7:30pm
Fri–Sun: 10am–4:30pm

Only guided tours with prior
online registration. Special tours
available by e-mail appointment.

61 Salon Dahlmann
A Finnish collector and the revival of the
salon tradition in Berlin

You simply can't ignore Berlin—Finnish collector Timo Miettinen is convinced of this. In 2010 he acquired, together with his three sisters, an impressive historical building in Berlin-Charlottenburg. The technology company owner initiated a salon with rotating exhibitions on the building's first floor. Since 2004 he has collected—together with his wife, the architect Iiris Ulin—international contemporary art with a focus on Germany and Finland. On Marburger Strasse 3 he also presents works from his collection, ranging from Albert Oehlen and Björn Dahlem to Marianna Uutinen. At the center of his interest, however, is his Salon Dahlmann—named after the home's previous owner—which hosts openings that are always well attended. Miettinen also regularly invites young curators to have a fresh look at other scenes and collectors.

Collectors:
Timo Miettinen & Iiris Ulin

Address:
Marburger Strasse 3
10789 Berlin
Germany
Tel +49 30 21909830
info@salon-dahlmann.de
www.salon-dahlmann.de

Opening Hours:
Sat: 11am–4pm
And by appointment.

In Berlin, it is still possible to find undiscovered spaces with provisional charm. The newest trend: former breweries are being converted into exciting locations for art. Here, the collector and medical equipment entrepreneur Hans Georg Näder, originally from Lower Saxony, is transforming the former Bötzow Brewery into a multifunctional complex for working, dining, and looking at art, while the German and Swiss couple Burkhard Varnholt and Salome Grisard run the Kindl—Zentrum für zeitgenössische Kunst inside a former brewery in Neukölln. A pulsating international art scene gathers at openings in the galleries of Mitte, Charlottenburg, or Kreuzberg, where the architectural dimensions also make more of an impression than in other locations around Germany: König Galerie presents exhibitions in the roughly 800-square-meter space of a former church, Sprüth Magers occupies a former dance hall, and Blain/Southern the old Der Tagesspiegel printing plant. The Martin-Gropius-Bau always attracts visitors with prestigious exhibitions of artists like Tino Sehgal or Thomas Struth. And C/O Berlin dedicates exhibitions to world famous photographers such as Steven Shore or Sebastião Salgado in the former Amerika Haus, across from the Bahnhof Zoo train station. Since 1998, the Berlin Biennale has been instigating contemporary discourse with new artistic positions. But new impulses can always be found: almost every evening, art enthusiasts can take part in intellectually stimulating events—artist talks, performances, or video screenings. And the art market? Gallery Weekend, which takes place around May 1, attracts hundreds of international collectors to the city. Via VIP shuttle or bike, visitors can hit about fifty galleries. At the start of the fall art season, in September, there's Art Berlin Contemporary (ABC), which sees itself as something quite other than a traditional art fair. It is embedded in Berlin Art Week, which every year offers a fireworks display of openings, performances, and talks. This much is clear: a regular visit to Berlin is mandatory for all art fans.

Nicole Büsing & Heiko Klaas

62 The Feuerle Collection
Antique Asian art and furniture meets contemporary art in a Berlin World War II bunker

Collector:
Désiré Feuerle

Address:
Hallesches Ufer 70
10963 Berlin
Germany
info@thefeuerlecollection.org
www.thefeuerlecollection.org

Only guided tours with prior
online registration.

Désiré Feuerle has assembled one of the most extensive collections of Asian art in Europe. It unites Khmer sculptures from the seventh to thirteenth century, Imperial Chinese lacquer and stone furniture, wood and stone Chinese Scholar-gentry furniture from the Han to the Qing dynasty, and contemporary works by artists such as Anish Kapoor, Zeng Fanzhi, and James Lee Byars, among others. A former gallerist, Feuerle was the first to exhibit **G** contemporary art alongside antique Asian artifacts in the 1990s. This highly unusual collection has an equally unorthodox home: a former World War II telecommunications bunker in Berlin-Kreuzberg, which has been open to the public since May 2016. Feuerle commissioned British architect John Pawson, known for his subtle redesigns of historic buildings, with the conversion of the two-story, 6 000-square-meter space. The museum generates new perspectives on global artistic positions.

63 Sammlung Arthur de Ganay
Architectural, city, and landscape photography in an extraordinary Berlin loft

Collector:
Arthur de Ganay

Address:
Köpenicker Strasse 10a
10997 Berlin
Germany
info@collectionarthurdeganay.com
www.collectionarthurdeganay.com

Only guided tours with prior e-mail
registration, every first Saturday of
the month from 2–4pm.

Once a month, on an entire floor of a spacious loft converted in 2006 from an old jelly factory in Berlin-Kreuzberg, photography fans swarm to hear Arthur de Ganay lead a tour through his remarkable collection overlooking the river Spree. The collection's nucleus is comprised of works by Becher students like Candida Höfer, Thomas Ruff, and Thomas Struth. But conceptual photographers also play a role—Lewis Baltz or Hiroshi Sugimoto, for example— and younger positions are given ample room. When de Ganay, a Paris-born architect, moved to Berlin, in 2001, he had been collecting for eight years. Now he's not just interested in bringing together works of art and making them publicly accessible; he also wants to push the medium of photography into equal standing with painting. Considering the immense caliber of his collection, photography stands quite the chance.

64 Sammlung Barbara und Axel Haubrok—Haubrokprojects
Contemporary avant garde instead of government vehicles in Berlin-Lichtenberg

Barbara and Axel Haubrok like art they don't immediately grasp. Perhaps this is why the Berlin couple, who moved from the Rhineland, has managed since 1988 to compile one of the most progressive collections of contemporary art in all of Germany. Their focus is clearly on contemporary Minimalist and Conceptual Art, with more than a thousand works by over a hundred international artists, including Stanley Brouwn, Carol Bove, Christopher Williams, and Wade Guyton. Understatement instead of extravagance: since 2005, the Haubroks have organized sophisticated exhibitions in Berlin, first at Strausberger Platz, and since 2013 in the roughly 18 000-square-meter compound of a former car-dispatch garage in Berlin-Lichtenberg. Where the former fleet of official vehicles of GDR ministries were once located, the collector couple has established a cultural center with workshops, warehouses, and exhibition spaces.

G

Collectors:
Barbara & Axel Haubrok

Address:
Herzbergstrasse 40-43
10365 Berlin
Germany
Tel +49 172 2109525
info@haubrok.org
www.haubrok.org

Opening hours vary depending on exhibition. Please check the website for the most current information.

65 Sammlung Hoffmann
International contemporary art in a collector's private residence

They were among the first to head to Berlin after the Fall of the Wall to make their personal collection of art available to the public. Erika and Rolf Hoffmann, from Mönchengladbach, had been collecting German and American artists such as Günther Uecker, Frank Stella, or Bruce Nauman for some time. When they moved to Berlin, in the mid-1990s, they had long since sold their textile company. They acquired a former sewing-machine factory in Berlin-Mitte, entirely renovated it, and then moved into two of its floors. And now they have created something of a ritual in the German capital: every Saturday small groups of visitors in grey felt slippers push through the spacious private rooms, led by young, laidback guides. Once a year the rooms are switched out with new works. Fresh acquisitions from Poland, Japan, or China have shifted the collection's focus ever more eastward. Since her husband's death, in 2001, Erika Hoffmann has been actively leading the project herself.

Collectors:
Erika & Rolf Hoffmann

Address:
Sophie-Gips-Höfe, Staircase C
Sophienstrasse 21
10178 Berlin
Germany
Tel +49 30 28499120
info@sammlung-hoffmann.de
www.sammlung-hoffmann.de

Only guided tours with prior registration, every Saturday from 11am–4pm.
Closed through August and between Christmas and New Year.

66 Kienzle Art Foundation
Exciting rediscoveries far from the mainstream

Collector:
Jochen Kienzle

Address:
Bleibtreustrasse 54
10623 Berlin
Germany
Tel +49 30 89627605
office@kienzleartfoundation.de
www.kienzleartfoundation.de

Opening Hours:
Thurs–Fri: 2–7pm
Sat: 11am–4pm
And by appointment.

Even in the Berlin art scene he is seen as an individualist, which says a lot. Jochen Kienzle collects and displays non-mainstream works of art, like those by painter Klaus Merkel, who in the 1980s worked exclusively in a limited gray palette. Or work by Josef Kramhöller, a painter and performance artist who committed suicide in 2000, at age thirty-one. Acknowledged as a talent by fellow artists, Kramhöller was pretty much ignored by the art market. With Jack Goldstein and Franz Erhard Walther, the collection also includes well-known names. Kienzle's parents collected modernist works; already as a high-school student he purchased his first work at Art Basel, and went on to study art history. In 2010 the former gallerist opened the Kienzle Art Foundation, and his engagement in the Berlin scene has earned him much credit. The Kienzle Art Foundation works closely with curators organizing exhibitions, film screenings, and discussion forums.

G

Collector:
König Family

Address:
Belltower Apartment
St. Agnes Church
Alexandrinenstrasse 118
10969 Berlin
Germany
Tel +49 30 26103080
turm@st-agnes.net

Visitation with overnight stay.
By appointment only.

67 König Family Collection
Contemporary Conceptual Art in a converted church tower

Johann König is one of those Berlin gallery owners who embodies the city's spirit in the most prominent of ways—at home and at international art fairs, where he often presents artists who work conceptually. This also suits König and Berlin: he commissioned architect Arno Brandlhuber to convert the former 1960s-era St. Agnes Church into a spectacular gallery—with roughly 800 square meters of exhibition space. But König reserved the square tower for his own collection. Here things are a bit cozier; 100 square meters of furnished space, spread over six levels, feature a rotating presentation of art that personally inspires him and his family—including artists such as Franz West, David Lamelas, Shannon Ebner, and Jorinde Voigt. Another highlight: the collection can only be viewed if you've made a reservation to stay there overnight.

68 Kunstsaele Berlin
*An exciting private collection and a gallery
together on one bel étage*

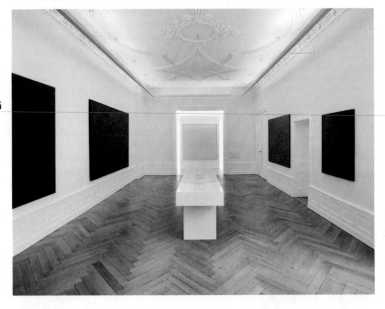

G

Typical Berlin: an art collector from outside the city shares a renovated bel étage with a young gallery. Since early 2010 this renovated apartment on Bülowstrasse hosts works from the Bergmeier collection. The Halle-born Geraldine Michalke, born Bergmeier, has amassed her collection over more than thirty years. The broad spectrum encompasses German Informel and young Leipzig photographers. Newer positions like Michael Müller or the Canadian artist Hajra Waheed round out the collection. Young curators are regularly invited to conceive exhibitions with works from the collection. The program is augmented by free-form exhibition projects. With the enterprising concept-art gallery Aanant & Zoo and their event program as an added extra, the Kunstsaele has since long become a hip meeting place in west Berlin.

Collector:
Geraldine Michalke

Address:
Bülowstrasse 90
10783 Berlin
Germany
Tel +49 30 81801868
info@kunstsaele.de
www.kunstsaele.de

Opening Hours:
Wed–Sat: 11am–6pm
And by appointment.

69 ME Collectors Room Berlin/ Stiftung Olbricht

A curiosity cabinet of existential themes from the Renaissance to now

Collector:
Thomas Olbricht

Address:
Auguststrasse 68
10117 Berlin
Germany
Tel +49 30 86008510
info@me-berlin.com
www.me-berlin.com

Opening Hours:
Tues–Sun: 12–6pm

The body, eros, and transitoriness: existential topics at the center of the collection owned by Thomas Olbricht, a physician and heir to the Wella fortune. Olbricht was influenced by his great-uncle Karl Ströher's passion for collecting. Moreover, he loves extremities: Cindy Sherman meets the grand-style painter Jonas Burgert; Marlene Dumas meets Andres Serrano. Since 2010 the collection has been **G** on display at a Düttmann & Kleymann-designed building on Auguststrasse in Berlin-Mitte. The ground floor houses a café, a shop, and a lounge; the remaining 1 300 square meters are reserved for exhibition space. The core of Olbricht's subjective *Wunderkammer* is formed by over 200 objects, dating back to the Renaissance and Baroque periods. The ME Collectors Room quickly became a space for dialogue with other collections and discourse over art in general. The "ME," by the way, is an acronym for "moving energies."

70 Collection Regard

Overlooked photography of the twentieth century with a focus on Berlin

Collector:
Marc Barbey

Address:
Steinstrasse 12
10119 Berlin
Germany
Tel +49 30 84711947
info@collectionregard.com
www.collectionregard.com

Opening Hours:
Fri: 2–6pm (closed on public holidays)
And by appointment.

It all began with a fortuitous discovery: a few years ago French photography collector Marc Barbey found a collection of negatives by the German photographer Hein Gorny (1904–1967). Since then he has administered the estate of the underappreciated photojournalist and commercial photographer. In 2011 Barbey showed the first part of the collection, Gorny's images of war-ravaged Berlin, accompanied by art historical research. Connoisseurs of photography were impressed. The software entrepreneur Barbey has been focused on growing the Collection Regard since 2005. He is endowed with a sharp instinct for other overlooked twentieth-century talents. Stylish vintage furniture from Scandinavia provides for a relaxed atmosphere in his Berlin-Mitte apartment, where not only exhibitions take place but also regular artist talks, guided tours, and movie screenings.

71 Rocca Stiftung
A thematically structured collection of
contemporary art in a villa

Joëlle Romba brings the best possible conditions to build-
ing her own art collection. The art historian, curator, and
collection consultant garnered experience in a Berlin gallery
and as the Berlin representative of the auction house
Sotheby's. For the past ten years Romba and her husband,
Eric, a lawyer, have acquired around 150 works of con-
temporary art, ranging from Gregor Hildebrandt, Thilo
Heinzmann, and Wolfgang Tillmans, to Matti Braun
and Charlotte Posenenske. The thematic foci of the collec-
tion—photorealistic painting, architecture in art, and the
rethinking of art historical models—lends the collection
structure and conceptual clarity. The Rombas present their
treasures in a villa dating back to the turn of the century
in Berlin-Nikolassee. Visitors are welcome by appointment.

G

Collectors:
Joëlle & Eric Romba

Address:
Berlin, Germany
Tel +49 30 89398917
info@rocca-stiftung.de
www.rocca-stiftung.de

Visitation permitted only
occasionally. Please inquire
by e-mail.

72 Sør Rusche Sammlung
A traditional collection of Old Masters meets
contemporary art

Thomas Rusche is a fourth-generation collector. The textile
entrepreneur's great-grandfather drove a horse and carriage
through the Münster region buying antiques from farmers.
His grandfather collected old paintings, and his father
focused on Old Masters of the seventeenth century. His fa-
ther also took his son to auctions and museums, and at age
fourteen Thomas Rusche acquired his first work of art. Today,
the collection boasts over 2 500 works from over 500 artists,
located at the family estate in the Westphalian city of Oelde,
and, at a second location, in an Art Nouveau apartment in
Berlin-Charlottenburg. The focus of the collection is now
on contemporary painting, with works by Marlene Dumas,
Norbert Bisky, Daniel Richter, Matthias Weischer, Martin
Eder, or Ruprecht von Kaufmann, among others. Rusche
bought their pictures early and before the artists were well-
known—a fact of which he remains proud.

Collector:
Thomas Rusche

Address:
Berlin, Germany
m.kuehn@kleidungskultur-soer.de
www.kleidungskultur-soer.de

Visitation permitted only
occasionally. Please inquire
by e-mail.

While these days it may be commonplace in virtually every industry for goods to be bought and sold with a click more often than with a handshake, the art market has remained more conservative in adopting digital technologies. But, this is changing. The online art market has grown at breakneck pace in recent years. According to figures compiled by The European Fine Art Foundation (TEFAF) in Maastricht, 4.7 billion dollars of art was traded online in 2015, a year-over-year increase of 7 percent. Most sales still occur at the low end of the spectrum, between 1 000 and 50 000 dollars, with prints, photography, and painting the most popular mediums. But many art market players are betting on that changing as well. The space is a competitive one, with legacy innovators like Artnet, the nearly thirty-year-old price database and online auction house, going up against more recent entrants like the newly combined team of Paddle8 and Auctionata to bring the gallery, art fair, auctions, and art media worlds online. The platforms vary in their strategy. Artsy invests in a more tech-minded marketplace approach, providing a platform for museums, galleries, and auction houses to display (and in the latter two cases sell) art. Paddle8 and Auctionata take on and sell their own inventory. All are banking on the fact that the over 60-billion-dollar art market will continue to expand beyond its traditional centers. As the art market is increasingly democratized, buyers of all stripes peruse the available inventory of works by their favored artists with the scroll of a mouse rather than on foot. In large part, art dealing remains a personal affair, conducted in the back rooms of galleries, across tables at art fairs, and in the salesrooms of major auction houses. There will be a significant contingent of collectors for whom the online art buying experience can never replace the opening day at Art Basel or the thrill of the salesroom floor. But especially as young art lovers mature, the ease of access to new artists online will certainly see the sector grow.

Alexander Forbes

73 Safn
Iceland's best, in Berlin

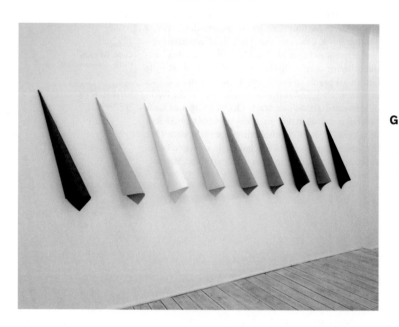

G

Collector:
Pétur Arason

Addresses:
Levetzowstrasse 16
10555 Berlin
Germany
Tel +49 30 39839285
berlin@safn.is

Bergsta astræti 52
101 Reykjavík
Iceland
Tel +354 891 9694
safn@safn.is
www.safn.is

Opening Hours:
Berlin
Fri–Sat: 1–5pm
And by appointment.
Reykjavík
By appointment only.

Having taken various forms in the Icelandic capital of Reykjavík since 2003, Safn (Icelandic for "collection") opened a second location—this time in Berlin's Hansaviertel—in March 2014. Both spaces show artists from the 1 200-work-strong collection of Pétur Arason and his wife, Ragna Róbertsdóttir, who also happens to be one of Iceland's most prominent artists. That collection spans Minimal and Conceptual Art heroes like Donald Judd, Lawrence Weiner, and Carl Andre. But Safn Berlin takes a less-expected tack: the gallery-style, ground-floor space focuses on the couple's deep knowledge of the Icelandic art scene and has undertaken an ambitious project of exposing some of country's most exciting artists, like Kristján Guðmundsson, Hreinn Friðfinnsson, and Sigurður Guðmundsson, to an international audience. It actualizes a role long held by Arason and Róbertsdóttir as prime ambassadors for the small Nordic island to the world writ large.

74 Sammlung Schürmann
Art and antagonism in a collection growing since 1972

Gaby and Wilhelm Schürmann's collection has been part
of their lives for four decades. Wilhelm Schürmann, a
photographer, describes the moment of confronting a
new artwork as being like "sudden enlightenment." For
the collector couple, this is where the value of art truly
lies: in asking us to continuously modify our own set
of values. They find this kind of edginess in the works
of renowned artists like Martin Kippenberger or Cady
G Noland, as well as in the unsettling works of Monika Baer
or Michael E. Smith. Continuously expanding since 1972,
the Schürmann's collection is housed in a private Berlin
apartment and shown to interested parties occasionally
upon request.

Collectors:
Gaby & Wilhelm Schürmann

Address:
Berlin, Germany
visit@schuermann-berlin.de

Visitation permitted only
occasionally. Please inquire
by e-mail.

75 Sammlung Christian Kaspar Schwarm
*A young private collection of Conceptual and
political art*

Christian Kaspar Schwarm describes his collection, now a
decade old, as a constant movement between two thematic
poles or, more precisely, as an oscillation between two
dimensions: "romanticism" and "hardness." The romanti-
cism here doesn't imply the historical cultural movement
but rather stands for the contemporary interpretation
of emotion and desire, which characterizes, for example,
the work of David Horvitz. In addition to more than
one hundred works of this artist alone, the collection in-
cludes series of works by other conceptual artists like Slavs
and Tatars, Fiona Banner, Peter Piller, or Jonathan Monk.
These have been selectively complemented most recently
by film-based works by artists like Guan Xiao or Mario
Pfeifer. Whenever he can, Schwarm enjoys giving tours to
art lovers through his premises in Berlin-Kreuzberg.

Collector:
Christian Kaspar Schwarm

Address:
Berlin, Germany
scsz@scsz.eu

Visitation permitted only
occasionally. Please inquire
by e-mail.

76 Sammlung Gnyp Springmeier
International contemporary art on a single story of a Berlin building

Collectors:
Marta Gnyp &
Giovanni Springmeier

Address:
Berlin, Germany
homecollection@springmeier.eu
www.springmeier.eu

Visitation permitted only
occasionally. Please inquire
by e-mail.

Marta Gnyp and Giovanni Springmeier live with their collection. Since the 1990s the doctor has been purchasing contemporary art, from Phyllida Barlow to Liam Gillick, from Michael Kunze to Leidy Churchman. The art advisor and author Gnyp tries her hand at picking out the relevant and promising artists of our time, often before the big breakthrough, as was the case with Avery K. Singer, Zachary Armstrong, Ulay, and Rose Wylie. Recently, they **G** combined their collections together in one apartment. When they occasionally open up their private rooms for visitors, you immediately get a sense of their enthusiasm for artistic positions and for the elaborate staging of their comprehensive collection of all media, which can be summed up under the general theme *Man and His Complexities.* What makes this experience unique is the holy alliance between art and life, where international art goes hand-in-hand with select design objects.

77 Sammlung Ivo Wessel
Profound and humorous German and international video and concept art

Collector:
Ivo Wessel

Address:
Berlin, Germany
email@ivo-wessel.de

Visitation permitted only
occasionally. Please inquire
by e-mail.

Ivo Wessel is a fixture of the Berlin art scene. He's a frequent guest at podium discussions, a favorite interview partner when the topic is private collections, and, together with Olaf Stüber, an organizer of the successful monthly film-screening series *Videoart at Midnight*, at Kino Babylon. This all makes sense, as the main focus of the software developer's collection is video art. Wessel owns work by artists of his generation, such as Bjørn Melhus, Stefan Panhans, or Tracey Moffatt, all of which lean toward the dreamily surreal. He also collects works of concept art by the likes of Karin Sander, Via Lewandowsky, or Sven Johne. For Wessel, how the work is shown is not important. His private rooms, located on a former military property, have more of a "warehouse feel than exhibit space." If you want to visit, arrange a personal tour with Wessel himself.

78 Wurlitzer—
 Berlin-Pied-à-Terre Collection
 An intimate view on emerging and established European artists

G

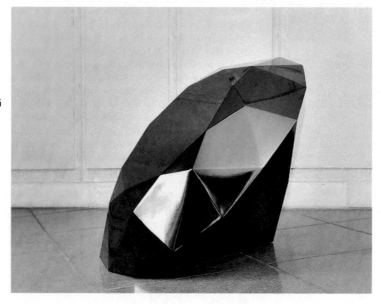

Gudrun and Bernd Wurlitzer fell into collecting somewhat by chance. While the pair has actively purchased works from artists' friends for several decades, it wasn't until a more recent move to Berlin that they began collecting in earnest. Faced with the numerous empty walls Berlin is famed for offering its transplants, Gudrun and Bernd Wurlitzer turned to those old friends and many more new acquaintances to help fill in the gaps. The collection now counts works by Alicja Kwade, Dirk Bell, Michail Pirgelis, Roe Ethridge, Jeppe Hein, Manfred Pernice, and Jonathan Meese, among others, in its ranks. But it has remained a rather private affair: architect Gudrun Wurlitzer and her art adviser husband invite art enthusiasts to the very Berlin *pied-à-terre* that spurred the collection forward in the first place on a by-appointment basis. Interested guests can also preview the space on their platform for young artists, Artitious.

Collectors:
Gudrun & Bernd Wurlitzer

Address:
Berlin, Germany
gudrun.wurlitzer@artitious.com
www.wurlitzercollection.com

Visitation permitted only
occasionally. Please inquire
by e-mail.

In 2012, we published the first edition of this handy companion to private, publicly accessible art collections worldwide. With the art world in constant flux, we knew from the beginning that this would become an ongoing project, with subsequent editions to follow. In the course of research and preparation, we continually stumble upon exciting stories, innovative projects, and other publications we'd like to share with our readers. Since including all of these findings in the Art Guide would exceed the scope of our travel-friendly pocket format, we decided to launch the BMW Art Guide Blog, an interactive platform featuring all the additional material we could not fit into our book, accessible by anyone, anywhere. As an additional place for thoughtfully curated content, the blog provides enough space to talk about individual collection visits, publishes personal interviews with collectors from around the world, and offers background information and insights into the topics that keep the art world buzzing. You can also find out more about the making of the Art Guide and receive further up-to-date book recommendations, hand-picked from our editors. With illustrated posts published on a regular basis, we aim for quality of content rather than quantity of posts, in order to generate material that dives deeply into the world of collecting. If you always wanted to know why a former French mining town is starting to show up on the art radar, why a bottle of sake once helped collector Donald M. Hess acquire a beloved art work, and what Beatrix Ruf thinks about the *BMW Art Guide by Independent Collectors*, follow the link to explore: www.bmw-art-guide.com.

The Blog has been selected by the German Design Award 2015 and received a special mention in the category Excellent Communications Design—Audiovisual and Digital Media.

Independent Collectors

79 Karin und Uwe Hollweg Stiftung
Fluxus, Informel, and Pop live in discreet
Hanseatic ambience

Collectors:
Karin & Uwe Hollweg

Address:
Altenwall 6
28195 Bremen
Germany
office@hollweg-stiftung.de

By appointment only.

Businessman Uwe Hollweg and his wife, Karin, a painter, have been collectors since the early 1970s. They are known in Bremen as patrons and supporters of the local Kunsthalle. That the private collectors only sometimes open their collection to visitors is a bit of Hanseatic understatement. But whoever does manage to nab one of the very rare appointments will discover a fine collection in a historic trading house not far from the Kunsthalle. The collection bears the strong **G** imprint of the collector couple's eclectic tastes, with works ranging from British Pop-Art pioneer Richard Hamilton to those by Dieter Roth and Wols and the melancholic paintings of Bremen's local art hero, Norbert Schwontkowski. The couple also owns an impressive collection of artists' books. Chairs and sofas add to the cozy ambience. "I find it very important that our guests have the opportunity to sit down and be comfortable," says Karin Hollweg.

80 Fürstenberg Zeitgenössisch
Innovative young art infiltrates princely pomp

Collectors:
Christian & Jeannette
zu Fürstenberg

Address:
Am Karlsplatz 7
78166 Donaueschingen
Germany
Tel +49 771 229677563
info@fuerstenberg-
zeitgenoessisch.com
www.fuerstenberg-
zeitgenoessisch.com

Opening Hours:
April–November
Tues–Sat: 10am–1pm, 2–5pm
Sundays and public holidays:
10am–5pm

Expectations are high: the aristocratic couple Christian and Jeannette zu Fürstenberg are creating a collection by seeking "young, emerging artists who have distinguished themselves in recent years by new formal languages and concepts, and in so doing have influenced the international discourse." Moritz Wesseler, the well-connected director of the Kölnischer Kunstverein, advises the couple. Since 2011 contemporary art has gradually been replacing the hunting trophies, goblets, and uniforms normally seen in a princely setting. Rising stars like Dirk Bell, Julian Göthe, or Kris Martin are already represented with their own artist rooms or interventions. The collection features regular thematic exhibitions of current positions.

81 Kunsthalle HGN
*With the gaze of a globetrotter: figurative painting,
sculpture, and photography in Duderstadt*

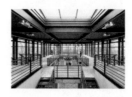

"I find myself in the pieces—collecting is a reflection of my
development," says Hans Georg Näder, head of a medical
technology company headquartered in Duderstadt, in
Lower Saxony. During the many business trips he takes
around the world, Näder consistently visits exhibitions and
galleries—and especially likes to acquire non-European
art. Twenty years ago he began building his ever-growing
collection, focused on figurative painting, sculpture, and
photography, and which now ranges from Neo Rauch and
Norbert Bisky to Dan Flavin to Sylvie Fleury. The rough-
ly 650-square-meter Kunsthalle HGN, in Duderstadt,
opened in 2011 and presents one exhibition annually. The
building's five staggered levels convey the character of an
open workshop. Näder also shows parts of his collection
at the local Hotel zum Löwen and in the former Bötzow
Brewery, in Berlin.

G

Collector:
Hans Georg Näder

Address:
Karl-Wüstefeld-Weg
37115 Duderstadt
Germany
info@kunsthallehgn.de
www.kunsthallehgn.de

Please check the website
for the most current information
on opening hours.

82 Museum DKM
An eclectic collection from antiquity to the present

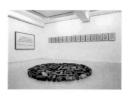

Germany is becoming a nation of nonprofits, with over
350 new foundations established each year. Dirk Krämer
and Klaus Maas see their own Museum DKM as part of
this trend. The two collectors have been involved with art
for over twenty years, along the way encouraging the re-
sponsible behavior of private collectors vis-à-vis the public.
They established their foundation in 1999, and ten years
later they opened a private museum designed by Swiss
architect Hans Rohr. Their collection covers a wide array
of areas: from ancient art through classical photography
to contemporary art—particularly Concrete and Con-
ceptual positions like Blinky Palermo or Ai Weiwei.
Krämer and Maas also administer the estate of the Ger-
man sculptor Ernst Hermanns, an important representa-
tive of Concrete Art.

Collectors:
Dirk Krämer & Klaus Maas

Address:
Güntherstrasse 13-15
47051 Duisburg
Germany
Tel +49 203 93555470
mail@museum-dkm.de
www.museum-dkm.de

Opening Hours:
Sat–Sun: 12–6pm
Every first Friday of the month
from 12–6pm
And by appointment.

83 MKM Museum Küppersmühle für Moderne Kunst

Masterpieces of German painting in an impressive mill in Duisburg's harbor

Collectors:
Sylvia & Ulrich Ströher

Address:
Innenhafen Duisburg
Philosophenweg 55
47051 Duisburg
Germany
Tel +49 203 30194811
office@museum-kueppersmuehle.de
www.museum-kueppersmuehle.de

Opening Hours:
Wed: 2–6pm
Thurs: 11am–6pm
Sundays and public holidays:
11am–6pm

No photos, no interviews, no public appearances: the Darmstadt collector couple Sylvia and Ulrich Ströher are surely some of the Republic's most discreet art collectors. Their collection includes over 1 500 major works of German art since 1945 such as Gerhard Richter, Georg Baselitz, Anselm Kiefer, and Rosemarie Trockel. Here abstract painting is the focus. A 1908-erected mill and silo complex converted into a museum by Swiss architects Herzog & de Meuron in 1999 serves as the fitting architectural framework. Roughly two-thirds of the 3 600-square-meter exhibition space, spread over three floors, is reserved for the collection. The remaining area provides space for the three or four temporary exhibitions per year. Centrally situated in Duisburg's inland harbor, the MKM Museum Küppersmühle is one of the largest private museums in Germany.

G

84 JaLiMa Collection

Young contemporary art at a new collectors' hotspot in Düsseldorf

Collectors:
Jan-Holger & Mariam Arndt

Address:
Walzwerkstrasse 14
40599 Düsseldorf
Germany
info@jalimacollection.com
www.jalimacollection.com

Opening Hours:
Sat: 2–5pm
And by appointment.

That a good neighborhood creates productive synergy is not only true in economics. In September 2012 Jan-Holger Arndt and his wife, Mariam, opened their Düsseldorf exhibition space in a 12 000-square-meter, repurposed industrial building, where roughly seventy artists also have their studios. Hence the surrounding environment is right: everyone here has something to do with art. Arndt, a lawyer from Hamburg, and his German-Persian wife, a doctor from Oldenburg, set out in their inaugural exhibition, *Life in the Woods—Aspects of Escapism*, the standards of what JaLiMa hopes to achieve in the future: exhibitions of young contemporary art drawn from the collection, supplemented by—where it makes sense—loans from other collectors and galleries. What remains is the question of the collection's unusual name, JaLiMa. It's an endearing compression of the German phrase "Jan liebt Mariam": Jan loves Mariam.

85 Sammlung Philara
*Spectacular private museum in Düsseldorf's
Flingern district*

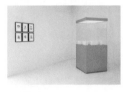

The Stiftung Philara, founded in 2007, was previously
housed in a former factory on the outskirts of Düsseldorf.
In summer 2016, Gil Bronner moved everything to a cen-
trally located, old industrial glass manufacturing plant
in Flingern, a district popular with galleries. The new
museum building features nearly 1 800-square-meters of
exhibition space, a café, and a spacious rooftop sculpture
G garden. The busy real-estate developer from Düsseldorf
feels bound to art on several levels. He not only owns a
building with seventy artists' studios—the largest in the
city—he also organizes exhibitions four times a year,
endows artist stipends, and adds works to his collection,
seemingly without pause. Bronner buys works that speak
to him emotionally and aesthetically. Installations by
Tobias Rehberger or Tomás Saraceno can be found along-
side works of artists from the so-called New Leipzig School,
such as Tilo Baumgärtel.

Collector:
Gil Bronner

Address:
Birkenstrasse 47
40233 Düsseldorf
Germany
info@philara.de
www.philara.de

Opening hours vary depending on
exhibition. Please check the
website for the most current
information.

86 Julia Stoschek Collection
An ambitious young collector zeroed in on media art

For Julia Stoschek, opening a private museum in 2007 was the
climax of her rapid collecting career: one day while taking
a walk, the 1975-born heiress came across an historic
landmark factory building. Today it holds one of the most
extensive private collections of media art in Germany.
After undergoing complex modifications by the Berlin-
based architecture firm Kuehn Malvezzi, the reinforced-
concrete building shows a smattering of videos, installa-
tions, and photographs spread across its multiple floors.
The 2 500 square meters represent a veritable Who's Who
of the international media-art scene, with annual exhibits
featuring artists ranging from Douglas Gordon to Thomas
Demand, to Pipilotti Rist or Andreas Gursky. The young
collector is also devoted to up-and-coming stars, like the
Frenchman Cyprien Gaillard. With an exhibition of works
from her collection in summer 2016, Stoschek is now also
testing the waters in Berlin.

Collector:
Julia Stoschek

Address:
Schanzenstrasse 54
40549 Düsseldorf
Germany
Tel +49 211 5858840
besuch@julia-stoschek-collection.net
www.julia-stoschek-collection.net

Opening Hours:
Sat–Sun: 11am–6pm
And by appointment.

87 Kunstwerk—Sammlung
Alison & Peter W. Klein

Contemporary and Aboriginal art in a remodeled factory

Collectors:
Alison & Peter W. Klein

Address:
Siemensstrasse 40
71735 Eberdingen-Nussdorf
Germany
Tel +49 7042 3769566
kunstwerk@sammlung-klein.de
www.sammlung-klein.de

Opening Hours:
Wed, Fri, Sun: 11am–5pm

They don't follow art market trends. Alison and Peter W. Klein, who live just outside Stuttgart, buy what they like: photography of the Helsinki School, paintings by Karin Kneffel, Anselm Kiefer, Sean Scully, works of the American photo-artist Gregory Crewdson, but also works by younger, emerging artists. Over nearly thirty years, the Swabian and his American wife have brought together around 2 000 works **G** of contemporary painting and photography. They regularly travel to Australia, which is why contemporary Aboriginal art constitutes a second pillar of their collection. Klein sold his company, a manufacturer of clutch systems, in 2007, and a year later opened this spacious 1 000-square-meter private museum in Nussdorf—the town where Klein was once the largest employer.

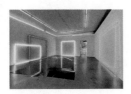

88 Kunstraum Alexander Bürkle

Monochrome painting and Minimal art in dialogue with younger artists

Collector:
Paul Ege

Address:
Robert-Bunsen-Strasse 5
79108 Freiburg
Germany
Tel +49 761 5106606
kunstraum@alexander-buerkle.de
www.kunstraum-alexander-
buerkle.de

Opening Hours:
Tues–Fri: 11am–5pm
Sundays and public holidays:
11am–5pm

Established in 2004, the Kunstraum Alexander Bürkle is located in northern Freiburg on the premises of the electronics wholesale company Alexander Bürkle. The collector, Paul Ege, the third-generation head of the company, founded in 1900, has a clear guideline: "A collection should not be a mere accumulation. I think the strength of a collection lies in its unique focus." Based on this principle, three to four internationally staffed exhibitions are shown annually in the nearly 1 000-square-meter art space, which is committed to the neutrality of the white cube. Classics of Minimalism like Fred Sandback, Donald Judd, or—in the electronics industry, almost a must—light artist Dan Flavin, meet younger artists like the Swiss painter Adrian Schiess, known for his radical monochrome art.

89 Morat-Institut für Kunst und
Kunstwissenschaft
*An excellent print collection, African tribal art, and
an extensive library*

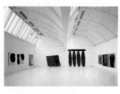

At the Morat-Institut für Kunst und Kunstwissenschaft, in
Freiburg, the focus is on research. The institute organizes
symposiums, publishes catalogue raisonnés, and oversees
a library with around 50 000 volumes. The institute boasts
the largest collection of works by the Viennese painter Carl
Schuch, and earns additional points with an extensive
print collection featuring work by Giorgio Morandi, Max
Beckmann, and Albrecht Dürer. Treasures like a complete
set of prints by Francisco de Goya, or high-quality West
African sculptures are often requested on loan by other
museums. The foundation resides in a 1950s light-flooded
shed-roof hall. Since early 2010 the institute has tried to
streamline and decelerate, focusing exclusively on its own
collection rather than cultivating special exhibitions.

G

Collector:
Franz Armin Morat

Address:
Lörracher Strasse 31
79115 Freiburg
Germany
Tel +49 761 4765916
eva.morat@morat-institut.de
www.morat-institut.de

Opening Hours:
Sat: 11am–6pm
And by appointment.

90 Sammlung Blankenburg
*Contemporary art in a charming historic building
in Hamburg-Winterhude*

A spacious apartment with Parisian charm in the Win-
terhude district of Hamburg—this is where Andrea and
Markus von Goetz und Schwanenfliess live with their art.
On her birthday in 2006 the sociologist and young artists'
patroness wished for her first work: a large-scale watercolor
by Hanna Nitsch. That was the starting point for the Blan-
kenburg collection, named after the family farm in Lower
Saxony. Meanwhile, the collection, which focuses on young
contemporary art and, increasingly, on representatives
of the 1980s, includes roughly one hundred works, from
Rinus van de Velde, Ralf Ziervogel, Werner Büttner, and
Georg Baselitz to Oda Jaune. "For me, the works function
like antennas with two ends," says Andrea von Goetz und
Schwanenfliess. "The one end oriented toward the outside
world and the unseen, and the other toward one's inner
world, the soul, the hidden realm of the self."

Collectors:
Andrea & Markus
von Goetz und Schwanenfliess

Address:
Hamburg, Germany
office@vgs-art.com

By e-mail appointment only.

91 Deichtorhallen Hamburg—
Sammlung Falckenberg

*Positions of social criticism in German and
American contemporary art*

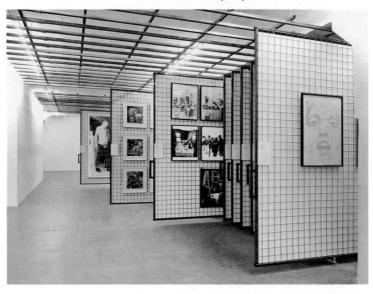

G

Collector:
Harald Falckenberg

Address:
Phoenix-Hallen
Wilstorfer Strasse 71, Gate 2
21073 Hamburg
Germany
Tel +49 40 32506762
sammlungfalckenberg@
deichtorhallen.de
www.deichtorhallen.de/sammlung-
falckenberg

Please check the website
for the most current information
on opening hours.

Irony, social criticism, and the grotesque: Harald Falckenberg's art collection is essentially about resistance. Over the past twenty years, the Hamburg-based businessman has assembled around 2 000 works of art, mainly by German and American contemporary artists who use biting sarcasm to hold a mirror up to society's ills. Paul McCarthy, Andreas Slominski, Martin Kippenberger, and Paul Thek are just some of his favorites. Since 2001 Falckenberg has shown his collection in a 6 000-square-meter former rubber factory in Hamburg-Harburg, called the Phoenix Hallen, cleverly altered by the architect Roger Bundschuh. Unconventional temporary exhibitions and guest appearances by other private collections makes it one of the most important spaces for contemporary art. Since 2011 the Sammlung Falckenberg has cooperated closely with the Deichtorhallen Hamburg, which is now in charge of overall business operations.

92 Sammlung Wemhöner
Selected exhibits of an expansive collection in the
East Westphalian city of Herford

"The art I encounter and surround myself with improves my quality of life. It gives me strength and inspires me," says Heiner Wemhöner. In spring of 2014 the businessman from the East Westphalian city of Herford presented around 10 percent of his collection, compiled since the late 1990s, in Berlin's Osram-Höfe, the former home of one of Europe's largest lightbulb factories. This was the first time he exhibited his collection publicly—and apparently he enjoyed it. Now Heiner Wemhöner or his curator, Philipp Bollmann, guide interested art lovers through his company building in Herford, where around sixty works are on display: photographs by Isaac Julien, sculptures by Stephan Balkenhol, works on paper by Richard Serra, as well as works by Chinese artists, such as Zhou Tiehai or Yang Fudong. If there's time, the tour can be extended to Wemhöner's private sculpture park, with works by Antony Gormley and Tony Cragg.

G

Collector:
Heiner Wemhöner

Address:
Planckstrasse 7
32052 Herford
Germany
Tel +49 5221 770210
www.sammlung-wemhoener.com

By appointment only.

93 Museum Modern Art Hünfeld—
 Sammlung Jürgen Blum
Circa 3 000 works of Concrete, Constructivist, and
Conceptual Art

It's not an outpost of the Museum of Modern Art in New York City, but the Museum Modern Art Hünfeld is well worth the detour. Thanks to the German-Polish artist and collector Jürgen Blum, the small Hessian city near Fulda has a stellar private museum, with roughly 1 000 square meters of exhibition space, in a historic landmark building—a former gas plant. His collection brings together the East and the West, Concrete Art and conceptual thought, starkly reduced forms, and intellect. Along the way it highlights works by the Polish avant garde. Now a foundation, the collection's exhibition administration has been taken over by the city of Hünfeld. Additionally, the artist Günter Liebau was appointed as external curator to organize temporary exhibitions of contemporary art of various strains. A sculpture garden brings the presentation outdoors.

Collector:
Jürgen Blum

Address:
Hersfelder Strasse 25
36088 Hünfeld
Germany
Tel +49 6652 72433
Tel +49 151 40470183
info@museum-modern-art.de
www.museum-modern-art.de

Opening Hours:
Tues–Sun: 3–6pm
And by appointment.

94 Fotografische Sammlung—
Schloss Kummerow
Top-notch photo collection in a carefully renovated castle

Collector:
Torsten Kunert

Address:
Schloss Kummerow
Dorfstrasse 114
17139 Kummerow
Germany
Tel +49 152 59868126
post@schloss-kummerow.de
www.schloss-kummerow.de

Please check the website
for the most current information
on opening hours.

In 2011, Berlin real estate entrepreneur Torsten Kunert acquired a decaying Schloss Kummerow in Mecklenburg-Vorpommern, a two-and-a-half-hour drive from either Berlin or Hamburg. The entrepreneur, who originally hails from eastern Germany, had the historic gem in the Mecklenburg Switzerland Nature Park carefully renovated, and moved his collection there in May 2016. The reserved collector has approximately 2 000 works, including many highlights of GDR photography, at the approximately 3 500-square-meter castle on Kummerow Lake. He is particularly interested in positions with social and political relevance. Photographs by renowned East German photo artists like Ute & Werner Mahler, Helga Paris, or Sibylle Bergemann are presented alongside international stars such as Marina Abramović, Thomas Struth, and Hiroshi Sugimoto.

G

95 Sammlung Würth
From the Middle Ages to the present: art at
fifteen sites in Europe

Collector:
Reinhold Würth

Address:
Würth Museum
Reinhold-Würth-Strasse 15
74653 Künzelsau-Gaisbach
Germany
Tel +49 7940 152200
museum@wuerth.com
www.kunst.wuerth.com

Opening hours vary depending
on exhibition. Please check the
website for the most current
information.

"Art at Würth should not take place in an ivory tower, but in everyday life; it should be experienced close to the workplace," says company president Reinhold Würth. Since the 1960s, the owner of a wholesale company for assembly and fastening materials has amassed a comprehensive collection of art—from the Middle Ages through the modern period to the present—comprised of roughly 16 000 works. In 1991 the Museum Würth opened at the company's headquarters, in Künzelsau. Then, in 2001, the Kunsthalle Würth was opened in Schwäbisch Hall. Today, fifteen exhibition spaces inside innovative architectural structures are located at various European locations of the Würth Group, from Norway to Spain. The temporary exhibitions shown here are drawn from the collection. Works from Pablo Picasso to Gerhard Richter, from Paul Gauguin to Alex Katz —and the largest compilation of works by Christo and Jeanne-Claude in central Europe—mark the impressive range of the Würth Collection.

G

96 Sammlung Froehlich
An impressive group of works by German and
American art stars

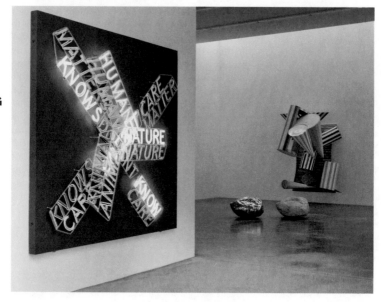

He was a blood-brother to Joseph Beuys. He was a regular at Andy Warhol's Factory. He met with Donald Judd at the artist's Texas studio. Josef Froehlich, a Stuttgart industrialist originally from Austria, does not just buy art, he also cultivates close relationships with artists. His life as a collector began with a run-in with Joseph Beuys at Documenta 7 in 1982. There, Froehlich helped him with his action *7000 Eichen*. Beuys thanked him with a work of art. A variety of important German and American artists—Gerhard Richter, Rosemarie Trockel, or Bruce Nauman—have since all found their way into the collection. Sammlung Froehlich comprises around 300 works and has been shown at the Tate Modern in London and the Museum of Modern Art (MOMA) in New York City. Since 2009 it has been housed in the architecturally adventurous building on the premises of Froehlich's Stuttgart firm.

Collectors:
Josef & Anna Froehlich

Address:
Kohlhammerstrasse 20
70771 Leinfelden-Echterdingen
Germany
Tel +49 711 753944
www.sammlung-froehlich.de

By appointment only.

Art and architecture often make harmonious and attractive allies, with many private collectors taking great pains to find the appropriate architectural framework for their art. Some of them commissioning the careful renovation of historical buildings; others erecting brand new ones. The documenta-tested, Berlin-based architect-trio Kuehn Malvezzi, for example, transformed a former picture-frame factory in Düsseldorf into a multifunctional enclosure for Julia Stoschek's media-art collection. On the other side of the Rhine, in the district of Flingern, Gil Bronner opened his new collector's museum in summer 2016. Situated in the refined, converted old industrial halls of a former glazing factory, it also boasts a café and sculpture garden on the roof, making it the perfect environment for large-scale works by artists such as Tomás Saraceno or Tobias Rehberger. Some collectors even open their private homes and apartments by appointment. For visitors, it's interesting to see how the living environment engages in a dialogue with art. Munich-based Karsten Schmitz, of Stiftung Federkiel, commissioned the artist group Famed to transform his office apartment on the premises of the Leipziger Baumwollspin-nerei, with minimal intervention, into a habitable *Gesamtkunst-werk*. Art collectors frequently have a clear preference for good design: Alexander Ramselaar lives with his art collection and avant-garde furniture in a historic townhouse in Rotterdam, where well-stocked bookshelves serve as a room divider. It is ideal, of course, when collectors are able to commission their favorite architects to create new spaces for their art. The most recent example: the Fondazione Prada in Milan. None other than the art-savvy, Rotterdam-based, star architect Rem Koolhaas was selected to convert a former distillery into a functioning ensemble of old and new. Here, he couldn't resist making an ironic gesture: in a free-form interpretation of the legend of King Midas, Koolhaas transformed the tallest building on site into a golden tower.

Nicole Büsing & Heiko Klaas

97 Arbeitswohnung Federkiel
A former working-class apartment as subtly ironic Gesamtkunstwerk

Collector:
Karsten Schmitz

Address:
Leipziger Baumwollspinnerei
Spinnereistrasse 7
04179 Leipzig
Germany
sammlung@federkiel.org
www.federkiel.org/sammlung

Visitation permitted only
occasionally. Please inquire
by e-mail.

The Munich economist Karsten Schmitz is no stranger to Leipzig. As an art collector and founder of the Stiftung Federkiel—whose mission is the preservation of Leipzig's Baumwollspinnerei as a location for galleries, studios, and institutional exhibition—Schmitz is among the most important private sponsors of this Leipzig art center. His own apartment, a former working-class home on the premises, is for the collector both a place to generate ideas and an exhibition space. But he also uses it regularly to accommodate collector friends, artists, or scholars. He invited the Leipzig artist-group Famed to use the apartment and its furniture as artistic material to create a permanent intervention. The result is an ironic narrative installation that runs through all of the rooms, providing a cheeky visual link between them.

G

98 G2 Kunsthalle
Large-scale paintings of the New Leipzig School in dialogue

Collector:
Steffen Hildebrand

Address:
Dittrichring 13
04109 Leipzig
Germany
Tel +49 341 35573793
info@g2-leipzig.de
www.g2-leipzig.de

Opening Hours:
Wed: 3–8pm
Thurs–Mon: Guided tours with
prior online registration.

Given that the G2 art space is located in the up-and-coming eastern German town of Leipzig, it is fitting that the March 2015 inaugural exhibition focused on works by artists of the New Leipzig School. Most of these, including Neo Rauch, Matthias Weischer, and Tilo Baumgärtel, studied at the renowned local art school Hochschule für Grafik und Buchkunst Leipzig, and their figurative paintings have since gained an international profile. Collector Steffen Hildebrand, a property investor based in the city, was an early supporter, and now the art works he has brought together are displayed in a generous space in the center of Leipzig. Over the next few years, changing exhibitions—complemented by international loans—will showcase other parts of the continuously growing collection, which also includes other German and international artists, both emerging and established, working in a range of mediums.

99 Museum Brandhorst
*Art stars of the late twentieth century housed
in a dazzling new space*

The vibrant, shimmering façade of 36 000 ceramic rods in
twenty-three varying shades has a magnetic effect on people.
Nearly 350 000 visitors were attracted to the Museum Brand-
horst in 2009, the year it opened. But perhaps its success
is also a matter of what's found inside: nowhere in Europe
will you find more works by Andy Warhol—represented by
no less than one hundred pieces. Among the other highlights
are works by Gerhard Richter, Ed Ruscha, and Cy Twombly,
to name just a few. Located in the heart of Munich's art
quarter, this distinctive building—designed by Sauerbruch
Hutton—quickly became one of the most popular exhi-
bition spaces in all of Germany. The 700-work collection
belongs to the late Henkel heiress Anette Brandhorst and
her husband, Udo, who began assembling art in the 1970s.
They found a comfortable home for the collection in Munich,
and the State of Bavaria covers building-maintenance
costs. The Brandhorsts' foundation is endowed with
120 million euros, which guarantees a deep source of funds
for purchasing new work at the highest level.

G

Collectors:
Anette & Udo Brandhorst

Address:
Kunstareal München
Theresienstrasse 35A
80333 Munich
Germany
Tel +49 89 238052286
presse@museum-brandhorst.de
www.museum-brandhorst.de

Opening Hours:
Tue–Wed: 10am–6pm
Thurs: 10am–8pm
Fri–Sun: 10am–6pm

100 Sammlung Goetz
*Impressive architecture for international
contemporary art*

Before she began concentrating on her own private collec-
tion, in 1984, Ingvild Goetz had been a gallerist for fifteen
years. With around 5 000 works by over 300 artists, she
now ranks among the most important private collectors of
contemporary art in Germany. She started out with Arte
Povera. Then came works by American artists of the 1980s
and the Young British Artists of the 1990s, as well as some
German stars. Names like Richard Prince, Tracey Emin,
or Rosemarie Trockel are represented prominently. Since
1993 the collection has been housed in a cube constructed
of frosted glass and birchwood, designed by the Swiss
architects Herzog & de Meuron. In 2014, Goetz donated
375 works of media art and her stylish private museum to
the State of Bavaria. She nevertheless remains a passionate
collector and director of the museum.

Collector:
Ingvild Goetz

Address:
Oberföhringer Strasse 103
81925 Munich
Germany
Tel +49 89 95939690
info@sammlung-goetz.de
www.sammlung-goetz.de

Opening Hours:
Thurs–Fri: 2–6pm
Sat: 11am–4pm
By telephone appointment only.

101 Alexander Tutsek-Stiftung
The use of glass as a material in international contemporary art

Collectors:
Alexander Tutsek &
Eva-Maria Fahrner-Tutsek

Address:
Karl-Theodor-Strasse 27
80803 Munich
Germany
Tel +49 89 55273060
info@atstiftung.de
www.atstiftung.de

Opening Hours:
Tues–Fri: 2pm–6pm
Closed on public holidays.

The challenging goal of the Alexander Tutsek-Stiftung, founded in 2000, is to push the fascinating material of glass out of the niche of "applied art." The internationally oriented collection and exhibition space focuses on the deployment of this fragile material in post-World War II and contemporary art. Its aim is to sensitize the broader public to "the subtle, abstract, and transcendent themes" that are suited specifically to an expression in glass. The **G** foundation's headquarters, in a national landmark Art Deco mansion in Munich-Schwabing, was once the private residence and studio of the German sculptor Georg Albertshofer, and now hosts annual exhibits of glass sculptures. Since 2008 the foundation has also been supporting contemporary photography.

102 The Walther Collection
Highbrow contemporary photographic art in the midst of the Swabian provinces

Collector:
Artur Walther

Address:
Reichenauer Strasse 21
89233 Neu-Ulm/Burlafingen
Germany
Tel +49 731 1769143
info@walthercollection.com
www.walthercollection.com

Opening hours vary depending
on exhibition. Please check
the website for the most current
information.

Additional exhibition locations:
New York, United States
of America, p. 227

This is the tale of a man who went out to discover the world and returned to his hometown with a museum. Artur Walther worked as an investment banker on Wall Street. But in 1994 the then forty-five-year-old made a clean break and began to focus on art. More specifically, on photography. He went on African journeys with former Documenta director Okwui Enwezor to gather his extensive collection of African photographic art. Positions from Asia and Western artists, such as August Sander or Bernd & Hilla Becher, complete the collection. After all this, Walther returned, and on his parents' property he erected a clear white cube with a 500-square-meter main gallery to display his finds. Two regional-specific houses also serve as exhibition spaces. The grand opening in Neu-Ulm was in 2010; an outpost in New York City was launched a year later.

103 Herbert-Gerisch-Stiftung
*Contemporary sculpture in the park,
modern and current art in the villa*

G

In the middle of Schleswig-Holstein lies Arcadia—this is how Brigitte and Herbert Gerisch describe their sculpture park in Neumünster. Here you'll find contemporary sculptures by Bogomir Ecker, Ian Hamilton Finlay, Markus Lüpertz, or Mimmo Paladino situated among intricate paths, water lily ponds, and fields of forget-me-nots. Established in 2001, the foundation transformed an overgrown historical *Reformkunst* garden designed by Harry Maasz into a high-profile international sculpture garden. Brigitte Gerisch and her husband, who died in 2016, restored the run-down Villa Wachholtz inside the park to its original glory. In 2007, both the mansion and the park were opened to the public. Since then, exhibitions of modern and contemporary art by artists from Emil Nolde to Henry Moore, to Mark Dion and Carsten Höller, as well as young unknown talents, have been presented at Villa Wachholtz and the former swim hall of Villa Gerisch, located next door.

Collectors:
Brigitte & Herbert Gerisch

Address:
Brachenfelder Strasse 69
24536 Neumünster
Germany
Tel +49 4321 555120
kontakt@gerisch-stiftung.de
www.herbert-gerisch-stiftung.de

Opening Hours:
Wed–Sun: 11am–6pm
And by appointment.

Collector:
Karl-Heinrich Müller

Address:
Minkel 2
41472 Neuss
Germany
Tel +49 2182 8874000
museum@inselhombroich.de
www.inselhombroich.de

Opening Hours:
April–September
Mon–Sun: 10am–7pm
October
Mon–Sun: 10am–6pm
November–March
Mon–Sun: 10am–5pm

104 Museum Insel Hombroich
*Two thousand years of art in harmony with nature
and the landscape*

The idyllic Museum Insel Hombroich, today operated by a
private foundation supported by the state of North Rhine-
Westphalia, was founded by a Düsseldorf art collector and
patron. In 1982 Karl-Heinrich Müller (1936–2007) acquired
twenty-five hectares of wild meadow snaking alongside the
river Erft. Today, visitors to the Museum Insel Hombroich
stroll through this vast terrain, passing along the way sculp-
tures by Per Kirkeby and Eduardo Chillida, eventually **G**
running into Erwin Heerich's modest brick pavilions. Müller
assembled his collection based solely on his personal tastes,
thus one also discovers African fetishes and centuries-old
Khmer sculptures alongside works by Lovis Corinth, Yves
Klein, or Gotthard Graubner. Since 1994, the neighboring,
former NATO missile base also belongs to the foundation,
as well as the Kirkeby-Feld, showcasing the architectural
sculptures of the Danish artist.

Collectors:
Marianne & Viktor Langen

Address:
Raketenstation
Hombroich 1
41472 Neuss
Germany
Tel +49 2182 570115
info@langenfoundation.de
www.langenfoundation.de

Opening Hours:
Mon–Sun: 10am–6pm

105 Langen Foundation
*European and Asian art presented in a fascinating
building by Tadao Ando*

A highlight for architecture fans: the Langen Foundation
fits perfectly into the spaciousness of the former NATO
missile base on the island of Hombroich. For founder
Marianne Langen, who died in 2004, the minimalist build-
ing, made of exposed concrete by the Japanese architect
Tadao Ando, is the most important work of art she ever
acquired. Together with her husband, Viktor Langen, she
began to compile a collection of modernist work at the be-
ginning of the 1950s, now numbering roughly 300 works of
art ranging from Max Ernst and Paul Klee to Pablo Picasso.
The second focus is on a collection of Japanese artworks qui-
te unique to Europe: nearly 500 scrolls, Shoji screens, and
sculptures spanning eight centuries. The collectors' motto:
Art is not luxury; it is necessity. The 1 300-square-meter exhi-
bition space is used to show contemporary art in dialogue
with the permanent collection.

106 Gratianusstiftung
*Plentiful space for artifacts from the Paleolithic
to the present*

A comprehensive view of the world: the Reutlingen-based collector couple Hanns-Gerhard Rösch and Gabriele Straub offer a concise overview of the world's art history in a modernized mansion from 1904. The collectors mix epochs and genres in thirteen rooms on two floors. The spectrum runs from Paleolithic tools through African tribal art, and from Columbian shamanic figures to precious East Asian artifacts and works by modernists like Henri Matisse, Giorgio Morandi, or Paul Klee. The collectors are brave enough to leave their shows up for a longer duration. The current exhibition, *Anziehungskraft Farbe, Geist und Erinnerung* (The Appeal of Color, Intellect, and Memory), features works by a range of artists from various generations, including Hans Arp, Blinky Palermo, or Norbert Prangenberg. It is designed so that visitors "experience the art without first knowing or thinking about biographies or chronological reference points."

Collectors:
Hanns-Gerhard Rösch &
Gabriele Straub

Address:
Gratianusstrasse 11
72766 Reutlingen
Germany
Tel +49 7121 490177
info@gratianusstiftung.de
www.gratianusstiftung.de

Opening Hours:
Mon: 2–6pm
Thurs: 6–8pm (only every
first Thursday of the month)
And by appointment.

107 Stiftung für konkrete Kunst
*Concrete Art by over one hundred artists
in a former factory building*

The Stiftung für konkrete Kunst, in Reutlingen, is not a place that rushes masses of people through its halls. Instead, personalized art education is the foundation's core mission. Each visitor is guided individually through the exhibition by either the collector, Manfred Wandel, or by the director, Gabriele Kübler. Theo van Doesburg's 1924 definition of Concrete Art provides the collection its philosophical basis: "There is nothing more concrete or more real than a line, a color, or plane." Wandel's private collection forms the foundation's core, augmented by additional bodies of work and archives. The three floors in a former cheesecloth factory are designed in a straightforward industrial style. But Concrete Art is not a dogma: in special exhibitions these works are placed in relation to Bauhaus furniture or Russian icons.

Collector:
Manfred Wandel

Address:
Eberhardstrasse 14
72764 Reutlingen
Germany
Tel +49 7121 370328
skk.kuebler@t-online.de
www.stiftungkonkretekunst.de

Opening Hours:
Wed, Sat: 2–6pm
And by appointment.

108 Sammlung Siegfried Seiz
*Figurative painting from the last decade
of East Germany*

Collector:
Siegfried Seiz

Address:
Reutlingen, Germany
info@sieger-seiz.de

Visitation permitted only
occasionally. Please inquire
by e-mail.

As soon you hear the phrase "painting from the GDR,"
Socialist Realism comes to mind—and with it all its stereo-
types. But business executive Siegfried Seiz's Reutlingen-
based collection shows that there was another, non-official
kind of figurative painting in East Germany. Sixty-six
primarily large-format paintings by twenty-three artists
have found a comfortable home in his 600-square-meter
exhibition space, built out of a former factory. The art **G**
historian Gisold Lammel pointed Seiz to artists' studios in
Berlin, Dresden, Leipzig, and Halle, which he visited during
the last decade of the GDR. Alongside early pictures by
Neo Rauch, Seiz's collection holds unexpected works, like
some wildly expressive paintings by Klaus Killisch, or the
realist punk portraits by Clemens Gröszer.

109 Messmer Foundation/
Kunsthalle Messmer
*Concrete and Constructivist Art, plus the estate
of Swiss painter André Evard*

Collector:
Jürgen A. Messmer

Address:
Grossherzog-Leopold-Platz 1
79359 Riegel am Kaiserstuhl
Germany
Tel +49 7642 9201620
info@kunsthallemessmer.de
www.kunsthallemessmer.de

Opening Hours:
Tues–Sun: 10am–5pm

His life is defined by art and design. In 2005 Jürgen A.
Messmer, a former manufacturer of premium writing
utensils, established the Messmer Foundation in memory
of his deceased daughter, Petra. In 2009 he opened the
Kunsthalle Messmer in a former brewery in Riegel am
Kaiserstuhl. In a 900-square-meter space he exhibits works
from his trove of 1 000 paintings and sculptures in the-
matic and monographic groupings in up to three shows a
year: classics like Paul Klee and Otto Freundlich, inspiring
figures of Concrete Art like Max Bill or Victor Vasarely,
as well as numerous younger positions. Loans from other
art institutions broaden the exhibitions' scope. Forming a
central pillar of the Messmer collection is the main part
of the estate of the Swiss painter André Evard (1876–1972),
which Messmer acquired in 1979 and has shown regularly
ever since.

G

110 Schauwerk Sindelfingen
A cool, remodeled factory with first-class
international contemporary art

For Swabian businessman Peter Schaufler beauty has a lot to do with purity and the harmony of form and color. His company, a manufacturer of refrigerator compressors, is a global market leader. Schaufler and his wife, Christiane Schaufler-Münch, are known for their self-effacing, reticent style. In fact, until the opening of their private museum, Schauwerk Sindelfingen, in summer 2010, only a handful of people were even aware that they had started building their private collection in the late 1970s, today one of the largest in Germany. This made the surprise even more impressive: a 6 500-square-meter exhibition space where visitors can see top-quality works by artists like Donald Judd, Frank Stella, Imi Knoebel, John Armleder, or Sylvie Fleury, and an equally impressive collection of photography, which boasts works by the most important of the Becher students, as well as international names like Nobuyoshi Araki or Vanessa Beecroft.

Collectors:
Peter Schaufler &
Christiane Schaufler-Münch

Address:
Eschenbrünnlestrasse 15/1
71065 Sindelfingen
Germany
Tel +49 7031 9324900
fuehrungen@schauwerk-sindelfingen.de
contact@schauwerk-sindelfingen.de
www.schauwerk-sindelfingen.de

Opening Hours:
Sat–Sun: 11am–5pm
Tues, Thurs: 3–4:30pm
(guided tours)

With the turbulent market for emerging art having calmed slightly, greater attention has once again been placed on those collectors who fervently support and push forward the careers of the artists they've chosen to acquire. Museum shows and biennials wouldn't happen without the many works that have been supported, sight unseen, owing to the lasting relationships and trust that exist between collector and artist. Varied models of patronage abound, of course. For instance, that of London supermarket heir Alex Sainsbury, whose family owns an already-enviable collection and whose father and uncles donated a wing to The National Gallery. Interested in delving deeper into contemporary art, he opened Raven Row, in 2009. Located near Whitechapel Gallery, Sainsbury's exhibition space and residency program quickly became an important point of reference for Londoners on the lookout for new and notable contemporary artists. Collectors like Simon Franks and Robert Suss of the Franks-Suss Collection and Dominique and Sylvain Levy of the Dominique & Sylvain Levy Collection (DSLCollection), both featured in this edition of the Art Guide, began to support a new generation of artists from China, with the DSLCollection employing the Internet as its main exhibition venue to allow for wider access. Some collectors, like Francesca von Habsburg, take a multi-pronged approach. Her foundation, Thyssen-Bornemisza Art Contemporary (TBA21), funds scores of artist projects for biennials and other exhibitions worldwide, as well as residencies and international trips for its artist-recipients. The exhibition space TBA21—Augarten, in Vienna, is also used for showcasing consistently first-class shows of supported artists. It even housed groups of the Huni Kuin indigenous people of Brazil for a three-part collaborative exhibition with artist Ernesto Neto, in 2015. Regardless of the methods they use, patrons like these are indispensible when it comes to helping make the art world spin.

Alexander Forbes

111 Sammlung Schroth/ Stiftung konzeptuelle Kunst
Concrete and Minimalist Art at the Museum Wilhelm Morgner in Soest

Collector:
Carl-Jürgen Schroth

Address:
Thomästrasse 1
59494 Soest
Tel +49 2921 14177
info@skk-soest.de
www.skk-soest.de

Opening Hours:
Tues–Fri: 2pm–5pm
Sat–Sun: 11am–5pm

Carl-Jürgen Schroth discovered his interest in Constructivism in art class. But first he got a degree in mechanical engineering and then focused on expanding the family business, in the city of Arnsberg, in Sauerland. Schroth devoted his entire professional career to the development of better safety belts, but in his free time he was drawn ever closer to art. He began building a collection in the 1980s, with a focus on Concrete Art and Post-Minimalism, as well as on artists who were interested in scientific and mathematical investigations like light, space, and perception. Daniel Buren, François Morellet, or Victor Vasarely are featured prominently in addition to younger positions. Previously housed in private spaces, the collection moved into its new quarters inside the expanded and modernized municipal Wilhelm Morgner Museum in May 2016. Here works from the collection are on permanent display in Raum Schroth, a room flooded with light.

G

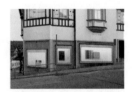

112 Sammlung Grässlin— Kunstraum Grässlin & Räume für Kunst
An extraordinary collection with a Black Forest backdrop

Collector:
Grässlin Family

Address:
Museumstrasse 2
78112 St. Georgen
Germany
Tel +49 7724 9161805
info@sammlung-graesslin.eu
www.sammlung-graesslin.eu

By appointment only.

Ever since the Grässlin family established the Räume für Kunst, in 1995, the city of St. Georgen has become obsessed with art. Every weekend the art-going crowd streaks through the vacant shops and factory floors elected to temporarily house artworks by figures like Albert Oehlen, Reinhard Mucha, Isa Genzken, or Cosima von Bonin. A tour of the impressive collection starts at the Kunstraum Grässlin, opened in 2006, and leads through the long since faded economic miracle of the 1960s, which is when the previous Grässlin generation began collecting Art Informel. Since the 1980s, their children have been adding contemporary works to the collection. Artist Martin Kippenberger also knew that St. Georgen breathed art, ever since he began coming to the Black Forest to recuperate from his excesses. Today, the Grässlins are among the largest holders of Kippenberger's works.

113 DasMaximum—KunstGegenwart
An inviting permanent exhibition of eight German and American artists

"It was always important for me to be in a dialogue with artists," says Heiner Friedrich. The former gallerist, collector, patron, and international art networker, who has lived in New York City since 1971, is co-responsible for such important projects as the Dia Art Foundation and Walter de Maria's Land-Art icon *The Lightning Field*. With his private museum in Traunreut, in southern Bavaria, Friedrich brings top artists to the city of his youth. In a space measuring over 5000 square meters you'll find works by Andy Warhol, Georg Baselitz, John Chamberlain, Dan Flavin, Imi Knoebel, Walter de Maria, and the nearly forgotten painter Uwe Lausen. An entire hall is dedicated to the early work of light artist Dan Flavin. Typical for the pioneering Friedrich: the collection is permanently on display, but opening hours change according to the shifting seasonal light.

G

Collector:
Heiner Friedrich

Address:
Fridtjof-Nansen-Strasse 16
83301 Traunreut
Germany
Tel +49 8669 1203713
mail@dasmaximum.com
www.dasmaximum.com

Opening Hours:
April-October
Sat–Sun: 12–6pm
November-March
Sat–Sun: 11am–4pm
And by appointment.
Closed in December.

114 Sammlung Halke
Contemporary art in a cool, modernist house on Lake Constance

If they are convinced of an artist, they immediately buy entire work groups. For example, photo series by Tobias Zielony or Elad Lassry. The Überlingen-based orthodontist Gunter Halke and his wife passionately collect young art. And it may well raise political or social issues. A large showcase work of Josephine Meckseper is placed right in the entrance hall of their light-flooded house. "The criteria are a mixture of spontaneity, enthusiasm, and a certain training of the eye," they say. "We try to be stubborn and deaf and often find without searching. We are eager to see whether the collection still looks fresh and justifiable twenty years from now." If you want to get to know the collection, you'll receive an extensive tour of its various rooms, running across works by André Butzer, Andy Hope 1930, Borden Capalino, or Günther Förg, among others.

Collector:
Gunter Halke

Address:
Überlingen, Germany
halke@web.de

By e-mail appointment only.

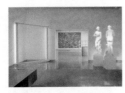

Collectors:
Friedrich E. Rentschler &
Maria Schlumberger-Rentschler

Address:
Magirus-Deutz-Strasse 16-18
89077 Ulm
Germany
Tel +49 731 3885478
maria.schlumberger@fer-collection.de
www.fer-collection.de

Only guided tours with prior
online registration.

115 Sammlung FER Collection
Minimal and Conceptual Art since the 1960s
as an intellectual challenge

Friedrich E. Rentschler collects art that inspires thought,
whether it's American Minimalism by Carl Andre or Sol
LeWitt, Conceptual work by Robert Barry, or Italian Arte
Povera by Giulio Paolini. Younger artists like Sylvie Fleury
or Mathieu Mercier have also found their way into the
collection of this pharmaceutical entrepreneur—which
has been growing constantly since 1960. This Ulm-based
collection could be characterized by its discerning selec- **G**
tivity and its collector's undeviating courage to acquire
works early on. Since 2009 Rentschler has shown his trea-
sures at the award-winning Ulmer Stadtregal, a former fac-
tory building turned into lofts, workshops, and cultural
institutions in the western part of the city. With a little
luck, you can catch a tour by Rentschler himself, who will
explain why he doesn't just collect with his eye but also
with his intellect.

Collectors:
Siegfried & Jutta Weishaupt

Address:
Hans-und-Sophie-Scholl-Platz 1
89073 Ulm
Germany
Tel +49 731 1614360
info@kunsthalle-weishaupt.de
www.kunsthalle-weishaupt.de

Opening Hours:
Tue–Wed: 11am–5pm
Thurs: 11am–8pm
Fri–Sun: 11am–5pm

116 Kunsthalle Weishaupt
Geometric American and European art since the 1960s

Siegfried Weishaupt likes to point out that he collects by
instinct. His father, Max, had good contacts in the Ulm
School of Design. Like his father, Siegfried was inspired by
director Max Bill and interested in the connections bet-
ween aesthetics and mathematics. In his early acquisitions,
in the mid-1960s, the young engineer focused on Concrete
and Geometric Art by professors at the Ulm School, such
as Josef Albers. Later, travels to America opened his eyes
to Color Field Painting, like the works of Mark Rothko.
Under the guidance of his daughter, the art historian
Kathrin Weishaupt-Theopold, the Kunsthalle Weishaupt
has acquired some more contemporary positions, like
Markus Oehlen, Robert Longo, or Liam Gillick. Works
from the collection are regularly shown in a transparent
glass building in the center of Ulm.

117 Museum Ritter—
Sammlung Marli Hoppe-Ritter
Square-centered geometric abstraction from the
twentieth and twenty-first century

Almost everyone knows the infamous square-shaped Ritter Sport chocolate bar. Marli Hoppe-Ritter, the grandchild of the company's founder, took this basic form as the starting point for her art collection. Kazimir Malevich defined the square in 1915 as "the first step of pure creation in art"; a small drawing by the Russian Constructivist forms the basis of the collection. Geometric-constructive works from Joseph Albers, Johannes Itten, and the Zurich Concrete artists to the Zero Group form the collection's inner core. Add to this a few younger artists like Gerold Miller or Paola Pivi, and the consistent 900-work collection progresses further into the present. Swiss architect Max Dudler constructed a modernistic limestone cube on the chocolate company's Waldenbuch property. Since its inauguration, in 2005, the Museum Ritter has staged three to four exhibitions annually, derived from the collection.

Collector:
Marli Hoppe-Ritter

Address:
Alfred-Ritter-Strasse 27
71111 Waldenbuch
Germany
Tel +49 7157 535110
besucherservice@museum-ritter.de
www.museum-ritter.de

Opening Hours:
Tues–Sun: 11am–6pm

118 Skulpturenpark Waldfrieden
World-class sculpture in harmony with nature

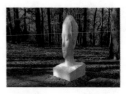

Skulpturenpark Waldfrieden combines the experience of nature with sustainable architecture and world-class sculpture. In 2006, British sculptor and Wuppertal resident Tony Cragg acquired the fallow, fourteen-hectare site located in Bergisches Land. The elegant villa in anthroposophical style, erected by manufacturer Kurt Herberts shortly after the war, was then carefully renovated. When strolling through the extensive park and its wealth of native and exotic tree species, you encounter not only a selection of Cragg's own sculptures, but also an ever-growing collection of prominent works by sculptors including Richard Deacon, Thomas Schütte, and Markus Lüpertz. Two large pavilions provide space for exhibitions of renowned artists and musical concerts. Film director Wim Wenders used one of these as a location for filming his homage to the late, Wuppertal-based choreographer Pina Bausch. In 2017, a third pavilion will be opened on the grounds.

Collector:
Tony Cragg

Address:
Hirschstrasse 12
42285 Wuppertal
Germany
Tel +49 202 47898120
mail@skulpturenpark-waldfrieden.de
www.skulpturenpark-waldfrieden.de

Opening Hours:
March–October:
Tues–Sun: 10am–7pm
November–February:
Fri–Sun: 10am–5pm

120

G

119

121

Great Britain

122–126

119 Chatsworth
*A ducal collection facilitates art historical dialogue
from antiquity to the present*

Collectors:
The Duke & Duchess
of Devonshire

Address:
Bakewell
Derbyshire DE45 1PP
Great Britain
Tel +44 1246 565300
www.chatsworth.org

Opening Hours:
March–December
Mon–Sun: 11am–5:30pm

The breathtaking landscape of the Peak District in Derbyshire and the palatial manor house may be the biggest attractions for visitors to the country estate of Chatsworth. Between ancient sculptures, valuable furniture pieces and aristocratic portraits of centuries past, the twenty-first century has also entered the collection. The 12th Duke of Devonshire, Peregrine Cavendish, passionately continues his family's 500-year-old collecting tradition, which over the generations has compiled one of the most important art collections in Europe. The Duke and his wife have carefully added works of contemporary art, design, and ceramics, by artists such as Allen Jones, Edmund de Waal, and Nicola Hicks. A small suite of rooms is entirely devoted to the contemporaries, and in the spacious garden, between the decorative hedges, one can find sculptures by Richard Long, Elisabeth Frink, and William Turnbull.

120 Jupiter Artland

*A sculpture garden where art is anything
but parked and forgotten*

In 1999 Robert and Nicky Wilson bought the historic
Bonnington House and its surrounding property. Since
then, monstrous exotic flowers have begun to bloom, cour-
tesy of *Love Bomb,* by Marc Quinn. And Charles Jenck's
Life Mounds have transformed part of the grounds into
wavy terraces. Such alterations have come about because
the couple has engaged internationally acclaimed sculp-
G tors and installation artists—Anish Kapoor, Jim Lambie,
or Antony Gormley—to create works specifically for their
garden. The works fit seamlessly into the landscape; some,
like Andy Goldsworthy's *Stone House,* spur an art double
take. Jupiter Artland is closed during the winter. The lively
dialogue the collectors demand of their art garden cannot
flourish when the garden is barren of natural life.

Collectors:
Robert & Nicky Wilson

Address:
Bonnington House Steadings
Wilkieston
Edinburgh EH27 8BB
Great Britain
Tel +44 1506 889900
enquiries@jupiterartland.org
www.jupiterartland.org

Opening Hours:
May 15–September 28
Thurs–Fri: 10am–5pm
And by appointment.
Online registration required.

121 Houghton Hall

*Lavish eighteenth-century interiors juxtaposed with
contemporary outdoor sculpture*

When exploring the sprawling, landscaped grounds of
Houghton Hall, one of England's finest Palladian houses,
stumbling across a contemporary sculpture feels like a
happy accident. The imposing house was built in the 1720s
for Great Britain's first prime minister, Sir Robert Walpole,
who assembled one of the country's greatest collections
of European art. Later, however, his indebted grandson
had to sell the collection's paintings to Catherine the Great
of Russia. The current owner, Lord David Cholmondeley,
continues in the collecting tradition, this time with a focus
on contemporary outdoor sculpture. The first commission
was *Skyspace* by James Turrell in 2000; works by Richard
Long, Anya Gallacio, Zhan Wang, Stephen Cox, Jeppe
Hein, and Rachel Whiteread were added later. For summer
2015, Turrell returned to create a site-specific light work to
illuminate the west-facing façade of the house as part of a
major exhibition of his work.

Collectors:
Rose & David Cholmondeley

Address:
King's Lynn
Norfolk PE31 6UE
Great Britain
Tel +44 14 85 528569
info@houghtonhall.com
www.houghtonhall.com

Opening Hours:
June–October
Fri–Sat: 12:30pm–7:30pm

122 Cranford Collection
*One of Europe's most important collections with
renowned contemporaries in Regent's Park*

G

Collectors:
Muriel & Freddy Salem

Address:
London, Great Britain
Tel +44 20 78130916
office@cranfordarts.org
www.cranfordarts.org

By e-mail appointment only.

For over forty years London has been the home of collectors
Muriel and Freddy Salem, a place where they acquired their
first works of art in the 1990s. First it was the Young British
Artists, then other European and American artists were
added to their collection. Their elegant home, designed by
John Nash in Regency style, is only a stone's throw away
from Frieze London, the annual contemporary art fair
held in Regent's Park. The number-one criterion: being
able to live with the artworks in order to confront and
experiment with them in their daily life. The collection
is rotated approximately every eighteen months and today
comprises nearly 700 works. A large number of these are
by women artists including Rebecca Warren, Bridget Riley,
and Carla Accardi. Distributed over four floors are large-
format works by Christopher Wool or Albert Oehlen,
alongside works by young stars like Valerie Snobeck and
Alex Israel.

123 The Franks-Suss Collection
A duo investing in the careers of young artists around the world

The Franks-Suss Collection was founded in 2002 to discover and support a new generation of artists from countries undergoing significant social, economic, or political change. Initially focused on China, collectors Simon Franks and Robert Suss soon widened their purview, with the help of curators Eli Zagury and Tamar Arnon. Nearly 1 000 works now fill the collection's main location in London and its outposts in New York and Hong Kong. Included are established names like Jonas Wood and Zeng Fanzhi, who they began collecting long before either made it big. More recent acquisitions include works by Hannah Perry, Diana Al-Hadid, and Zhai Liang. Despite their prescient track record, the two have collected in direct opposition to the art-as-an-asset-class trend, working closely with the artists on shows or at their residences, like the 2009 exhibition at Franks's Hampstead home, or at institutional spaces like the Saatchi Gallery.

G

Collectors:
Simon Franks & Robert Suss

Address:
34 Percy Street
London W1T 2DG
Great Britain
info@franks-suss.com

By appointment only.

124 David Roberts Art Foundation (DRAF)
A foundation with a focus on the avant garde from all media

In 2012 the David Roberts Art Foundation (DRAF) was pulled from the posh West End of London to a former furniture factory in vibrant Camden Town. The Scottish collector acquires art from British and international contemporaries, including photography by Ed Ruscha, paintings by Miriam Cahn, Gerhard Richter, Anselm Kiefer, and Louise Bourgeois, alongside important works by Martin Creed, Thomas Houseago, and Martin Kippenberger. While the collection and its throng of important names occupy part of the premises, the remaining area is charged with a different task: housing current artists' projects. Whether artistic interventions, movie nights, or panel discussions, all is welcome, as long as the platform hosts exciting forays into contemporary art.

Collector:
David Roberts

Address:
Symes Mews
London NW17JE
Great Britain
Tel + 44 20 73833004
info@davidrobertsartfoundation.com
www.davidrobertsartfoundation.com

Opening Hours:
Thurs–Sat: 12–6pm
Tues–Wed: by appointment only

The exclusive center, the elegant West, the hip East, or the up-and-coming South: in London contemporary art has developed its own urban coordinates around which you can plan your art walks. In the West, long distances must be traversed between institutions, such as the Serpentine Galleries, the Institute of Contemporary Arts (ICA), and the Saatchi Gallery. But in Mayfair—within the vicinity of the Royal Academy of Arts (RA)—the most prominent auction houses and galleries, such as Pace, Hauser & Wirth, David Zwirner, Sprüth Magers, or Blain/Southern are huddled between designer boutiques and grand hotels offering high tea. Super-dealer Larry Gagosian maintains his exhibition hall near King's Cross Station, in addition to his two galleries in Mayfair. From there it's just a stone's throw away to Golden Square, where Marianne Goodman has set up shop next to the Frith Street Gallery. North of Oxford Street, around Eastcastle Street, you can find another hotspot for contemporaries including the Alison Jacques Gallery and Carroll/Fletcher. The East End of London is not solely a hipster and media hub: from the Old Street Roundabout, near where Victoria Miro and Modern Art are located, additional galleries and scores of artists' studios stretch from Shoreditch to Hackney Wick. Any visit to the East should include the Whitechapel Gallery, whose exhibitions are always well worth seeing. Located off the beaten path, in the Southeast, are Jay Jopling's gallery White Cube, on Bermondsey Street, as well as Damien Hirst's new exhibition hall: Newport Street Gallery. Also situated south of the Thames, next to the perennially crowd-pleasing Tate Modern, are the art schools Camberwell College of Arts and Goldsmiths, which present graduate shows once a year. The non-commercial South London Gallery can also be found here. Following a visit you can round off a fine summer evening at Frank's Bar, surrounded by art students, on the roof terrace of a parking garage in Peckham, overlooking the annual sculpture exhibition *Bold Tendencies*—and the London skyline.

Anne Reimers

125 Saatchi Gallery
*Whether as collector or gallerist, he puts
Young British Artists first*

Collector:
Charles Saatchi

Address:
Duke of York's HQ
King's Road
London SW3 4RY
Great Britain
www.saatchi-gallery.co.uk

Opening Hours:
Mon–Sun: 10am–6pm

Charles Saatchi is known as a man who makes artists' careers. Born in Iraq, he's been collecting for over forty years. The Young British Artists have him to thank for jump-starting their stratospheric rise in the 1990s. The founder of the Saatchi & Saatchi advertising agency has a second passion as a gallerist. In the beginning, he was interested in artists like Andy Warhol or Donald Judd, whose work has been in Saatchi's private London museum since 1985. A few **G** years later he acquired a cornucopia of works by Damien Hirst, Tracey Emin, or Jake & Dinos Chapman, making the graduates of Goldsmiths College a flourishing brand name. His collection, which since 2008 has been housed in a classically restored building by the architecture firm Alford Hall Monaghan Morris, counts among the world's largest. This remains true, even though he gave part of it to the British government, and over 140 works were destroyed in a 2004 fire.

Collectors:
Anita & Poju Zabludowicz

Address:
176 Prince of Wales Road
London NW5 3PT
Great Britain
info@zabludowiczcollection.com
www.zabludowiczcollection.com

Opening Hours:
Thurs–Sun: 12–6pm
And by appointment.

126 Zabludowicz Collection
A collection in the unconventional ambiance of a church

After studying art, Anita Zabludowicz began, in 1994, to amass a private collection, placing young, international, untested positions at the center. Her husband, Poju Zabludowicz, the Finnish financier, preferred to collect more established names. Given this combination, one finds in the couple's 3 000-work collection of videos, photographs, drawings, and installations stars like Vanessa Beecroft or the Swiss duo Fischli/Weiss—as well as artists like Tom Burr or Ryan Gander, whose thematically complex works are less prevalent. The main exhibition space in London is located in a nineteenth-century Methodist church, where large parts of the collections have been shown since 2007. The second site, on the Finnish island Sarvisalo, is reserved exclusively for artist residencies, but once a year visitors can admire works by leading artists created in situ.

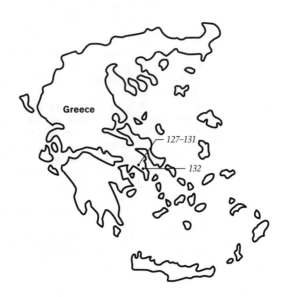

Greece

127–131

132

127 Deste Foundation for Contemporary Art
A renowned collection with a flair for color and provocation

While walking through New York's East Village in the 1980s, Greek Cypriot industrialist Dakis Joannou passed by the International With Monument Gallery, saw Jeff Koons's *One Ball Total Equilibrium Tank*, and bought it. This, anyway, is the legendary tale of how Joannou began his collection of contemporary art, today acknowledged as one of the most important in the world and shown in museums like the Palais de Tokyo, in Paris, and the New Museum, in New York. Joannou's Deste Foundation, established in 1983, aims to be a "container" for culture, an idea suggested by the design of the foundation's main entrance: a giant wooden crate similar to those used to transport works of art. Since 1999 the foundation has been supporting young artists through the biannual, 10 000-euro Deste prize, whose recipients include Anastasia Douka and Eirene Efstathiou.

Collector:
Dakis Joannou

Address:
Filellinon 11, Nea Ionia
14234 Athens
Greece
Tel +30 210 2758490
info@deste.gr
www.deste.gr

Open only during exhibitions.
Please check the website for the
most current information.

128 The George Economou Collection
German art in Greece

Collector:
George Economou

Address:
Kifissias Ave. 80, Marousi
15125 Athens
Greece
Tel +30 210 8090519
info@economoucollection.com
www.thegeorgeeconomoucollection.com

Opening Hours:
Mon–Fri: 10am–6pm

Greek ship-owner George Economou has a penchant for German art. His collection, which has been expanding rapidly since the late 1990s (*The Economist* says at a rate of roughly a new work every two days), offers in-depth insights into modern art in Germany, with a focus on art movements like Expressionism or Neue Sachlichkeit (New Objectivity). But the coverage does not end with modernism; it also includes artists ranging from Anselm Kiefer and Georg Baselitz, to Neo Rauch and Andreas Gursky. **G** "All my purchases of contemporary art have a strong historic element," says Economou. Alongside his interest in artists like Ellsworth Kelly, Cady Noland, or Jenny Saville, the collector is also drawn to postwar Conceptual Art. Since 2011, two to three exhibitions have been organized annually in his exhibition space in Athens.

129 Frissiras Museum
3 500 contemporary figurative paintings

Collector:
Vlassis Frissiras

Address:
Monis Asteriou 3 & 7, Plaka
10558 Athens
Greece
Tel +30 210 3234678
info@frissirasmuseum.com
www.frissirasmuseum.com

Opening Hours:
Wed–Fri: 10am–5pm
Sat–Sun: 11am–5pm

"In our age, art has a right to pure madness. Assuming a defensive position against the prevailing artistic atmosphere, I made my personal aesthetic choices and embraced contemporary painting with an anthropocentric slant." With his bold statement, Greek lawyer and passionate collector Vlassis Frissiras explains how he became the proud owner of over 3 500 contemporary paintings of the human figure. "Anything else leaves me indifferent," he told *The Athens News*, explaining the passionate nature of his connection to his paintings, adding: "I decided right away that I wanted the paintings to be anthropocentric. That's my character—it is monomaniacal and very focused." The Frissiras Museum includes, of course, a number of Greek artists, such as Yannis Moralis and Diamantis Diamantopoulos, as well as Europeans like David Hockney and Frank Auerbach.

130 Herakleidon—Experience in Visual Arts
The perfect place for mathematicians with an eye for art

Few visual motifs have found the commercial success of Dutch graphic artist M. C. Escher's interlocking patterns of nature and geometry, mathematics and architecture. The consequence of Escher's ubiquity is that almost anyone, no matter how unversed in art, can recognize his work when they see it. Lesser known, however, is exactly where to do so. That one of the largest collections of Escher's work is located in Athens, Greece, in a neoclassical building next to the Acropolis, may come as a surprise. Yet Paul and Anna-Belinda Firos's collection, aside from the impressive gathering of Escher prints, shows a general predilection for mathematical and geometrical patterns: Op Art pioneer Victor Vasarely and American engraver Carol Wax are both extensively represented. The institution also organizes exhibitions of earlier modernists like Edgar Degas, Edvard Munch, and Henri de Toulouse-Lautrec.

G

Collectors:
Paul & Anna-Belinda Firos

Address:
Herakleidon 16, Thissio
11851 Athens
Greece
Tel +30 210 3461981
info@herakleidon-art.gr
www.herakleidon-art.gr

Please check the website
for the most current information
on opening hours.

131 Portalakis Collection
International art in the heart of the business district

The typical art lover might not go to the business district to look for art, but, then again, the eighth floor of Zacharias Portalakis's brokerage company, located directly across from the former location of the Athens Exchange, is not your typical location. A self-made broker, Portalakis once told the *National Herald*, "All of the money I made is now colors." He started buying Greek artists at the end of the 1980s and then moved on to expatriated Greeks, such as Jannis Kounellis and Theodoros Stamos, the latter of whom he is the world's foremost collector. It was not always so: when Portalakis first met Stamos, the baffled collector says he did not understand the work. Instead, he let his then eight-year-old daughter choose a painting for her father's burgeoning collection, which today counts such international stars as Lucio Fontana, Christopher Wool, and Richard Prince among its highlights.

Collector:
Zacharias Portalakis

Address:
Pesmazoglou 8, 8th Floor
10559 Athens
Greece
Tel +30 210 3318933
info@portalakiscollection.gr
www.portalakiscollection.gr

Opening Hours:
Wed: 12–8pm
Sat: 11am–3pm
And by appointment.

132 Vorres Museum
*3 000 years of Greek history
and postwar Greek art*

G

Collector:
Ian Vorres

Address:
Diadochou Konstantinou 1
19002 Paiania
Greece
Tel +30 210 6642520
mvorres@otenet.gr
www.vorresmuseum.gr

Opening Hours:
Sat–Sun: 10am–2pm
And by appointment.

In the small town of Paiania, just east of Athens, the Vorres Museum strives to preserve Greek national heritage by covering 3 000 years of the nation's history. The nearly 6 000 works in the collection are divided into two sections: an impressive folk art collection, exhibited in four reconstructed village houses, and a museum of contemporary art, featuring paintings and sculptures by Greek artists from the second half of the twentieth century, including Lucas Samaras and Vlassis Caniaris. The sheer diversity of the collection reflects the personality of its owner, Ian Vorres, a Greek expatriate who lives in Canada and whose notable past endeavors include art critic, liaison between Canada and Greece, biographer of Russian grand duchess Olga Alexandrovna, and even mayor of Paiania.

H

133

Hungary

133 Vass Collection
Hungarian and international abstraction,
Constructivist and Concrete Art

In keeping with the Budapest cordwainer tradition, the name László Vass is known as a hallmark of quality and elegance in men's handmade leather shoes. Less well known—but no less refined—is the Vass Collection, preserved in the castle district of Veszprém, a small town of history and lore located 100 kilometers from Budapest. Incidentally, Veszprém is also known as "the city of queens": for centuries, Hungary's female royals were crowned by the local bishop. Vass began collecting contemporary Hungarian art in the 1970s and, influenced by an encounter with artist Jenő Barcsay, initially focused on native Constructivist Art and abstraction. He then turned to the same positions on an international level, assembling a collection of roughly 600 works by artists like Max Bill, Josef Albers, Manfred Mohr, Sean Scully, and Günther Uecker.

Collector:
László Vass

Address:
Vár Utca 3-7
8200 Veszprém
Hungary
Tel +36 88 561310
info@vasscollection.hu
www.vasscollection.hu

Opening Hours:
May–October
Mon–Sat: 10am–6pm
November–April
Mon–Sat: 10am–5pm

Iceland

134

I

134 Hafnarborg—The Hafnarfjörður Centre of Culture and Fine Art
Icelandic art of the twentieth century, plus plentiful special exhibitions

Collectors:
Sverrir Magnússon &
Ingibjörg Sigurjónsdóttir

Address:
Strandgata 34
220 Hafnarfjörður
Iceland
Tel +354 585 5790
hafnarborg@hafnarfjordur.is
www.hafnarborg.is

Opening Hours:
Wed: 12–5pm
Thurs: 12–9pm
Fri–Mon: 12–5pm

No matter if it's in Berlin, New York, or Venice, Icelandic art has great appeal. And whoever wishes to trace Icelandic art to the homeland of elves and mountain trolls should start with the Hafnarborg—The Hafnarfjörður Centre of Culture and Fine Art. In 1983 the pharmacist couple Sverrir Magnússon and Ingibjörg Sigurjónsdóttir donated their extensive collection of Icelandic modern art, and their private home, to the small town near Reykjavík. An extensive cultural center was developed around the building and opened in 1988. Almost every month there is a new special exhibition focusing mainly on Icelandic art. Today the ever-expanding collection includes 1 400 works. Icelandic artists living outside their home country, such as Ragnar Kjartansson, Egill Sæbjörnsson, or Ólafur Elíasson, have all had exhibitions there. Elíasson has the home-town advantage: he grew up in Hafnarfjörður.

135; 136

India

135 Devi Art Foundation
*The spectrum of Indian contemporary art
in one family collection*

Businesswomen Lekha Poddar began collecting art in the
1970s, concentrating on work that highlighted domestic
Indian art. Her son Anupam Poddar has since broadened the
scope of the family collection by harnessing work from the
Asian subcontinent: Pakistan, Bangladesh, and Sri Lanka,
as well as from Afghanistan, Tibet, and the Middle East. His
main interest is in experimental artists of his own genera-
tion whose genre-bending artworks mirror the vision of In-
dia. Examples range from Sudarshan Shetty through Subodh
Gupta or Jagannath Panda, all the way to Sakshi Gupta.
Also represented are the Iranian Golnaz Fathi and Kuwaiti
Hamra Abbas. The Devi Art Foundation, in Gurgaon,
near New Delhi, displays a large part of its collection in the
family's company building, completed in 2008.

Collectors:
Lekha & Anupam Poddar

Address:
Sirpur House, Plot 39
Sector 44, Gurgaon
India
Tel +91 124 4888177
info@deviartfoundation.org
www.deviartfoundation.org

Opening Hours:
Tues–Sun: 11am–7pm

136 The Kiran Nadar Museum of Art
 (KNMA)
150 years of Indian art

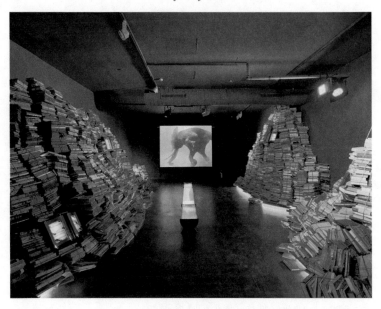

Collector:
Kiran Nadar

Address:
145, DLF South Court Mall, Saket
New Delhi 110017
India
roobina.karode@hcl.in
www.knma.in

Please check the website
for the most current informationon
opening hours.

One of the first private museums in India was opened in
New Delhi in 2010. Kiran Nadar not only aims to make
her twenty-year-old collection publicly accessible, but to
increase the quality of India's museum culture while doing
so. A large part of Nadar's program is dedicated to educa-
tion for schoolchildren and university students. Ninety
percent of the roughly 450 artworks are from India, while
the remainder comes primarily from Pakistanis and from
Indian artists who live abroad. In the museum's 1 600
square meters, visitors find key works by well-known Indi-
an modernists, such as Raja Ravi Varma or Maqbul Fida
Husain, the "Picasso of India." Alongside these are works
by a pioneering group of Bombay artists who worked to-
gether in the 1940s, as well as art by contemporaries like
Anish Kapoor, Bharti Kher, or Raqib Shaw.

137 OHD Museum of Modern &
 Contemporary Indonesian Art
A private collection with museum-level Indonesian art

Quite an accomplishment: since the 1980s former physician Oei Hong Djien has assembled roughly 3 000 works of Indonesian art. The result is a stellar overview of abstract and figurative painting, print, sculpture, photography, installation, and video art. The collection spans from the European-educated Prince Raden Saleh (1811–1880) to pioneer artists of the twentieth century, such as Affandi, S. Sudjojono, Hendra Gunawan, Widayat, and Soedibio. Notable are European artists like Rudolf Bonnet or Walter Spies, both of whom played important roles in Balinese modern art. Roughly half of the collection consists of contemporary artists, among them Entang Wiharso, Heri Dono, Nasirun, Nyoman Masriadi, and Rudi Mantofani. For some of them, the culture of the Wayang, or "shadow play," has been an important factor in their works. The collection is housed in three beautiful two-story buildings in the city of Magelang.

Collector:
Oei Hong Djien

Address:
Jl. Jenggolo 14
Magelang 56122
Central Java
Indonesia
Tel +62 293 362444
info@ohdmuseum.com
www.ohdmuseum.com

Opening Hours:
Wed–Mon: 10am–5pm
Closed on public holidays.

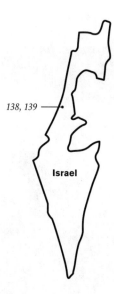

138, 139 —

Israel

138 Igal Ahouvi Art Collection
*International and Israeli contemporary art
in a university context*

Collector:
Igal Ahouvi

Address:
The Genia Schreiber University
Art Gallery
Entin Square, Tel Aviv University
54 Haim Levanon Street
Tel Aviv 69978
Israel
Tel +972 3 6408860
info@igalahouviartcollection.com
www.igalahouviartcollection.com

Opening Hours:
Sun–Wed: 11am–7pm
Thurs: 11am–9pm
Fri: 10am–2pm

With around 1 600 works, the international investor Igal Ahouvi owns one of the largest private art collections in Israel. It includes some 750 pieces of art by international artists, from Andy Warhol and Christopher Williams to Marlene Dumas. The second focus of the collection is on Israeli contemporary art, with 850 works by artists such as Sigalit Landau or Elad Lassry. Beginning in early 2014, Ahouvi began showing his collection at the Genia Schreiber University Art Gallery, in a planned series of twelve thematic exhibitions over a period of four years. This offers an ideal opportunity for both students and the broader public to engage in a substantive, critical encounter with major works of contemporary art. The academic character of the exhibition rooms creates a dispassionate context for reflection and analysis.

139 Givon Art Forum
*The Tel Aviv collection where art runs in the family
and ideas come first*

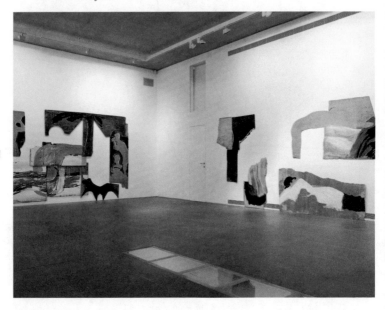

Launched in 2012 in Tel Aviv's oldest and most exclusive neighborhood, Neve Tzedek, the Givon Art Forum presents the private collection of Tel Aviv-based gallerist and collector Noemi Givon, as well as showing and caring for the collection of her father, the late Sam Givon. She opened the Forum in the belief that—in order to generate new ideas—there needed to be an exhibition space freed of the commercial constraints of a gallery and the structural limitations of a museum. The Forum's first exhibition, *Accelerating towards Apocalypse*, featured the collection of Israeli businessman Doron Sebbag—and Givon hopes to invite other collectors to exhibit in the future. Additional programming at the Givon Art Forum has drawn from her own holdings, with shows ranging from solo presentations of Aviva Uri and Gabriel Klasmer to thoughtfully curated group exhibitions such as *Who Is Content and Lives?* focusing on artists of the 1980s.

Collector:
Noemi Givon

Address:
Alroi 3, Neve Tzedek
Tel Aviv 6514905
Israel
Tel +972 3 9490999
www.givonartforum.com

Opening Hours:
Fri, Sat: 11am–3pm

Tel Aviv is an acclaimed place not only for art fans, but also for architecture enthusiasts: roughly 4 000 buildings are built in the Bauhaus or International Style. An audio tour of the White City and a visit to the Bauhaus Center Tel Aviv should also be on everyone's agenda. The Tel Aviv Museum of Art (TAM), founded in 1932, presents art of all periods, from the Old Masters to contemporary, in its historic building, erected in the 1970s, and in the geometric modulated Herta and Paul Amir Building, which opened in 2011. Also part of the major city museums, but run virtually independently, is the Helena Rubinstein Pavilion for Contemporary Art, which specializes in innovative exhibition formats of Israeli and international art. The Herzliya Museum of Contemporary Art focuses on art with a social and political dimension, often by Arab and Palestinian artists. Established in 1998 as a nonprofit space, the Center for Contemporary Art (CCA), with its two exhibition spaces and an auditorium, is a home for all those interested in video art, experimental film, and performance. The Sommer Contemporary Art gallery, opened in 1999 and located in a 1920s building at the top of Rothschild Boulevard, shows internationally renowned Israeli artists like Yael Bartana and Yehudit Sasportas. Other members of Sommer's program like Tom Burr and Saâdane Afif make the gallery an equally important showcase for international artists as well. This is much the same at Dvir Gallery, in the hipster neighborhood Florentin, whose program includes Claire Fontaine and Jonathan Monk as well as Israeli artists like Omer Fast and Ariel Schlesinger. The Chelouche Gallery for Contemporary Art, which moved into the west wing of the city's famed historic Twin Houses, in 2010, shows Michelangelo Pistoletto and William Kentridge, among other greats. The final amazing thing about Tel Aviv: from nearly every nook of the city the beach is just a few blocks away.

Nicole Büsing & Heiko Klaas

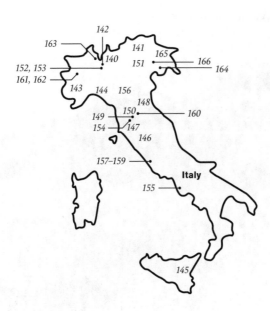

140 ALT Arte Lavoro Territorio Arte Contemporanea— Spazio Fausto Radici
Industrial archeology meets contemporary aesthetics

Collectors:
Tullio Leggeri & Fausto Radici

Address:
Via Gerolamo Acerbis 14
24022 Alzano Lombardo
Italy
Tel +39 035 4536730
info@altartecontemporanea.it
www.altartecontemporanea.it

Opening Hours:
Sat: 3–6:30pm
And by appointment.

The exhibition space ALT, near Bergamo, in northern Italy, is a testimony to the friendship between Tullio Leggeri, an architect and builder, and Fausto Radici, a one-time professional skier and businessman. The two men had shared a passion for contemporary art; they dreamed of opening their collections to the public. To this end, they bought the former headquarters of Italcementi, an old cement factory, and gave it it a new lease on life. Opened in 2009 and dedicated to Radici, who died in 2002, the ALT exhibition space shows part of the founders' own collections as well as new site-specific projects. Among the artists included are Enrico Castellani, Joseph Beuys, Maurizio Cattelan, Shirin Neshat, Vanessa Beecroft, Wim Delvoye, Carsten Höller, and Paul McCarthy.

141 ADN Collection
*Contemporary art and architecture in the vineyards
of South Tyrol*

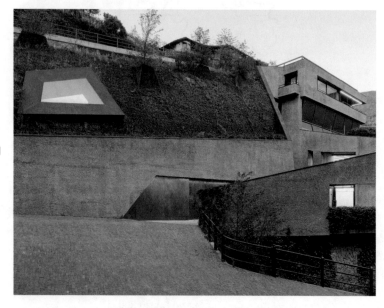

Beautiful landscape and sophisticated architecture already
makes a visit to the ADN Collection worthwhile. For the
construction of the vineyard-encircled building, which
houses both the collection and the private residence of
Antonio Dalle Nogare, a mountain was hollowed out and
the pink porphyry stone was reused as a building material.
This is how local architects Walter Angonese and Andrea
Marastoni impressively managed to insert the building
harmoniously into the landscape. Dalle Nogare, who began
collecting thirty years ago, focuses on Minimal and Con-
ceptual Art. In his collection, positions of the 1960s and
1970s stand in dialogue with younger contemporary artists.
The works are displayed in three main halls; additionally,
there are three "black boxes" for the presentation of videos
and a project room for temporary presentations.

Collector:
Antonio Dalle Nogare

Address:
Via Rafenstein 19
39100 Bolzano
Italy
Tel +39 0471 971626
info@adncollection.it
www.adncollection.it

By appointment only.

142 Rossini Art Site (RAS)
Large-scale sculptures in a landscaped park

Collector:
Alberto Rossini

Address:
Via Col del Frejus 3
20836 Briosco
Italy
Mob +39 335 5378472
info@rossiniartsite.com
www.rossiniartsite.com

Please check the website
for the most current information
on opening hours.

Just north of Milan is a park that fuses modern and con-
temporary sculpture, architecture, and landscape. It is, in
fact, an open-air museum, founded in 2010 by entrepreneur
Alberto Rossini and his wife, Luisa, in memory of their son
Pietro. Alberto Rossini's interest in art began in the 1950s.
Several large sculptures are located in the park, some of
them developed as site-specific projects. Among the artists
are important Italian names of the postwar period, includ-
ing Fausto Melotti, Pietro Consagra, or Giulio Turcato, as
well as international names such as Dennis Oppenheim,
César, Erik Dietman, or Nobuho Nagasawa. A pavilion in
the park used for exhibitions was designed by James Wines
of the New York architecture office Site—one of the largest
firms in the field of green architecture.

143 Collezione La Gaia
Minimal Art, Conceptual Art, and Arte Povera
in Piedmont

Collectors:
Bruna Girodengo &
Matteo Viglietta

Address:
Strada Monte Gaudio 13
12022 Busca
Italy
Tel +39 0171 945900
info@collezionelagaia.it
www.collezionelagaia.it

Visitation permitted only
occasionally. Please inquire
by phone or e-mail.

When Bruna Girodengo and Matteo Viglietta began col-
lecting art, at the end of the 1970s, they did so "on tiptoe
and with a big desire to learn." Initially the pair bought
modernist works—their first acquisition a 1918 collage by
Giacomo Balla—but they soon turned their attention to
art from the 1960s to the present. Today the collection
boasts nearly 1 200 pieces, including a significant group by
Arte Povera artists like Alighiero Boetti, Giuseppe Penone,
and Michelangelo Pistoletto, which are placed in a "con-
versation" with more contemporary works by the likes
of Bill Viola, Anish Kapoor, and Tony Cragg. Among
Girodengo and Viglietta's recent acquisitions, always
based on their personal preferences, are works by Bas Jan
Ader, David Hammons, Sanja Iveković, Robert Gober,
Roman Ondák, and Christian Rosa.

144 Fondazione Pier Luigi e Natalina Remotti

A marriage in the name of art, and a collection in a former church

Since their wedding nuptials, at the end of the 1960s, Pier Luigi and Natalina Remotti have been collecting contemporary art. "We have always looked for artists who are experimenting with a new language but who do not yet command exorbitant prices," says Natalina Remotti. "A collector must recognize an artist before the market does." Their collection includes works by Francesco Vezzoli, Vanessa Beecroft, and Nico Vascellari and has a special slant toward photography. Their foundation was opened in 2008 in a former church renovated by the artist Alberto Garutti. There they present their collection and organize exhibitions with additional artists they appreciate. "Our collection has grown quite nicely because my husband and I agree on things," Natalina Remotti says. "It's often happened that I've shown him a work of art at a fair and he says, 'I just bought that.'"

Collectors:
Pier Luigi & Natalina Remotti

Address:
Via Castagneto 52
16032 Camogli
Italy
Tel +39 0185 772137
info@fondazioneremotti.it
www.fondazioneremotti.it

Opening Hours:
Sat–Sun: 11–6pm
And by appointment.

145 Fondazione Brodbeck

Contemporary art in a post-industrial complex— in the shadow of a volcano

The 6 000-square-meter industrial complex in the neighborhood of San Cristoforo, in Catania, used to be a factory for producing licorice and processing nuts. It has also served as a garrison, a storage facility, and joinery. Now it is home to Fondazione Brodbeck, founded by industrialist Paolo Brodbeck in 2007, which aims to transform the region into an international art nexus. So far the commitment has entailed the renovation of a section of the industrial area and a chance to rethink the entire neighborhood. Brodbeck's collecting is equally sweeping: Arte Povera and Gruppo Forma, as well as international artists like Louise Bourgeois, Tony Cragg, and Julian Opie. With an eye to the future, Brodbeck supports young artists through a residency program. So far, it has hosted artists such as João Maria Gusmão + Pedro Paiva, whose works have found their way into Brodbeck's esteemed compendium.

Collector:
Paolo Brodbeck

Address:
Via Gramignani 93
95121 Catania
Italy
Tel +39 095 7233111
info@fondazionebrodbeck.it
www.fondazionebrodbeck.it

By appointment only.

146 Il Giardino dei Lauri
Contemporary blue chips in the Umbrian countryside

Collectors:
Massimo & Angela Lauro

Address:
Località San Litardo
ss Umbro Casentinese km 79
06062 Città della Pieve
Italy
Tel +39 33381099572
elda@ilgiardinodeilauri.it
www.ilgiardinodeilauri.it

Opening Hours:
Fri–Sat: 10am–1pm,
3:30–6:30pm
And by appointment.

Born into a family of art collectors, Massimo Lauro came in contact with art at a young age. He was love-struck by his parents' enthusiasm and eventually began collecting on his own. Knowing he could not compete with his parents' stately compilation, he began, in the 1990s, garnering the work of a younger generation. Today the collection that Massimo Lauro and his wife, Angela, have amassed in their Umbrian countryside residence boasts more than 300 works of established contemporary artists like Urs Fischer, Jeff Koons, Allora & Calzadilla, Takashi Murakami, and Fischli/Weiss. Some sculptures are installed in the garden: a hulking metallic hand by Piotr Uklański, and an unsettling sculpture of a hanged child by Maurizio Cattelan, which shocked some of Milan's residents in 2004. A neon rainbow by Ugo Rondinone glows over wandering garden visitors, asking, *Where Do We Go from Here?*

147 Sensus—Luoghi per l'Arte Contemporanea
Space as leitmotif in a 1960s building

"Collecting has always been a priority for me. As a child I was already collecting things that triggered my imagination. I used them to create my own world." This is how insurance broker Claudio Cosma explains the motivation behind his passion of the last thirty years. "My greatest satisfaction," he says, "is to assist in the creation of works, to exchange ideas with artists to such an extent that these works would not exist without me." This approach is reflected in the name of Cosma's showroom in Florence, which refers to perception: Sensus. Opened in December 2012, on the ground floor of a 1960s building, and then expanded onto the first level in April 2013, the collection's overarching theme is the relationship between art and its surrounding space. Along with Italian artists like Fabrizio Corneli, Angelo Barone, and Maurizio Nannucci are Asian representatives like Maitree Siriboon or Yuki Ichihashi.

Collector:
Claudio Cosma

Address:
Viale Gramsci 42
50132 Florence
Italy
info@sensusstorage.com
www.sensusstorage.com

By e-mail appointment only.

148 Fondazione Dino Zoli
Twentieth-century Italian art in a multifunctional museum

The Fondazione Dino Zoli, located in the city of Forlì, in the central-north region of Emilia-Romagna, calls itself a "dynamic museum." Rightly so: opened by local industrialist Dino Zoli in 2007, the foundation not only houses his exquisite collection of modern art, but also hosts a vibrant series of talks, music events, fashion shows, and book launches, with a regional focus. The foundation's connection to the surrounding locale is also evidenced by exhibitions of paintings by Mattia Moreni, an artist from Emilia-Romagna. The collection as a whole functions as a visual excursus of twentieth-century Italian art, featuring established names like Alberto Magnelli, Mimmo Paladino, and Fabrizio Plessi, as well as those lesser-known internationally but beloved in Italy: Salvatore Fiume and Emilio Scanavino.

Collector:
Dino Zoli

Address:
Viale Bologna 288
47100 Forlì
Italy
Tel +39 0543 755770
info@fondazionedinozoli.com
www.fondazionedinozoli.com

Opening Hours:
Mon–Fri: 10am–1pm, 4–7pm

149 Castello di Ama per l'Arte
Contemporanea

*Site-specific installations for a dual passion:
art and wine*

Collectors:
Marco & Lorenza Pallanti

Address:
Località Ama
53013 Gaiole in Chianti
Italy
Tel +39 0577 746031
info@castellodiama.com
arte@castellodiama.com

By e-mail appointment only.

One thing is essential for the vintner couple Marco and
Lorenza Pallanti: the uniqueness of place. This is true of
their wines, of course, whose uniqueness is owed to the
soil's inherent qualities, but also of their art collection,
which is exclusively comprised of site-specific installations.
Since 2000 they have invited artists once a year to install
work on their vineyard estate. The project was created in
collaboration with Lorenzo Fiaschi of the Galleria Continua
in San Gimignano. The first artist was Michelangelo
Pistoletto, who set up a four-meter-high tree with a mirror
hidden inside of it—a trademark of the artist—in the base-
ment of the Villa Pianigiani. After Pistoletto, many other
well-known artists, such as Daniel Buren or Ilya & Emilia
Kabakov, came and dealt with this unique space in their
own striking way.

Collectors:
Nunzia & Vittorio Gaddi

Address:
Viale Carducci 627
55100 Lucca
Italy
Tel +39 0583 587748
info@collezionegaddi.com
www.collezionegaddi.com

By appointment only.

150 Collezione Nunzia e Vittorio Gaddi

International contemporary art in the city and country

Tuscan notary Vittorio Gaddi has been collecting con-
temporary art since the early 1990s. His first work was
the sculpture *The Daughter of the Sun*, by the Italian ar-
tist Giò Pomodoro. After this, his attention shifted to
more international and emerging art. Today, Gaddi owns
around 350 works by artists such as Tomás Saraceno, Haris
Epaminonda, Benedikt Hipp, Nathalie Djurberg, Ólafur
Elíasson, Isabelle Cornaro, or Ariel Schlesinger. His inter-
est is triggered less by a specific style or medium than by
an artist's contemporaneity. From the very outset Gaddi
wanted his collection to be publicly accessible. Today it is
divided among a 1920s Art Nouveau mansion, in the city of
Lucca, and two old farmhouses nestled in the countryside.
One of these adjacent houses was intended as a country
chalet but was gradually taken over by art. The other was
renovated for the collection in summer 2012.

151 La Casabianca
Graphic art from the 1960s to the 1990s

Aspiring collectors with insufficiently deep pockets can always turn to works on paper for beauty and value. Giobatta Meneguzzo turned to exactly such work in the 1970s, and his decisions have paid off. Today he possesses a distinguished collection of more than 1 200 works by 700 international artists spanning from the 1960s to the 1990s. His collection, in La Casabianca, is housed in a seventeenth-century palace—replete with a library—in a small town in the Veneto region. The collection's artworks are grouped together by movement and, all told, evidence a tight spectrum: Minimalism and Pop, Conceptual Art and Transavanguardia. All the works are hung salon style—and without labels—so that visitors approach the works with an unbiased eye.

Collector:
Giobatta Meneguzzo

Address:
Largo Morandi 1
36034 Malo
Italy
Tel +39 0445 602474
info@museocasabianca.com
www.museocasabianca.com

Opening Hours:
Sun: 10am–12:30pm, 3–6pm
And by appointment.

152 Fondazione Opera
Contemporary art meets toys and antiques

If you're the son of a passionate collector who was already purchasing works by Lucio Fontana and Piero Manzoni in the 1960s, chances are that you would fall in love with art at an early age. This is precisely what happened with Guido Galimberti. He was twenty years old when he acquired his first work of art: *Flowers*, by Andy Warhol, which he paid for in installments. For years he had worked as a financial consultant but considered art his passion. In 2007 he transformed his hobby into his profession and became an art consultant. Galimberti's handling of art is playful and provocative, combining works of contemporary artists like Nedko Solakov and Pascale Marthine Tayou with Asian antiques or toys. You will find, for example, a top hat by Giulio Paolini next to a Japanese samurai helmet, or a cube by Stuart Arends next to an antique Chinese vase.

Collectors:
Guido Galimberti &
Donatella Picenelli

Address:
Piazza San Marco 1
20121 Milan
Italy
info@operadv.com

By e-mail appointment only.

How commercial may a biennial be? And how culturally engaged may an art fair be? Contemporary art fairs have become events that go far beyond their commercial function. Sections arranged by well-known curators, panel discussions, artists talks, and performances are all based on a model initiated by ArCo Madrid in the 1980s, and which Vincenzo de Bellis, the artistic director of MiArt in Milan, has recently defined as "a process of biennializing the art fair." Biennials, on the other hand, have always claimed to be purely cultural events. Even mentioning "the art market" in this context can cause waves of outrage. Yet, it goes without saying that biennials have a significant effect on the career and market-value of the artists they exhibit. Though some people still idealize biennials as events free of business and commerce, it is worth remembering that until 1968 the Venice Biennale had a sales office, and it is no secret that, even today, gallerists make deals during opening days. What art fairs and biennials do have in common is the important role they play in proliferation at the global level; almost every single week, an art fair takes place some-where in the world. Participation in these fairs is fundamental to a gallery's business and reputation, even though it requires significant financial expenditure. Accordingly, biennials are sprout-ing up all over the globe. Some critics have complained about this increase, questioning the need for additional similar exhibi-tion formats. Undoubtedly both developments must be considered a side effect of globalization and the concomitant growth of in-terest in contemporary art. By linking together local art scenes and bringing them to the international stage, biennials ultimately also contribute to building bridges between worlds and promoting intercultural dialogue.

Silvia Anna Barillà

153 Fondazione Prada

*The foundation of the world-famous fashion designer
in a distillery converted by Rem Koolhaas*

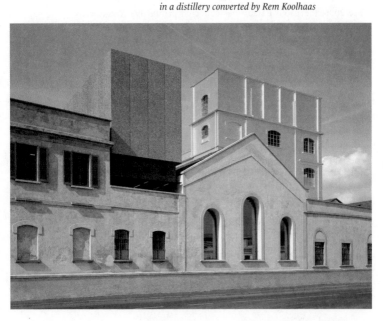

Collectors:
Miuccia Prada & Patrizio Bertelli

Address:
Largo Isarco 2
20139 Milan
Italy
Tel +39 02 56662611
info@fondazioneprada.org
www.fondazioneprada.org

Opening Hours:
Mon, Wed, Thurs: 10am–7pm
Fri–Sun: 10am–9pm

In May 2015, the new hub of Fondazione Prada—much-anticipated by the Milanese art scene—opened in a former distillery near the Porta Romana train station. High expectations were not disappointed; Dutch architect Rem Koolhaas designed a building that combines old and new in an original way. In the elegant spaces, art from the ever-growing collection of Miuccia Prada and her husband Patrizio Bertelli are presented in changing exhibitions. Works from the 1960s by artists like Walter De Maria, Donald Judd, Enrico Castellani, and Lucio Fontana form an integral part of the collection. Since its inception in the 1990s, the foundation has increasingly devoted itself to promoting ambitious artist projects. This includes a show by Polish artist Goshka Macuga, who realized her exhibition at the Fondazione in 2016.

154 Depart Foundation
Young American art in Tuscany, Rome and L.A.

Since 2005, Pierpaolo Barzan has collected primarily young American art. "At first I was driven by the desire to build a collection that reflects my generation," Barzan explains. "So I was interested in artists like Sterling Ruby, Joe Bradley, and Nate Lowman. After that, it was only natural to continue with the next generation." Meanwhile, the collector has acquired about 500 works, by artists such as Cory Arcangel, Grear Patterson, Lucien Smith, or Kour Pour. Parts of the collection are on display in his estate in Tuscany. In addition, Barzan regularly organizes exhibitions in collaboration with museums and institutions in Rome, such as the Museo d'Arte Contemporaneo Roma (MACRO). He and his wife Valeria Barzan also opened a project space in Los Angeles in 2014, with which the couple aims to promote cultural exchange between artists from Europe and America.

Collectors:
Pierpaolo & Valeria Barzan

Address:
Via di Poggio Golo
53045 Montepulciano
Italy

Los Angeles:
9105 West Sunset Boulevard
Los Angeles, CA 90069
United States of America

info@departfoundation.org
www.departfoundation.org

By e-mail appointment only.

155 Fondazione Morra Greco
International contemporary art in the historic heart of Naples

The Neapolitan palace that houses the foundation of dentist Maurizio Morra Greco has contained art for centuries. It was used in the seventeenth century as an exhibition hall by the Caracciolo, the royal family of Avellino. Today, works by Italian artists such as Roberto Cuoghi and Diego Perrone are represented, as are those of international names such as Mark Dion or Manfred Pernice. "I started to buy antiques at the age of fourteen," says Morra Greco. "Then I understood that contemporary art is an expression of my time." The artists of Morra Greco's collection not only draw the zeitgeist to Naples, they also provide a connection to the city: the foundation regularly invites artists to create site-specific works. One of the most spectacular was an installation by the German artist Gregor Schneider, who transformed the basement of the palace into a shadowy labyrinth.

Collector:
Maurizio Morra Greco

Address:
Largo Avellino 17
80138 Naples
Italy
Tel +39 081 210690
info@fondazionemorragreco.com
www.fondazionemorragreco.com

Please check the website
for the most current information
on opening hours.

156 Collezione Maramotti
From prêt-à-porter to contemporary art

Collector:
Maramotti Family

Address:
Via Fratelli Cervi 66
42124 Reggio Emilia
Italy
Tel +39 0522 382484
info@collezionemaramotti.org
www.collezionemaramotti.org

Please check the website
for the most current information
on opening hours.

Achille Maramotti, founder of fashion group Max Mara,
was not only the inventor of prêt-à-porter in postwar Italy,
he was also an enthusiastic collector of art. His focus was on
painting—above all, Transavanguardia—but he also assem-
bled works by international stars such as Julian Schnabel
and Alex Katz, of whom he was the first European collec-
tor. Sharing Maramotti's collection with the public dates
back thirty years: initially it hung in the corridors of the
Max Mara factory. When production was moved to accom-
modate company expansion, the factory was turned into
a museum that exhibited 200 of Maramotti's 600-work
trove. Though he passed away in 2005, Maramotti's three
children have continued to buy and commission works by
young artists for their family's collection, such as those by
Jacob Kassay and Kara Tanaka.

157 Fondazione Giuliani
Contemporary flair with blue-collar neighbors

Over the past few years, Rome's contemporary art scene has
boomed—not least because of the opening of the Museo
Nazionale Delle Arti Del XXI Secolo (MAXXI). Giovanni
Giuliani and his wife, Valeria, have also played a part here
by opening their impressive private exhibition space in
2010—a white cube in the basement of a housing project
in the neighborhood of Testaccio. The area alone is worth
a visit: a working-class district with strong character that
offers an attractive nightlife. The Giulianis, who began
collecting at the end of the 1980s, now maintain nearly
400 works, primarily sculptures and installations by artists
including Cyprien Gaillard, Mona Hatoum, Alicja Kwade,
and Nedko Solakov, as well as works by figures of Arte Povera
and Conceptual Art. The exhibition space has regular open-
ing hours, but the collection—at times also integrated into
the foundation's exhibition program—can be toured by
request only.

Collectors:
Giovanni & Valeria Giuliani

Address:
Via Gustavo Bianchi 1
00153 Rome
Italy
Tel +39 06 57301091
info@fondazionegiuliani.org
www.fondazionegiuliani.org

Please check the website
for the most current information
on opening hours.

158 Casa Musumeci Greco
*An historic apartment for contemporary art
in central Rome*

Visiting the Roman house of Ines Musumeci Greco—a former
art writer and gallerist—means not only visiting a collection
of works by contemporary Italian and international artists
—Nico Vascellari, Luisa Rabbia, Jonathan Monk, Pascale
Marthine Tayou, or Chen Zhen—but entering a private
apartment where life meets art, and where modernity meets
history. Musumeci Greco's apartment is located inside
Palazzo Bennicelli, a stately seventeenth-century building
in the heart of the historic center and directly adjacent
to a clock tower designed by the famous Baroque architect
Francesco Borromini. Renovated with an eye toward the
idiosyncrasies of the historic location, the apartment regu-
larly hosts artists' talks and lectures, evincing Musumeci
Greco's preference for a direct, daily relationship with artists
and their work.

Collectors:
Ines & Giuliano Musumeci Greco

Address:
Piazza dell'Orologio 7
00186 Rome
Italy
inesmusumeci@hotmail.com

By e-mail appointment only.

159 Nomas Foundation
*Nomadism and otherness against the force
of homogeneity*

Collectors:
Raffaella & Stefano Sciarretta

Address:
Viale Somalia 33
00199 Rome
Italy
Tel +39 06 86398381
info@nomasfoundation.com
www.nomasfoundation.com

Opening Hours:
Tues–Fri: 2:30–7pm

The word *nomas* is Latin for "nomad." This is how the Romans described the Saharan Berbers, who spoke neither Latin nor Greek and opposed any foreign attempt to suppress their culture and identity. The Rome-based collectors Raffaella and Stefano Sciarretta were inspired by this concept of nomadism and otherness when they opened their foundation in 2008. Here they present their expansive collection, complemented by exhibitions, talks, and seminars. One of their goals is to offer residencies to support young artists with their projects. The Sciarrettas began to collect in the 1990s—at first Italian Pop Art, and then international contemporary works. Today they own about 700 artworks by 300 artists, among them Rossella Biscotti, Alexandre Singh, and Ryan Gander.

160 Collezione Gori—Fattoria di Celle
Site-specific and Land Art nestled in the Tuscan hillside

Collector:
Giuliano Gori

Address:
Via Montalese 7
51030 Santomato di Pistoia
Italy
Fax +39 0573 479486
info@goricoll.it
www.goricoll.it

By appointment only.
Please inquire via website.

The beauty of the Tuscan countryside is known the world over. And at Fattoria di Celle, near Pistoia, the region's natural beauty is complemented by the profundity of art. It is here that Giuliano Gori, since the 1980s, has been inviting international stars like Robert Morris, Sol LeWitt, Richard Serra, or Daniel Buren to create site-specific works in the park surrounding his majestic residence. Each artist chose a location after carefully sizing up the local elements and conditions and allowing the local charm and history of the Tuscan region—birthplace of the Renaissance—to win them over. When you visit the Collezione Gori, be sure to bring the right shoes and time: more than thirty years of collecting have amassed an extensive variety of works that can take several hours to experience.

161 Fondazione Sandretto Re Rebaudengo
Not just a collection; a foundation to promote the new

I

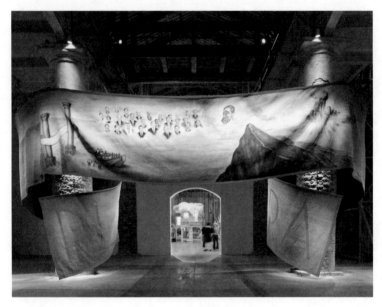

Thanks to a mix of institutional and private initiatives, the region of Piedmont has become an important hub for contemporary art in Italy. And among all the private ventures, perhaps the most well-known is Fondazione Sandretto Re Rebaudengo, which was established in 1995 by the Italian grande dame of contemporary collecting, Patrizia Sandretto Re Rebaudengo. The foundation prides itself on recognizing early on talented artists who have achieved international acclaim since the 1990s, like Californian multimedia artist Doug Aitken, for example. Among Sandretto Re Rebaudengo's more recent acquisitions are works by Tauba Auerbach and João Onofre. But because the main aim of the foundation is to promote the work of young artists, it not only shows works from the collection, it also organizes thematic exhibitions and supports the production of work by artists just entering the fray.

Collector:
Patrizia Sandretto Re Rebaudengo

Address:
Via Modane 16
10141 Turin
Italy
Tel +39 011 3797600
info@fsrr.org
www.fsrr.org

Opening Hours:
Thurs: 8–11pm
Fri–Sun: 12–7pm

162 Videoinsight Foundation
Art and psychotherapy—a healing combination

Collector:
Rebecca Russo

Address:
Via Ferdinando Bonsignore
10131 Turin
Italy
Tel +39 331 3093959
videoinsight@videoinsight.it
www.fasv.it

By e-mail appointment only.

Art can heal. That's the theory psychotherapist and art collector Rebecca Russo advocates and implements at her center Videoinsight. For her, a work must convey universal messages that relate to human needs—this principle has guided her collecting. Ten years ago she started to show art—mostly videos—to her patients. She uses it as a kind of Rorschach test for self-reflection. She also offers this method in the form of group therapy once a week to an interested art audience. One may also visit the monthly rotating exhibitions usually devoted to one artist. The collection includes, among others, Joseph Kosuth, Santiago Sierra, Natalie Djurberg, Yael Bartana, Marinella Senatore, Ragnar Kjartansson, Eva Kot'átková, and Franceso Vezzoli, as well as many artists from Asia, such as Japanese Koki Tanaka or Indonesian Etang Wiharso.

163 Villa e Collezione Panza/
Fondo Ambiente Italiano (FAI)
Minimal Art in a neoclassical villa in dialogue with antique furniture and African art

Collector:
Giuseppe Panza di Biumo

Address:
Piazza Litta 1
21100 Varese
Italy
Tel +39 0332 283960
faibiumo@fondoambiente.it
www.villapanza.it

Opening Hours:
Tues–Sun: 10am–6pm

When Giuseppe Panza di Biumo passed away, in 2010, the *Los Angeles Times* described him as "a Milanese businessman who was the first great international collector of postwar American art." In the mid-1950s, after a trip to America, di Biumo began acquiring art super-stars like Mark Rothko, Bruce Nauman, and Richard Serra. His collection holds a few Europeans but consists mostly of American Abstract Expressionist, Pop, Minimal, and Conceptual Art. Large parts of di Biumo's trove are now in museums like the Guggenheim in New York, and the Museum of Contemporary Art, Los Angeles (MOCA). But an important group of works is still maintained in his neoclassical villa near Varese. One wing boasts light installations by Dan Flavin and James Turrell, and Minimal Art and monochromes sit next to Renaissance furniture and African and pre-Columbian art, arrangements decided upon by di Biumo's own keen eye.

164 François Pinault Foundation/
 Palazzo Grassi & Punta della Dogana
 High art with an even higher profile

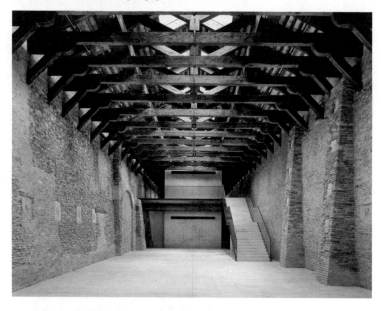

Luxury-goods magnate François Pinault is not only famous in the fashion world, he's also famed in the art world, as the owner of the auction house Christie's and as a collector of contemporary art. Since 2006 the fruits of his passion can be admired in Venice. Here, Pinault commissioned the Japanese architect Tadao Ando, first to modify the Palazzo Grassi and then, in 2009, the historic customs building Punta della Dogana, which is situated at the eastern tip of the Dorsoduro district. In both places he presents his collection in curated temporary exhibitions. Among the artists shown are Martial Raysse, Wade Guyton, Danh Vo, and Philippe Parreno. Pinault's hope is that "his collection can be appreciated by as many people as possible, especially by the younger generation," he says in summing up his mission as a collector. "It opened me up. With a bit of luck, it might change their lives too."

Collector:
François Pinault

Addresses:
Palazzo Grassi
Campo San Samuele 3231
30124 Venice
Italy

Punta della Dogana
Sestiere Dorsoduro 2
30123 Venice
Italy

Tel +39 041 2719031
www.palazzograssi.it

Opening Hours:
Wed–Mon: 10am–7pm

Venice is known the world over for its extraordinary beauty and legendary canals, but in the context of art there is another reason for its fame: the Biennale. Every two years the art world gathers in the Giardini and at the adjacent Arsenale for the oldest and most prestigious art biennial in the world. Founded in 1895, the Venice Biennale has lost none of its appeal and significance. But contemporary art doesn't simply stop here with this big event. The Fondazione Bevilacqua La Masa promotes exhibitions of well-known international artists such as Peter Doig and Sebastião Salgado, and also fosters emerging artists with a residency program. The Fondazione Giorgio Cini, which is committed to the promotion of Italian twentieth-century glass art, also hosts major exhibitions of contemporary art when the Biennale is in town. Furthermore, there is the Fondazione Querini Stampalia, which owns a collection of Old Masters but also integrates current positions into its exhibition program. In 2011, the Venetian art scene was augmented by the addition of Fondazione Prada at Ca' Corner della Regina. Established by fashion designer and art collector Miuccia Prada and her husband Patrizio Bertelli, the foundation has already presented a number of trailblazing exhibitions. In Dorsoduro, another private foundation is set to launch in 2017 next to the Peggy Guggenheim Collection and the exhibition spaces of collector François Pinault. The Moscow-based V-A-C Foundation of Russian collector Leonid Mikhelson is opening its Venice outpost in a palazzo, offering exhibitions in addition to residencies for artists and curators. And even if Venice is not a relevant center for the art market, there are some interesting galleries, such as the Galleria Michela Rizzo, Caterina Tognon, and the historical Galleria Il Capricorno, founded in 1970 by prestigious art dealer Bruna Aickelin—all of which attest to Venice being much more than "just" the Biennale.

Silvia Anna Barrilà

165 Prato d'Arte Collezione Marzona
*Land Art without borders: installations
in the Carnia mountains*

Collector:
Egidio Marzona

Address:
Villa di Verzegnis
33020 Verzegnis
Italy
Tel +39 0433 487779
carnia.musei@cmcarnia.regione.fvg.it

The park is open at all times.

It's a truism that many great ideas are conceived in conversation over a glass of wine with good friends on a midsummer's eve. This was surely the case with Prato d'Arte, a sculpture garden founded in the late 1980s in Verzegnis, a town of 400 residents in northeastern Italy. The two friends were German art dealer Konrad Fischer— an early supporter of American Minimal and Conceptual artists who was responsible for bringing many of them to Europe—and Egidio Marzona, one of the world's most important collectors of Conceptual, Minimal, Land Art, and Arte Povera, who donated a large part of his collection to Berlin's Hamburger Bahnhof museum in 2002. The sprawling Prato d'Arte Collezione Marzona contains thirteen sculptures by the likes of Bruce Nauman, Richard Long, Dan Graham, and Lawrence Weiner, among others, all nestled in the landscape of the mountainous region of Carnia, home to the Marzona family for generations.

166 AMC Collezione Coppola
*A curious collector acquiring art to broaden his
understanding of the world*

Collector:
Antonio Michele Coppola

Address:
Via Zamenhof 615
36100 Vicenza
Italy
Tel +39 0444 913410
info@collezionecoppola.it

Opening Hours:
Mon–Fri: 10am–12pm,
2:30–4:30pm
Sat: by appointment only

Founded in 2008, the AMC Collezione Coppola consists of the private collection of Antonio Michele Coppola, the founder of Italian medical supply firm Biomax. Coppola's significant holdings of works by artists such as Nathalie Djurberg, Nicola Samorì, Marcel Dzama, Neo Rauch, Nina Canell, Ruprecht von Kaufmann, and Uri Aran are representative of the collector's on-going effort to better understand, interpret, and even simply sense the world around him. Figurative painting and installations play the principal roles here. However, video has also made its way into the collection. Coppola credits this addition and others to continual encounters with artists and fellow collectors, which allow his own tastes to grow. He has taken his in-depth support of the artists who make up the AMC collection even further with his publication *Solo*, which is published once or twice annually and showcases the work of one artist in his collection each issue.

J

167 Dream House
*High-quality Asian and international art
in an extravagant building*

A house made by an artist for art: installation artist
Dominique Gonzalez-Foerster designed a colorful, structur-
ally eye-catching house for the collector Daisuke Miyatsu.
In and around the Dream House you'll find works by Asian
and international contemporary artists like Yayoi Kusama,
Yoshitomo Nara, Yang Jun, Lee Kit, or Ólafur Elíasson.
Many of the works were designed particularly for the Dream
House—where the telecommunications employee lives
with his family. Media art is the main focus of this roughly
300-work collection, spanning from Yang Fudong or Cao
Fei & Ou Ning, from China, through American Tony Oursler,
to Nina Fischer & Maroan el Sani from Germany. Works
from the video collection, which began in 1994, are project-
ed upon request.

Collector:
Daisuke Miyatsu

Address:
3-3-17 Wakamiya
Ichikawa
Chiba Prefecture 272-0812
Japan
Fax +81 47 3321141

Visitation permitted only
occasionally. Please inquire
by fax or post.

168 Takahashi Collection
*One of the most important collections of
contemporary Japanese art*

J

Collector:
Ryutaro Takahashi

Address:
Tokyo, Japan
art@takahashiryutaro.com
www.takahashi-collection.com

Visitation permitted only
occasionally. Please inquire
by e-mail.

Psychiatrist Ryutaro Takahashi is regarded as one of the most important collectors of contemporary art in Japan today. It all began in 1997 when he visited an exhibition of the artist Yayoi Kusama in Tokyo, where works from her *Net Paintings* series in particular captured his eye. Since then, Takahashi has concentrated on collecting works mainly by contemporary Japanese artists—in addition to Yayoi Kusama this includes Yoshitomo Nara, Makoto Aida, and Kohei Nawa, and others. He now owns more than 2 500 works that he exhibits at his three clinics in Tokyo. Takahashi says that patients show great interest in the works and ask questions—especially when the hanging is changed. The opening of his own museum is planned for 2019. Until then, you can request to see approximately forty works at his private apartment and studio in Tokyo's Minato-ku district.

Lebanon

169

169 Aïshti Foundation

A leading Lebanese contemporary art collection setting standards in the Middle East

Housed in a David Adjaye-designed shopping center, the Aïshti Foundation is dedicated to the collection of Tony Salamé, luxury retailer and owner of the Aïshti shopping mall empire. Opening to great fanfare in October 2015, it is the most significant collection of contemporary art in Lebanon. Jeffrey Deitch and other respected curators have served as advisors to the collection, helping Salamé assemble over 2 500 artworks within sixteen years. The collection focuses mainly on international contemporary art from the 1960s onwards. Italian avant-garde positions from Piero Manzoni to Lucio Fontana serve as a fulcrum for newer positions from Willem de Rooij to Ryan Sullivan to Tauba Auerbach. Sterling Ruby, Wade Guyton, Seth Price, and Rudolf Stingel round out the list. It is the first time these artists have been presented in Lebanon, and the foundation thus offers Beirut residents unique access to the Western art scene.

Collector:
Tony Salamé

Address:
Aïshti by the Sea
Jal Eld Dib, Seaside road
Beirut
Lebanon
Tel +961 4 717716
www.aishtifoundation.com

Opening Hours:
Wed–Sun: 11am–7pm

Luxembourg

170

L

Collector:
Patrick Majerus

Address:
Luxembourg City, Luxembourg
m@jerus.lu

Visitation permitted only
occasionally. Please inquire
by e-mail.

170 Sammlung Majerus
*Trenchant contemporary concept art with critical
potential*

"Either you're a collector or you're not," says Patrick Majerus,
perhaps the only officer in the Luxembourg army with a
distinct interest in contemporary concept art, primarily
from Berlin. His collection attained international attention
in 2010, when it was shown at the Kunstsaele Berlin. Majerus
collects entire groups of works from just a few select artists
of his generation, convinced that it is more important to col-
lect deeply than broadly. Around thirty artists, mostly bet-
ween the ages of thirty and forty, including Tim Berresheim,
Katja Novitskova, Dominik Sittig, Michael E. Smith, and
Sven Johne, share the walls in Majerus's remodeled private
home, which, as one might guess, does not keep fixed
opening hours. Instead, he likes to personally guide like-
minded art enthusiasts through his collection from time
to time.

Mexico

171, 172

M

171 Fundación Jumex Arte Contemporáneo
*Young Latin American and international
contemporary art at its best*

Viva México! Since the end of 2013, when the Museo Jumex opened in the posh district of Polanco, Mexico City has become even more firmly established on the international art map. With its roof in the shape of a saw blade, this building, designed by British star architect David Chipperfield, his first in Latin America, is already worth a visit. The new headquarters of the largest collection of contemporary Latin American and international art on the continent, with 2 800 works, shows artists such as Francis Alÿs, Damián Ortega, Tacita Dean, or Danh Vo, in addition to international temporary exhibitions that travel to Mexico for the first time. Eugenio López Alonso, a colorful character and the sole heir of Jumex, the country's largest juice company, continues to present parts of his collection at the previous location, at Galería Jumex, on the company's premises outside the city.

Collector:
Eugenio López Alonso

Addresses:
Museum:
Miguel de Cervantes Saavedra 303
Col. Ampliación Granada
Mexico City C.P. 11529
Mexico

Gallery:
Vía Morelos 272
Col. Santa María Tulpetlac
Ecatepec de Morelos C.P. 55400
Mexico

Tel +52 55 57758188
info@fundacionjumex.org
www.fundacionjumex.org

Please check the website
for the most current information
on opening hours.

172 Colección Contemporánea

*A global collection from a seasoned art collector
in Mexico City*

M

Collector:
Gina Diez-Barroso de Franklin

Address:
Avenida Constituyentes 455
Col. América
Mexico City C.P. 11820
Mexico
www.coleccioncontemporanea.com

Opening Hours:
Mon–Sat 10am–5pm

Colección Contemporánea is the newest addition to the growing private museum scene in Mexico City. The collector and entrepreneur Gina Diez-Barroso de Franklin opened her space to the public in late 2015, with a dual focus on art and design. Half of the museum houses Diez-Barroso's private collection, featuring artists including Robert Indiana, Lu Shengzhong, Liu Bolin, Marcus Lyon, and Iván Navarro; the other half hosts temporary exhibitions. The program features collaborations with, among others, Bard College, New York, as well as private galleries. Coming from a family of art collectors—Diego Rivera painted one of his *Calla Lilies* works for her mother—she has a long association with the Mexican art scene. In 2004, Diez-Barroso founded Centro, the first university in Mexico for art media and design, and the museum reflects this interdisciplinary approach.

179, 180
176
174, 175

Netherlands

177

178

173

181

N

173 Collectors House
Cooperation between international collectors and a city museum

"Strength in unity," goes the saying. This is also the principle of the Collectors House, in Heerlen, a collaboration between the municipal museum Schunck, the Dutch collector Albert Groot, and several international collectors. Their shared goal is to show works of contemporary art that are otherwise rarely seen in public. The exhibitions at the Collectors House bring together works currently residing in different locations—in the Netherlands, Hong Kong, or Romania—and places them in a constructive dialogue with each other. Among the artists shown have been Marina Abramović, Mircea Cantor, Hans Op de Beeck, and Cao Fei. At a time when culture and museums are experiencing drastic cutbacks, initiatives that combine public and private certainly offer an alternative solution.

Collector:
Albert Groot

Address:
Raadhuisplein 19
6411 HK Heerlen
Netherlands
Tel +31 45 5711525
info@collectorshouse.eu
www.collectorshouse.eu

Opening Hours:
Thurs–Sun: 1–5pm

174 Concordia Collection
*Local and international artists in a historic house
in Rotterdam*

Collector:
Julian Oggel

Address:
Westersingel 103
3015 LD Rotterdam
Netherlands
Tel +31 10 2409715
Mob +31 653 771561
julian.oggel@xs4all.nl

By e-mail appointment only.

On one of the most beautiful streets of Rotterdam, between the lively Witte de Withstraat and the Museum Boijmans Van Beuningen, sits the home of Julian Oggel, a lawyer and the CEO of an investment firm. The house itself is worth a visit: built in 1904, it is one of the few buildings to have survived the destruction of World War II. Oggel's collection, which he has been amassing since 2002, is eclectic and yet retains a strong connection to the city. This has much to do with the presence of local artists like Ron van der Ende and Marin de Jong, and of international artists who have produced work while here, such as Keith Haring and Ivan Chermayeff. Oggel has a preference for Pop Art but also owns works of Hyperrealism and Conceptual Art. In the neighboring townhouse he rents luxury apartments—furnishing these with works from his collection upon request.

N

175 Alexander Ramselaar Collection
*A townhouse of young talent from Rotterdam,
the Netherlands, and around the world*

Collector:
Alexander Ramselaar

Address:
Mathenesserplein 97
3023 LA Rotterdam
Netherlands
office@backinggrounds.com
www.alexander-ramselaar.com

Visitation permitted only
occasionally. Please inquire
by e-mail.

Rotterdam collector Alexander Ramselaar discovered his first artwork in a gallery on the way to work. He was immediately transfixed. After a longer period of collecting modern design, the real estate specialist, who now advises arts and cultural institutions, began to shift his focus toward contemporary art. In his unique 1920s penthouse, the hospitable collector presents art in the dining room and bedroom, in the stairwell, and even in the bathroom. Ramselaar, an avid traveler, first collected work from the Rotterdam art scene and now does so internationally: Diango Hernandez, Rossella Biscotti, Giorgio Andreotta Calò, Pieter Hugo, Guy Tillim, James Beckett, or Michael Bauer are just some of the artists in his collection. Moreover, after becoming frustrated by the massive cuts in the Dutch cultural budget, Ramselaar and a few other collectors established the Foundation C.O.C.A. to support young artists.

176 Museum Beelden aan Zee
*Modern and contemporary sculpture nestled
in the Netherlands' pristine dunes*

The Museum Beelden aan Zee is camouflaged so perfectly,
you almost walk right past it. Located in the middle of
sand dunes in the swanky seaside resort of Scheveningen,
the entrance to the most important collection of sculp-
tures in the Netherlands hides behind an exposed concrete
façade. Though highly frequented tourist attractions—the
spa hotel, the pier, or the casino—are right around the
corner, the inside of the house that opened in 1994 is quiet.
Under the leitmotif "man—the human image," Theo and
Lida Scholten began in 1966 to bring together more than
1 000 sculptures from all major art centers around the
world. The spectrum ranges from Armando to Marc
Quinn, all the way to Berlinde De Bruyckere. Every year
three to four thematic and monographic exhibitions are
curated from the collection.

Collectors:
Theo & Lida Scholten

Address:
Harteveltstraat 1
2586 EL The Hague/Scheveningen
Netherlands
info@beeldenaanzee.nl
www.beeldenaanzee.nl

Opening Hours:
Tues–Sun: 11am–5pm

N

177 De Pont Museum
*Masterpieces of contemporary art in the
spacious halls of a former wool mill*

Berlinde De Bruyckere, Roni Horn, Anri Sala, Fiona Tan,
Rosemarie Trockel, Luc Tuymans, and Mark Wallinger—
the Tilburg-based collection of the De Pont Museum, in
the southern Netherlands, is remarkable. Since opening
its doors in 1992 around 700 works by international con-
temporary artists have come together to be presented in
a 6 000-square-meter space. Benthem Crouwel Architects,
from Amsterdam, renovated a wool mill from the 1930s so
sensitively that one can still feel the industrial character of
the building. The construction was made possible by Jan de
Pont (1915–1987), a Tilburg businessman, who provided a
large part of his estate for the promotion of contemporary
art. In summer 2016, a new wing for film, video art, and
photography was opened. At the same time the entrance
underwent a gentle facelift.

Collector:
Jan de Pont

Address:
Wilhelminapark 1
5041 EA Tilburg
Netherlands
Tel +31 13 5438300
www.depont.nl

Opening Hours:
Tues–Sun: 11am–5pm

It can be difficult to acquire works by promising and in-demand artists in galleries, particularly if gallery owners prefer to place them exclusively in prestigious collections. Auctions, however, are a more democratic affair: anyone—with sufficient financial means—can bid. Typically, works are offered that have one or more previous owners, which means the secondary market is not necessarily the place to discover new artists. This is the task usually reserved for galleries, which often develop the careers of their protégés over long periods. But if and when a certain price level and corresponding popularity are attained, auction houses enter the picture, taking on the works of these artists and increasing their value. Phillips, an auction house specializing in contemporary art, regularly brings new names into the game. At Christie's, young artists are introduced to the auction market in First Open auctions. These have been held in New York and London since 2014, but also online. Similarly, Sotheby's has introduced promising talents for several years under the auction title Contemporary Curated. If the hammer price far exceeds the estimate in the catalogue, or if demand is very high, these artists might also appear in the high-priced and media-intensive evening sales. But auction houses have become more wary of creating short-term price bubbles for young shooting stars, whose price levels can heat up too quickly in the auction room, as was the case a few years ago with Jacob Kassay, Lucien Smith, or Christian Rosa. Investing in young artists whose prices have rapidly crossed the 100 000-dollar mark with an eye to future returns is a risky financial endeavor. It is difficult to predict whether an artist will have the power and potential to build a compelling body of work in the decades ahead and to remain a permanent presence in the public eye.

Anne Reimers

178 Museum van Bommel van Dam
*An enthusiastic Dutch couple and
their personalized collection*

N

Collectors:
Maarten & Reina
van Bommel van Dam

Address:
Deken van Oppensingel 6
5911 AD Venlo
Netherlands
Tel +31 77 3513457
info@vanbommelvandam.nl
www.vanbommelvandam.nl

Opening Hours:
Tues–Sun: 11am–5pm

Maarten van Bommel acquired his first artwork at the age
of sixteen. Later, as a stock trader, he continued growing
his collection. He and his wife, Reina van Dam, both now
deceased, began collecting together in 1944, but some-
what unsystematically: abstract Dutch paintings of the
Informel and CoBrA, but also African masks and Japa-
nese woodcuts. After searching extensively for an ideal
location to house their 1 000 works, a solution was found
in 1969 in the city of Venlo: a museum for their art and,
next door, a residential bungalow. A connecting door al-
lowed them to move freely between the two. Over the years,
other collectors have added to the collection, and under
the current director, Rick Vercauteren, it has become more
contemporary and international.

179 KRC Collection
*Dutch and international artists with
a critical-political approach*

Curiosity aroused Rattan Chadha's enthusiasm for con-
temporary art. In the mid-1980s, he came across one of
Andy Warhol's *Campbell's Soup* paintings and was shocked
at the price: 50 000 dollars for an image of soup cans?
Chadha wanted to understand the valuation, so for six
months he studied Warhol. He became convinced of
Warhol's artistic strategy, and bought the work. Born in
India in 1949, the entrepreneur had founded—and then
sold—the fashion label Mexx. His collection, one of the lar-
gest in the Netherlands, is located in an expansive, modern
space behind the historic façade of an old silver factory
near Leiden. It includes works by Candice Breitz, Thomas
Hirschhorn, Erik van Lieshout, and Marc Bijl—all artists
who have taken a critical stance towards contemporary
politics and society.

Collector:
Rattan Chadha

Address:
Voorschoten, Netherlands
info@krccapital.com
www.krccollection.com

Visitation permitted only
occasionally. Please inquire
by e-mail.

N

180 Museum Voorlinden
*A light-flooded private museum
in perfect harmony with nature*

The industrialist Joop van Caldenborgh, who acquired his
first work of art as a teenager, is considered one of the most
important art collectors in the Netherlands. Since 1995,
countless visitors have toured his impressive sculpture
garden on the estate of Clingenbosch, which includes ma-
jor works by Anish Kapoor, Sylvie Fleury, Sol LeWitt, and
Antony Gormley. From late 2016, the recently opened
Museum Voorlinden, a 4 000-square-meter exhibition space,
has served as the main attraction. Located on the neighbor-
ing forty-hectare estate of Voorlinden in Wassenaar, near
The Hague, the museum is home to the extensive collec-
tion of paintings, photography, video art, and installations.
Among the new attractions are a monumental steel sculp-
ture by Richard Serra, a *Skyspace* by James Turrell, and
a work by the Argentine Leandro Erlich. The museum's
floor-to-ceiling windows foster a harmonious coexistence
between exhibition space and landscape.

Collector:
Joop N.A. van Caldenborgh

Address:
Buurtweg 90
2244 AG Wassenaar
Netherlands
Tel +31 70 5121660
info@voorlinden.nl
www.voorlinden.nl

Guided tours of the sculpture
garden each Thursday from
May to October. Please check
the website to book your visit.

181 Bonnefanten Hedge House Foundation
Art from the 1960s to the present in a modern pavilion

N

Collectors:
Jo & Marlies Eyck

Address:
Kasteel Wijlreweg 1
6321 PP Wijlre
Netherlands
Tel +31 43 4502616
info@hedgehouse.eu
www.hedgehouse.eu

Opening Hours:
Thurs–Sun: 11am–5pm
And by appointment.

Over the past few decades, the collectors Marlies and Jo Eyck have turned their castle Wijlre, in Limburg, which they acquired in 1981, into a *Gesamtkunstwerk*. The owners of a paint wholesale company began collecting abstract painting in the late 1960s. Over time they added other kinds of art. Today, their collection includes artists from Donald Judd and René Daniëls to Marlene Dumas. Sculptural works, mainly site-specific, can be found in the palace garden, such as a fallen tree by Giuseppe Penone. In 1999 the architect Wiel Arets designed a modern exhibition-pavilion of concrete, glass, and steel called The Hedge House. In 2012, the Eycks entrusted the castle, the gardens, and the pavilion to the Bonnefantenmuseum in Maastricht, which organizes two annual exhibitions in the idyllic castle and guarantees the collection's endurance into the future.

182

New Zealand

N

182 Gibbs Farm
*A sculpture park in XXL-format with monumental art
in the grandness of nature*

It's as if giants had dropped their toys on green grass hills. At the Gibbs Farm sculpture park, opened in 1991, on the coast of New Zealand, art and nature correspond in a way that emphasizes the monumentality of both. Since the 1960s, entrepreneur Alan Gibbs has collected works by Richard Serra, Sol LeWitt, Andy Goldsworthy, George Rickey, and Daniel Buren—all artists known for grand outdoor gestures. But even art aficionados are amazed by the dimensions of these site-specific sculptures, some of which extend—in the case of Goldsworthy's Arches—into the water. It's not surprising that the park has become a visitor magnet. If you're looking to be one of them, however, book a tour as early as possible: Gibbs Farm is open to the public only one day a month.

Collector:
Alan Gibbs

Address:
Kaipara Harbour
North Auckland Peninsula
New Zealand
info@gibbsfarm.org.nz
www.gibbsfarm.org.nz

By appointment only.
Please inquire via website.

Norway

183

185
184 ● ── 186, 187

N

183 KaviarFactory
Contemporary art projects on an island
off the northern Norwegian coast

Collectors:
Venke & Rolf A. Hoff

Address:
Henningsværveien 13
8312 Henningsvær
Norway
Tel +47 907 34743
contact@kaviarfactory.com
www.kaviarfactory.com

Opening Hours:
Mon–Sun: 10am–6pm
And by appointment.

This exhibition space is as close to the Arctic Circle as it could be. In the summer of 2013, the Norwegian art collectors Venke and Rolf A. Hoff opened their art space in a former caviar factory on the Lofoten Islands. The KaviarFactory is located in the picturesque fishing village of Henningsvær, the gateway to the northern archipelago. The charming building was renovated by the Norwegian architecture firm Element. "Many international artists have visited us here," says Rolf A. Hoff, enthusiastically. "They all love this place and want to come back." Equally popular is their Lighthouse, which the Hoffs offer as guest quarters. The collectors own works by Norwegian and international artists such as Bjarne Melgaard, Marguerite Humeau, Paulo Nimer Pjota, Katherine Bernhardt, or Jack Goldstein, and they invite artists from all over the world to realize exhibitions in the 500-square-meter former factory.

184 Henie Onstad Kunstsenter (HOK)
Modern art and exhibitions with contemporary artists in spectacular architecture

Sonja Henie (1912–1969) is considered one of the most successful figure skaters in history. Together with her husband, Niels Onstad, a ship owner and art patron, she amassed a collection of modern art. In 1968 they opened the Henie Onstad Kunstsenter (HOK), high over the Oslo Fjord, south of the capital city. Norwegians Jon Eikvar and Sven Erik Engebretsen won the architectural competition, and erected a spectacular neo-expressionist structure that meshes nicely with the surrounding landscape. The building was extended in 1994, and again in 2003, and is now complemented by a sculpture park featuring works by Per Kirkeby and Tony Cragg, among others. Spread across 3 500 square meters, the HOK offers highlights of its collection, from Henri Matisse through Hans Hartung to Fernand Léger, as well as temporary exhibitions with contemporaries such as Ilya Kabakov, Omer Fast, or Olav Christopher Jenssen.

Collectors:
Sonja Henie & Niels Onstad

Address:
Sonja Henie vei 31
1311 Høvikodden
Norway
Tel +47 67 804880
post@hok.no
www.hok.no

Opening Hours:
Tues–Thurs: 11am–7pm
Fri–Sun: 11am–5pm

N

185 Kistefos-Museet
Prime public art in the Norwegian woodlands

The roughly 4000-inhabitant-strong Oppland municipality of Jevnaker is certainly not on the shortlist of art world hotspots. But for lovers of large-scale sculpture and the great outdoors, Christen Sveaas's Kistefos park stands out. The largest publicly accessible sculpture park in all of Scandinavia, Kistefos currently features thirty-two artworks, by the likes of Marc Quinn, Elmgreen & Dragset, and Jeppe Hein. The park is part of the Kistefos-Museet, which investor and industrialist Sveaas founded in 1996 to commemorate the sawmill built by his grandfather on the Randselva River in 1889. The Industrial Museum now occupies that building, with the sculptures spread across the vast, pristine grounds. Open to the public twenty-four hours a day, 365 days a year, the works, from Ólafur Elíasson's *Viewing Machine*, which looks out over the river, to Anish Kapoor's *S-Curve*, make Kistefos well worth the hour's trip north from Oslo.

Collector:
Christen Sveaas

Address:
Samsmoveien 41
3520 Jevnaker
Norway
Tel +47 61 310383
post@kistefos.museum.no
www.kistefos.museum.no

The park is open at all times.

186 Astrup Fearnley Museet
Major works of contemporary art in a new Renzo Piano building on a fjord

Collector:
Hans Rasmus Astrup

Address:
Strandpromenaden 2
0252 Oslo
Norway
Tel +47 22 936060
info@fearnleys.no
www.afmuseet.no

Opening Hours:
Tues, Wed, Fri: 12–5pm
Thurs: 12–7pm
Sat–Sun: 11am–5pm

Norwegians seldom complain about strained finances. Oil and gas resources supply an influx of capital, and Oslo has become the most expensive city in the world. Perhaps this is why private museums are somewhat more grandiose in Norway than elsewhere, a fact perfectly illustrated by the brand new building of the Astrup Fearnley Museum, which was founded in 1993. Ship owner and collector Hans Rasmus Astrup commissioned none other than Italian architect Renzo Piano, still one of the most in-demand architects in the world. A 4 000-square-meter exhibition space, built in 2012, reflects maritime flair in glass, steel, and wood in an exposed location on a fjord, housing series of works by well-known, blue-chip artists such as Francis Bacon, Anselm Kiefer, Jeff Koons, Takashi Murakami, and Cindy Sherman. The collectors are also interested in young Norwegian art and, more recently, in newcomers from Asia and Latin America.

N

187 Ekebergparken—
Collection Christian Ringnes
A three-kilometer-long sculpture trail with a harbor view

Collector:
Christian Ringnes

Address:
Kongsveien 23
0193 Oslo
Norway
Tel +47 21 421919
info@ekebergparken.com
www.ekebergparken.com

The park is open at all times.

In the hills framing the Norwegian capital of Oslo an enchanting sculpture park is hidden among the trees. The Ekebergparken—pictured in the background in Edvard Munch's famous painting *The Scream*—is an eighteenth-century public park featuring remains from the Stone, Bronze, and Viking Ages. Since September 2013, visitors have been able to encounter more than thirty sculptures, by artists from Aristide Maillol to Tony Cragg and Lynn Chadwick. The transformation of this previously neglected park is the brainchild of the collector Christian Ringnes, whose foundation lent the artworks to the city after Oslo declined a donation. The art here enters a fascinating dialogue with nature: an aluminum sculpture by Louise Bourgeois floats between trees, and bronze muses, lost in thought, by Guy Buseyne and Salvador Dalí, are located between a pavilion by Dan Graham and installations by James Turrell and Jenny Holzer.

Poland

188

189

188 Art Stations Foundation
Polish and international art trends
in a consumer temple

P

Art and business are often seen as separate things. But this
isn't the case for Polish businesswoman Grażyna Kulczyk,
who says, "I have always known that I would not be satis-
fied by being an entrepreneur by day, and a collector
'after-hours.' So I married the two, adopting a fifty-fifty
philosophy." To this end, Kulczyk turned an old brewery,
the Stary Browar in Poznan, into a complex comprising
a shopping mall and an exhibition hall: the Galeria Art
Stations. Her collection boasts more than 400 works,
including pieces by key Polish artists of the twentieth cen-
tury, like Jacek Malczewski and Tadeusz Kantor; interna-
tional names like Victor Vasarely and Sam Francis; and a
smattering of contemporary photography. Kulczyk is also
fascinated by artists who explore the coexistence of art,
science, and technology, as seen in works by Ólafur Elíasson
or Loris Gréaud.

Collector:
Grażyna Kulczyk

Address:
Półwiejska 42
61-888 Poznań
Poland
Tel +48 61 8596122
office@artstationsfoundation5050.com
www.artstationsfoundation5050.com

Opening Hours:
Mon–Sun: 12–7pm

Warsaw has two versions of an institution named Foksal. Galeria Foksal was initiated by artists and critics in 1966. Located in an annex to Zamoyski Palace, a protected historic landmark, the non-commercial art center features a program still organized by artists today. Established Polish positions are presented as well as international artists such as Andrea Fraser or Anselm Kiefer. The Foksal Gallery Foundation (FGF) developed out of this in 1997. Since 2001, however, both ventures have gone their separate ways. The FGF has contributed significantly to the global boom of Polish contemporary art, with artists like Monika Sosnowska or Piotr Uklański, and the 1960s-era rationalist building it calls home, with its new façade designed by Swiss architects Diener & Diener in 2015, is even a must for visitors. But Warsaw, a metropolis enlivened by increasing amounts of color in recent years, still has plenty more to offer art enthusiasts. The Museum of Modern Art in Warsaw is located just behind the FGF, and while this may still only be a temporary solution, New York architect Thomas Phifer has already secured the commission for a new building. Other highlights are the Zachęta—National Gallery of Art, founded in 1860, which today often presents socially critical exhibitions showcasing international artists, and the Centre for Contemporary Art Ujazdowski Castle (CCA), a space fully committed to interdisciplinary, experimental exhibition formats and building an international network. Even the delightful castle gardens invite you to linger a while longer. Also worth planning is a visit to Raster Gallery, founded in the city center by two art critics in 2001. It represents important Polish artists such as Wilhelm Sasnal and Marcin Maciejowski, but also the artist collective Slavs and Tatars, made up of primarily anonymous members. Anyone traveling to Warsaw in the summer should not miss taking in the Chopin concert series in Łazienki Park. The lively social affairs are held on Sundays around the monument to the great composer and master pianist.

Nicole Büsing & Heiko Klaas

189 Michał Borowik Collection
*Young Polish art melding aesthetics
and content*

Collector:
Michał Borowik

Address:
Warsaw, Poland
contact@borowikcollection.com
www.borowikcollection.com

By appointment only.

"I collect artworks by young Polish artists in a variety of **P** media. It gives me great pleasure to live with objects that reflect our times." This is how Michał Borowik describes his approach. When he chooses a piece to include in his discerning collection, he does so with an eye toward artworks that inject aesthetics with meaning. "I really dislike empty shells," he says, insisting at the same time that the artist's medium fit that message. This attitude has earned Borowik a place on the list of the world's fifty most interesting collections assembled by people under fifty years old, a list drawn up by American magazine *Modern Painters* in 2011. Among other artists, Michał Gayer, Magdalena Starska, and Michał Smandek are some of the young Polish artists one finds in Borowik's stunning assembly.

Portugal

190, 191 —

190 Museu Colecção Berardo
*One of Portugal's largest private collections
in a public art center*

P

Think big! José Berardo has achieved a lot. The son of farm workers, he had to leave school at age thirteen to work as an unskilled vineyard laborer. At age eighteen he immigrated to South Africa, and what followed was the ascent from fruit picker to owner of gold and diamond mines. Berardo went back to Portugal in 1986 and began his rule over a multinational consortium of companies. His museum-quality and thoroughgoing art collection mirrors his entrepreneurial self-confidence. From Cubism to the Becher School, nearly every art movement is represented. Special attention is paid to Portuguese artists like Helena Almeida or Pedro Cabrita Reis. Since 2007 the roughly 900 works are permanently exhibited at the Centro Cultural de Belém.

Collector:
José Berardo

Address:
Praça do Império
1449-003 Lisbon
Portugal
Tel +351 213 612878
museuberardo@museuberardo.pt
www.museuberardo.pt

Opening Hours:
Mon–Sun: 10am–7pm

191 FLR—Fundação Leal Rios
*Portuguese and international art in a former
auto repair shop*

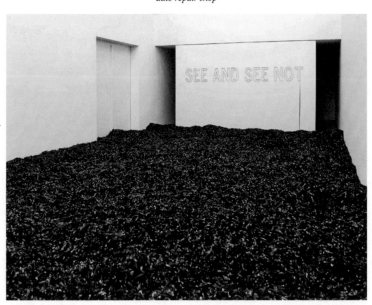

Collectors:
Manuel & Miguel Leal Rios

Address:
R. Centro Cultural, 17 B
1700-106 Lisbon
Portugal
Tel +351 210 998623
www.lealriosfoundation.com

Opening Hours:
Thurs–Sat 2:30–6:30pm
And by appointment
Closed on public holidays.

P

Portuguese brothers Manuel and Miguel Leal Rios think of art as "a visionary, global language." The two have devoted themselves to building an art collection together since 2002, with designer Miguel Leal Rios serving as the curator for the collection, which has been open to the public from 2012. Located south of the Lisbon airport, the roughly 1 000-square-meter former auto repair shop has enough space to present works of all genres in temporary, themed exhibitions. Known for his clear, formal language, architect Alexandre Marques Pereira converted the premises into a multifunctional white cube. In addition to national artists like Helena Almeida—the pioneer of Portuguese photographic and Conceptual Art who was born in 1934—the brothers' collection includes recognized names such as Erwin Wurm, David Maljković, or Lawrence Weiner. Besides visual art, exhibitions are also regularly devoted to design.

Qatar

192

192 Mathaf—Arab Museum of Modern Art
A royal collection spanning 200 years of Arab art

The Art Newspaper once reported that Qatar is the world's biggest art buyer and has initiated some of the most important purchases of modern and contemporary art over the last few decades. Indeed Qatar's royal family has played an active role in acquisitions, with the aim of building a top-class collection for Qatar's growing network of museums. The latest of them is Mathaf, which is dedicated solely to Arab art. It opened in December 2010 thanks to the commitment of the Emir's son, Sheikh Hassan bin Mohammed bin Ali Al Thani, and thanks to the support of museum officials. The Sheikh began collecting in the 1980s and has amassed some 6 000 works, including pieces by artists throughout the Middle East, North Africa, and the Arab Diaspora, from 1840 to today.

Collector:
Sheikh Hassan bin Mohammed bin Ali Al Thani

Address:
Education City Student Center
Al-Luqta Street
Doha
Qatar
Tel +974 4402 8855
mathaf_info@qma.org.qa
www.mathaf.org.qa

Opening Hours:
Tues–Thurs: 11am–6pm
Fri: 3–8pm
Sat–Sun: 11am–6pm

Romania

194

193

Collector:
Roger Akoury

Address:
Bucharest, Romania
Tel +40 744763858
office@mare.ro
www.mare.ro

By appointment only.

193 MARe—Muzeul de Arta Recenta
A Bucharesti collection featuring the first comprehensive survey of Romanian postwar art

MARe, the Museum of Recent Art, is the outcome of a discussion between collector Roger Akoury and art critic and curator Erwin Kessler. The concept was to trace the trajectory of Romanian art from the 1960s through today. The **R** collection now includes 300 works by seventy prominent Romanian artists. It also features Romanian modernism and avant-garde works by artists such as Victor Brauner and Daniel Spoerri, and contemporary Romanian positions such as Miklos Onucsan, Dan Perjovschi, and Victor Man, among others. The museum fills an art-historical blind spot by providing the first comprehensive overview of recent Romanian painting, sculpture, installation, and photography. Currently, the collection can be seen by appointment in a warehouse in Bucharest, but, starting in mid-2017, MARe's new home will open its doors to the public with a program of temporary exhibitions.

194 The Ovidiu Şandor Collection
*A Romanian collector fostering a contemporary art
community in his hometown*

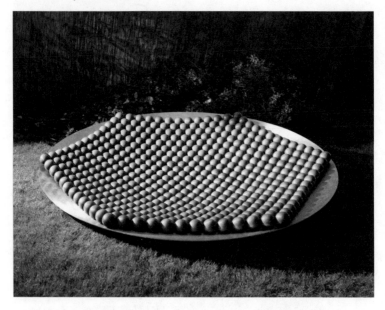

It all began with an interest in antique maps. Now some twenty years later, Ovidiu Şandor's collection includes more than 300 works of Romanian contemporary art. Şandor started his collection by purchasing modern art from his home country, but soon a passion for younger artists took hold—in step with growing acclaim for artists of the so-called Cluj School. Key figures of that movement, such as Adrian Ghenie, Victor Man, Mircea Cantor, and Ciprian Mureşan all feature prominently in Şandor's collection. Additionally, he has made a particular effort to collect works by older figures from Romania who have been rediscovered in recent years, from Geta Brătescu and Ana Lupaş to artists of the Sigma Group—Ştefan Bertalan and Doru Tulcan among them—which was founded in Şandor's hometown Timişoara. The collector also launched the Art Encounters Foundation, which organized its first biennial in October 2015.

Collector:
Ovidiu Şandor

Address:
Timişoara, Romania
contact@artencounters.ro

Visitation permitted only occasionally. Please inquire by email.

R

197

Russia

195, 196

195 The Ekaterina Cultural Foundation
*Russian and international contemporary art
in a pioneering private museum*

Collectors:
Ekaterina & Vladimir Semenikhin

Address:
Kuznetsky Most, 21/5
107996 Moscow
Russia
Tel +7 495 6215522
info@ekaterina-foundation.ru
www.ekaterina-fondation.ru

Opening Hours:
Tues–Sun: 11am–8pm

Ekaterina and Vladimir Semenikhin were among the first
Russian collectors to open their collection to the public. In
the catalogue to their first exhibition, in 2007, the couple
wrote: "Those mysterious private collections that were
treated with suspicion by both the state and society dur-
ing Soviet times are now gradually stepping out of the
shadows." The Semenikhins have been collecting inter-
national contemporary works since 2003, but they were
such early supporters of the post-Soviet avant garde that
the *Financial Times* deemed them "pioneers among Russian
private collectors" and "the unofficial patron saints of
Russia's contemporary arts scene." The Ekaterina Cultural
Foundation consists of 800 works of Russian art, from Ivan
Shishkin to Komar & Melamid to Dubossarsky & Vinogradov.

R

196 Stella Art Foundation
An exhibition space for contemporary Russian art

Since opening her gallery in 2003, Stella Kesaeva, art collector and wife of the billionaire Igor Kesaev, has become an influential player on the Russian art scene. She was appointed commissioner for the 2011, 2013, and 2015 Russian Pavilions at the Venice Biennale, and in Moscow she runs a private space with works from her personal collection and elsewhere. The Stella Art Foundation consists of approximately 800 pieces, mainly by contemporary Russian artists like Ilya Kabakov, Andrei Monastyrski, Yuri Albert, and Oleg Kulik. But it also has some famed international talents: Andy Warhol, Bill Viola, and Robert Mapplethorpe. Kesaevas's plans to build an art museum in a former bus depot in Moscow were foiled by bureaucratic hurdles.

Collector:
Stella Kesaeva

Address:
Skaryatinsky Pereulok, 7
121069 Moscow
Russia
Tel +7 495 6913407
info@safmuseum.org
www.safmuseum.org

Opening Hours:
Tues–Sun: 12–7pm

197 Novy Muzei
*Soviet nonconformist art: the only alternative
to Socialist Realism*

R

If you think the only art movement in Russia before the end of the Soviet era was Socialist Realism, you should visit the Novy Muzei in Saint Petersburg. It holds Aslan Chekhoyev's collection of the unofficial movements of Russian modern art from the postwar era to the end of the twentieth century. After Josef Stalin died in 1953, there was an underground wave of liberalization in the arts in Russia, and artists began experimenting, even if they could not exhibit. One famous episode of state repression of unsanctioned art was in 1974, when police broke up a show with a bulldozer and water cannons. Chekhoyev's collection is an important effort to direct public attention to works by artists like Lydia Masterkova, Lev Kropivnitsky, and Vladimir Nemukhin. Figures in their contemporary collection are artists like Oleg Kulik and the AES+F group, among others.

Collector:
Aslan Chekhoyev

Address:
6-ya Liniya, 29
199004 St. Petersburg
Russia
Tel +7 812 3235090
info@novymuseum.ru
www.novymuseum.ru

Opening Hours:
Thurs–Sun: 12–7pm

Despite of the omnipresent threat of censorship, Moscow has developed a vibrant contemporary art scene, thanks primarily to the support of Russian business tycoons and private collectors. The city's premier art center is the Garage Museum of Contemporary Art, founded in 2008, by collector Daria Zhukova. Named after its first location, a former bus depot built in 1926, the institution moved into its permanent domicile in Gorki Park in 2015: a former 1960s-era restaurant extensively renovated and expanded by Rem Koolhaas. Another active institution is the V-A-C Foundation, established in 2009 by businessman Leonid Mikhelson, who aims to integrate Russian contemporary art into national and international discourse. Plans for new exhibition spaces are already underway: Renzo Piano is transforming a former power station on the Moskva into a museum. Other patrons of the arts are Russian collectors Vladimir Smirnov and Konstantine Sorokin, who, since 2011, have made studios available to young artists in a former factory building south of Gorki Park. Among the most important state-owned institutions are the Moscow Museum of Modern Art (MMOMA) and the National Centre for Contemporary Arts (NCCA), an exhibition and research institute focusing on the twenty-first century. Since 2008, the MMOMA and the NCCA have been organizing the Moscow International Biennale for Young Art, which is dedicated to a younger generation of artists. Russia's largest biennial, the Moscow Biennale of Contemporary Art, takes place in September, alongside Cosmoscow. Another hub for the art scene is the Winzavod Centre for Contemporary Art, a former nineteenth-century wine making facility, where the 11.12 Gallery, Regina Gallery, Pechersky Gallery, and artists' studios are housed. Other locations worth visiting for contemporary art around the city are the well-established Triumph Gallery as well as Artwin Gallery, one of the newest additions.

Silvia Anna Barrilà

198 Serbia

Serbia

198 Kolekcija Trajković
A survey of postwar Serbian art in a private Belgrade apartment

Collectors:
Slavica & Daniel Trajković

Address:
Palmoti eva 33
11000 Belgrade
Serbia
+38 163218100
office@kolekcijatrajkovic.com
www.kolekcijatrajkovic.com

By e-mail appointment only.

Slavica and Daniel Trajković's collection focuses exclusively on Serbian art, spanning the postwar period through the present day. Housed in their home, a light, spacious nineteenth-century apartment in central Belgrade, the collection includes more than 1 000 works by over 150 artists. It ranges from paintings to works on paper to video, providing an impressive overview of Serbian art from the Communist period under Tito through today. Of special interest is their collection of Serbian radical art and its documentation through posters, catalogues, and letters. The Trajkovićs regularly lend works to local and international museums, and also established an eponymous foundation in 2010, dedicated to the preservation and promotion of their collection and to fostering discourse around artistic practices. The collectors have their sights firmly set on creating a wider, international audience for Serbian art.

S

Singapore

199

199 The Private Museum
A collector's room—also for other collectors

The architect and real estate developer Daniel Teo began
to collect art in the 1990s. His collecting intensified after
1994, when he teamed up with the Swede Björn Wetterling
to open the Wetterling Teo Gallery in Singapore, one of
the first international art galleries in Southeast Asia. Teo
is particularly interested in Pop Art; the first work he ac-
quired was by James Rosenquist. He also collects ink paint-
ings and works by local artists. Alongside images by Roy
Lichtenstein, Jim Dine, and Tom Wesselmann are those
by Lim Tze Peng, Chua Ek Kay, and Kumari Nahappan. In
2008 he opened The Private Museum, where he exhibits his
own collection—and that of fellow collectors. "I have met
many collectors," Teo says, "and I would like to encourage
more collectors to step forward to showcase their collec-
tions. It is an important way to establish relationships be-
tween artists, collectors, and the public."

S

Collector:
Daniel Teo

Address:
51 Waterloo Street, #02-06
Singapore 187969
Singapore
Tel +65 6738 2872
mail@theprivatemuseum.org
www.theprivatemuseum.org

Opening Hours:
Mon–Fri: 10am–7pm
Sat–Sun: 11am–5pm
And by appointment.

South Africa

201

200 — *202*

200 The New Church Museum
Contemporary African art as a mirror of society

Collector:
New Church Foundation

Address:
102 New Church Street
Tamboerskloof, Cape Town
South Africa
info@thenewchurch.co
www.thenewchurch.co

Opening Hours:
Tues, Thurs: 12–3pm
Sat: 11am–3pm

The name "The New Church" does not refer to a church as exhibition space but rather to the street on which the museum is located. What is church-like, however, is the museum's strong commitment to social issues: according to its founding idea, the institution is inspired by "art's ability to facilitate the examination of society's values and norms, and believes that this has tremendous social benefit." The New Church Museum comprises a collection of about 450 works of contemporary African art. Among them are works by renowned representatives such as Meschac Gaba, Willem Boshoff, and Pieter Hugo. Two to three times per year, guest curators work with the collection, occasionally bringing external loans into dialogue. The museum is housed in a converted Victorian house, which has been renovated to include a minimalistic exhibition space at the rear.

201 The Hess Art Collection, Glen Carlou
Contemporary art for all and references to historical and present-day Africa

Whether at his vineyards in California's Napa Valley, in the Argentine Andes, or in the South African Cape Town region, cosmopolitan art-and-wine lover Donald M. Hess fuses his passion for wine, contemporary art, and art education. "I truly believe contemporary art should be made available to the widest possible audience," Hess says, "and that collectors have a responsibility to make their collections accessible to the public to the best of their ability." Everyone is welcome. No entrance fee. At his vineyard Glen Carlou, in Klapmuts, not far from Cape Town, Hess features work by talents like the British artist Andy Goldsworthy, the South African Deryck Healey, and the Ivory Coast-born painter Ouattara Watts, who lives in New York City. Hess's collection of contemporary art reflects the rich cultural heritage of Africa.

Collector:
Donald M. Hess

Address:
Simondium Road
Klapmuts 7625
South Africa
Tel +27 21 8755528
welcome@glencarlou.co.za
www.glencarlou.co.za

Opening Hours:
Mon–Fri: 8:30am–5pm
Sat–Sun: 10am–3pm

Additional exhibition locations:
Salta, Argentina, p. 013
Napa, United States of America, p. 224

202 Rupert Museum
South African art highlights since 1940 in a region known for its wine

S

A fire at their private home prompted collectors Huberte and Anton Rupert to build a museum for their extensive art collection. They found the right partner in Hannes Meiring, an artist and architect from Cape Town. Meiring's design updated the simple, seventeenth-century farmhouse to reflect contemporary tastes. In 2005 the Rupert Museum opened in South Africa's famous wine capital, Stellenbosch, and exhibits mainly South African art from 1940 to 2005 in a 2 000 square-meter-space. Artists shown include the New Objectivity landscape painter Jacobus Hendrik Pierneef, the sculptor Anton van Wouw and the painter Irma Stern, who was friends with the German Expressionists. Contemporary artists like William Kentridge have also found their way into this sizable collection.

Collectors:
Huberte & Anton Rupert

Address:
Stellentia Avenue
Stellenbosch 7600
South Africa
Tel +27 21 8883344
rupertmuseum@remgro.com
www.rupertmuseum.org

Opening Hours:
Mon–Sat: 10am–4pm

203 Arario Museum in Space
*Wide-ranging collection of Korean and Western art by
the country's leading collector and gallerist*

Collector:
Kim Chang-il

Address:
83 Yulgok-ro, Jongno-gu
Seoul 110-280
South Korea
Tel +82 2 7365700
info@arariomuseum.org
www.arariomuseum.org

Opening Hours:
Mon–Sun: 10am–7pm

Collector and gallerist Kim Chang-il began collecting
Korean art in the 1970s, but it was a visit to the Museum
of Contemporary Art, Los Angeles (MOCA) in 1981 that
sparked his interest in international contemporary art.
In 2014, he resurrected a seminal 1970s office building in
downtown Seoul to display his private art collection, which
ranges from Korean contemporaries to the New Leipzig
School to the Young British Artists. The building's
labyrinthine corridors, narrow staircases, and low ceilings
house works by Keith Haring, Mona Hatoum, and Subodh
Gupta. Kim rotates the pieces regularly—his collection
of 3 700 works is one of the largest and most significant
in Southeast Asia. There are four additional branches of
the Arario Museum, one on Jeju Island. The polymath
restaurateur and department-store proprietor also mana-
ges to find time to sculpt, draw, and paint—adding his own
pieces to his ever-growing collection.

204 Adrastus Collection—Arte 21
A collection presenting the diversity of art in the age of globalization

S

An enthusiasm for art runs in the family, now in its eighth generation: for the past twenty-five years Javier Lumbreras has devoted himself to his passion for collecting. Together with his wife Lorena Pérez-Jácome, the Spanish Investor founded the Adrastus Collection in 2000. Both are mainly interested in the diversity of twentieth-century artistic creation: "We are trying to acknowledge the works that are produced in certain cultural margins, pieces that circulate on the peripheries of capitalism and of Western hegemonies." Walid Raad and Minerva Cuevas are two of the couple's favorite artists. The collection, which thus far includes about 600 works by artists from thirty-five countries, has a new home since fall 2016: a former Jesuit boarding school and attached church in Arévalo is gradually being transformed into a 14 000-square-meter museum.

Collectors:
Javier Lumbreras & Lorena Pérez-Jácome

Address:
San Ignacio de Loyola 8
05200 Arévalo, Ávila
Spain
www.adrastuscollection.org

Please check the website
for the most current information
on opening hours.

Moving images in the windows of chic boutiques, in dimly lit bodegas, or stylish tapas bars—once a year, Barcelona transforms into a paradise for lovers of video art. During the ten-day springtime Loop Festival, artists' videos are shown in approximately one hundred locations—sometimes in subtle locales, sometimes more prominently displayed. Toward the end of the festival international art audiences regularly flock to the three-day Loop Fair, held in the converted "black-box" suites of a four-star hotel. This is perhaps the best opportunity to get to know the local institutions and galleries. While the Museu Picasso and the Fundació Joan Miró focus on the art of these two superstars, complemented by smaller exhibitions, the Fundació Antoni Tàpies repeatedly distinguishes itself with a decidedly contemporary program that shows artists from Allan Kaprow to Harun Farocki in addition to its collection. In summer 2015, the well-connected Carles Guerra was appointed as new director, much to the enthusiasm of the local art scene. New energy is also flowing at the Museu d'Art Contemporani de Barcelona (MACBa), which, since February 2015, has been headed by the Argentine Ferran Barenblit. The blinding-white Richard Meier building was opened in 1995 in the trendy Raval district and showcases an excellent collection of Spanish and international art from the 1950s to today. Temporary exhibitions are devoted to the latest trends but also to earlier avant-garde movements. From here it's just a few steps to one of the most exciting commercial galleries: Àngels Barcelona focuses on conceptually charged and socially critical photography, film, and video art. Since fall 2015, the local offshoot of the Madrid-based Fundación Mapfre has graced the scene as its newest addition. Located in the sumptuously designed Casa Garriga i Nogués, this foundation specializes in carefully crafted monographic exhibitions of major photographers such as Hiroshi Sugimoto.

Nicole Büsing & Heiko Klaas

205 Fundació Suñol
Two rooms, two ideas: Spanish classics meet new art

Collector:
Josep Suñol

Address:
Passeig de Gràcia 98
08008 Barcelona
Spain
www.fundaciosunol.org

Opening Hours:
Mon–Fri: 11am–2pm, 4–8pm
Sat: 4–8pm
And by appointment.

Real estate mogul Josep Suñol's 1 200-work collection, opened in 2007, counts as one of the largest in Catalonia. Represented are the three great Spaniards of the twentieth century—Pablo Picasso, Joan Miró, and Salvador Dalí—as well as artists of the subsequent generation, including Antonio Saura, Antoni Tàpies, and Eduardo Chillida. The collection also holds works from Italy and Switzerland, like those by Giacomo Balla, Lucio Fontana, and Alberto Giacometti, and by a younger generation of artists, mostly from Catalonia. Two yearly exhibitions permit the public to warm to the collection. Nivell Zero, a second exhibition space with a separate entrance, leans toward the radically contemporary: events that take place there have a laboratory or workshop feel. Exhibitions and a smattering of film and video screenings deal with current themes.

206 Fundació Vila Casas
Three buildings, three points of focus: painting, sculpture, and photography

Collector:
Antoni Vila Casas

Addresses:
Museo Can Framis:
Carrer Roc Boronat 116-126
08018 Barcelona, Spain
Tel +34 93 3208736
Museo Can Mario:
Plaça Can Mario 7
17200 Palafrugell, Spain
Tel +34 972 306246
Museo Palau Solterra:
Carrer de l'Església 10
17257 Torroella de Montgrí, Spain
Tel +34 972 761976
www.fundaciovilacasas.com

Opening hours vary depending on exhibition and season. Please check the website for the most current information.

The Catalonian pharmaceutical businessman Antoni Vila Casas is fortunate to be able to show his foundation's extensive holdings of modern and contemporary art in three architecturally compelling museums around Catalonia. The Museo Can Framis, in Barcelona, is located in a former wool factory, replete with a new addition. Its 3 800 square meters are devoted to painting. Over 350 sculptures are housed at the Museo Can Mario, in a renovated cork factory in Palafrugell on the Costa Brava. And not far from there, at the Renaissance-era palace Palau Solterra, in Torroella de Montgrí, is where Vila Casas shows 300 works from his collection of photography. With names like Lluís Barba, Oriol Jolonch, or Francesca Llopis, Catalonian art dominates in a collection now comprising nearly 1 000 works.

S

207 Centro de Artes Visuales/ Fundación Helga de Alvear

One of the world's most important collections of contemporary art

The German Helga de Alvear has lived in Madrid for over fifty years. She runs a successful gallery in the city with an international art program. But de Alvear not only sells art to collectors; she has often also been her own best client. This has allowed her to assemble a collection of roughly 3 000 works by artists like Georg Baselitz, Martin Creed, Steve McQueen, Anri Sala, Jeff Wall, Juan Muñoz, or Louise Bourgeois—the remarkable list could go on. Since 2010, Alvear has been slowly presenting parts of her collection in the city of Cáceres in southwestern Spain. Her collection is housed in a 3 000-square-meter patrician villa, redesigned by the highly sought-after Madrid architects Mansilla + Tuñón. In 2015, construction began on a spectacular, 5 000-square-meter new expansion that will add four more floors for exhibitions as well as an auditorium.

Collector:
Helga de Alvear

Address:
Calle Pizarro 8
10003 Cáceres
Spain
Tel +34 927 626414
general@fundacionhelgadealvear.es
www.fundacionhelgadealvear.es

Opening Hours:
June–September
Tues–Sat: 10am–2pm, 6–9pm
Sun: 10am–2:30pm
October–May
Tues–Sat: 10am–2pm, 5–8pm
Sun: 10am–2:30pm

208 CDAN—Centro de Arte y Naturaleza/ Fundación Beulas

Spanish postwar painting and rotating exhibits relating to landscape

Collectors:
José Beulas & Maria Sarrate

Address:
Avenida Doctor Artero s/n
22004 Huesca
Spain
Tel +34 974 239893
cdan@cdan.es
www.cdan.es

Opening Hours:
April–October
Thurs–Fri: 6–9pm,
Sat: 11am–2pm, 6–9pm
Sun: 11am–2pm
November–March
Thurs–Fri: 5–8pm,
Sat: 11am–2pm, 5–8pm
Sun: 11am–2pm

Art and nature are the focus of activities of the CDAN—Centro de Arte y Naturaleza/Fundación Beulas, opened in 2006 near the northeastern Spanish city of Huesca. The core of CDAN is formed by a private collection owned by painter José Beulas, born in 1921. In the 1950s he began collecting the work of friends and companions: primarily regional landscape painters and sculptors, but also representatives of New Figuration and Informel, like stars Antonio Saura and Antoni Tàpies. In 2000, Beulas converted all of his assets and property into a public foundation. An organic, wavy building by star architect Rafael Moneo houses the art center. The surrounding landscape is spectacular, and with the help of the foundation, it has been blessed with land-art projects—eight so far—by artists including Richard Long, Per Kirkeby, and Ulrich Rückriem.

209 OTR Espacio de Arte

Perpetual surprises in a manageable and modern project space

Collectors:
José Antonio Trujillo & Elsa López

Address:
Calle de San Eugenio 10
28012 Madrid
Spain
info@espaciodearteotr.com
www.espaciodearteotr.com

By appointment only.

The aim of this downtown Madrid art space, opened in 2008, is not just to present a collection. Located near the Prado, the 300-square-meter OTR Espacio de Arte is dedicated to promoting young, not-yet-established art. Two to three thematic exhibits annually investigate artistic questions that cross into architecture. José Antonio Trujillo and Elsa López show work from their own collection, as well as that of guest artists. Spanish and Latin American positions dominate, among them Montserrat Soto and Ernesto Neto. Artists like John Baldessari, Katharina Grosse, and Rémy Zaugg are also represented in the collection, displayed in exhibitions that nicely fuse concepts with sensual color.

S

210 Fundación Rosón Arte Contemporáneo (RAC)

An award-winning concept art collection far from the Spanish art metropolises

The Galician city of Pontevedra lies in the outermost region of northwest Spain. Here, you have to be brave to open an ambitious exhibition hall. Luckily, the Madrid-educated architect Carlos Rosón Gasalla is a risk-taker. His collection of 280 artworks from more than 160 Spanish and international artists opened on the ground floor of his house in 2007. It's not the simple artistic positions that triggered his passion for collecting. Rather, Rosón Gasalla favors art with conceptual and ironic leanings: work by John Baldessari, Mateo López, Ana Mazzei, Baltazar Torres, and Philippe Parreno, for example. Accolades have come quickly for the carefully curated exhibitions, which take place twice a year: in 2009 he received the collector award of the Madrid art fair ArCo. Rosón Gasalla's foundation also sponsors an artist-in-residence program, which has hosted artists such as Tania Bruguera, Caio Reisewitz, and David Zink Yi.

Collector:
Carlos Rosón Gasalla

Address:
Padre Sarmiento 41
36002 Pontevedra
Spain
Tel +34 986 842950
info@fundacionrac.org
www.fundacionrac.org

By appointment only.

211 Fundación Chirivella Soriano

Spanish painting since 1957 in a beautifully restored gothic palace

Notary Manuel Chirivella Bonet and his wife, Alicia Soriano Lleó, collected art for over twenty years before purchasing property containing a dilapidated gothic palace in the oldest section of Valencia in 2001. The permission to destroy the palace came a few days later. Apparently, a misunderstanding: the couple did not want to tear down the building; they wanted to restore it. They opened their collection—spread across 1 000 square meters—in 2005. The focus is on Spanish painting since 1957. That is the year both collectors were born, but the selection also serves an art historical purpose: in 1957 the followers of the Informel movement founded a breakaway artist group dedicated to new geometric abstraction and new kinds of figuration. Artists like Antonio Saura are well represented in the collection, which also shows more recent Spanish art.

Collectors:
Manuel Chirivella Bonet &
Alicia Soriano Lleó

Address:
Calle deValeriola 13
46001 Valencia
Spain
Tel +34 196 3381215
info@chirivellasoriano.org
www.chirivellasoriano.org

Opening Hours:
Tues–Sat: 10am–2pm, 5–8pm
Sun: 10am–2pm

Sweden

212

Collectors:
Wanås Foundation

Address:
289 90 Knislinge
Sweden
Tel +46 44 66071
info@wanaskonst.se
www.wanaskonst.se

Opening hours vary depending
on exhibition and season. Please
check the website for the most
current information.
The park is open daily
8am–7pm.

212 Wanås Foundation/Wanås Konst
Site-specific contemporary art in southern Sweden

Wanås castle in southern Sweden is a fortress from the fif-
teenth century and the private home of Charles and Marika
Wachtmeister, located one-and-a-half-hours away from
Copenhagen by car. In 1987, Marika Wachtmeister began
to exhibit sculptures on the sprawling estate, featuring
site-specific works by Igshaan Adams, Dan Graham, Ann
Hamilton, Jeppe Hein, Jenny Holzer, Tadashi Kawamata,
Maya Lin, and Yoko Ono. The Wanås Foundation is also
known for its atmospheric sound works by artists Janet
Cardiff and Robert Wilson. Today, more than fifty per-
manently installed works comprise the continuously
expanding outdoor collection. A spacious stable, built in
1759, has been used to house temporary exhibitions and
the Wanås Estate is also the site of an eco-friendly agri-
cultural business. The Wanås Hotel & Restaurant, opened
in 2016, offers guests the chance to enjoy magical early
morning walks in the park and locavore dinners in the
old stable blocks.

S

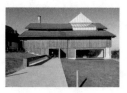

213 Kunstmuseum Appenzell/ Kunsthalle Ziegelhütte

A perfect synthesis of the pristine with modern and avant-garde architecture

A must-see for architecture fans: inspired by the vision of functional museum architecture—as the Swiss artist Rémy Zaugg dreamed of—the architect-duo Annette Gigon and Mike Guyer built the Kunstmuseum Appenzell (formerly: Museum Liner) in 1998, an architectural gem in the Appenzell region. Right next to the museum, the Heinrich Gebert Kulturstiftung opened a second venue in 2003, the Kunsthalle Ziegelhütte, which was restored by architect Robert Bamert and extended with an exhibition hall. Wood, iron, brick, and exposed concrete are unified in a successful synthesis of modernity and the local in this multifunctional industrial monument. Up to six special exhibitions a year showcase the broad range of the collection, from classic modernism to contemporary art, which includes more than 1 000 works of the artists Carl August and Carl Walter Liner, alongside 400 works by the likes of Hans Arp, Frank Stella, or Beat Zoderer.

Collectors:
Myriam Gebert-Macconi &
Heinrich Gebert

Addresses:
Kunstmuseum Appenzell:
Unterrainstrasse 5
9050 Appenzell
Switzerland
Tel +41 71 7881800

Kunsthalle Ziegelhütte:
Ziegeleistrasse 14
9050 Appenzell
Switzerland
Tel +41 71 7881860
www.h-gebertka.ch

Please check the website
for the most current information
on opening hours.

214 Fondazione Rolla/
Rolla.info

*A collection of modern and contemporary photography
in Ticino*

Collectors:
Rosella & Philip Rolla

Address:
Via Municipio
6837 Bruzella
Switzerland
Tel +41 77 4740549
rosella@rolla.info
www.rolla.info

By appointment only.

What began as a collection of modern and contemporary photography that was running out of space, took shape in a vacant former kindergarten in the small community in the Valle di Muggio, Ticino. This is where the Fondazione Rolla found its home in 2010. With the help of their foundation, Rosella and Philip Rolla provide researchers and photography enthusiasts access to important works by representatives like Robert Adams, Josef Sudek, and Eugène Atget, but also to works by contemporary photographers such as Thomas Struth, James Welling, and Vincenzo Castella. The Rollas' collection is, however, not only devoted to photography: Phil Rolla, an engineer who grew up in the US, is also mainly interested in American Minimal Art. His professional background may explain the couple's preference for German photography, in particular for the architectural and industrial photography of Albert Renger-Patzsch, Bernd & Hilla Becher, and Christof Klute.

215 Kloster Schoenthal

Nature-inspired sculptures in a pristine landscape

Collector:
John Schmid

Address:
Schönthalstrasse 158
4438 Langenbruck
Switzerland
Tel +41 61 7067676
mail@schoenthal.ch
www.schoenthal.ch

The park is open at all times.

There is a special place about fifty kilometers southeast of Basel in the gentle foothills of the Swiss canton of Jura. Basel-based entrepreneur and collector John Schmid has created a sculptural landscape with thirty-two works by Swiss and international artists around the former Schoenthal monastery. But urban art lovers had better exchange their fine shoes for rubber boots to walk the sculpture trail, which meanders through fifty hectares of fields, meadows, and forest. Twenty-four artists, from Richard Long to Ulrich Rückriem and Nicola Hicks, have engaged the natural environs with great sensitivity and realized works that meld perfectly into the landscape. Schmid, who maintains friendly relations with all the artists, acquired the estate and its landmark building in 1985.

S

216 Museum Sammlung Rosengart
The crème de la crème of classic modernism:
Picasso, Klee, and friends

The Lucerne-based Rosengart collection inhabits a neo-classical building formerly owned by the Swiss National Bank. Carefully remodeled by the Basel architecture firm Diener & Diener, the building, finished in 2002, offers perfect conditions for this impressive collection of classic modernism. Art dealer Siegfried Rosengart (1894–1985) didn't just collect Pablo Picasso, Georges Braque, and Henri Matisse; he and his daughter Angela, who entered the family business at age sixteen, were actually close friends with all of them. And thus, "all the paintings were chosen with the heart," Angela Rosengart says. The ground floor is devoted to Picasso, and the first floor contains paintings by his contemporaries Fernand Léger and Wassily Kandinsky. In the secure basement, where bolted safes used to hold gold reserves of the Swiss national bank, a fine collection of Paul Klee works hangs gently illuminated.

Collectors:
Siegfried & Angela Rosengart

Address:
Pilatusstrasse 10
6003 Lucerne
Switzerland
Tel +41 41 2201660
info@rosengart.ch
www.rosengart.ch

Opening Hours:
April–October
Mon–Sun: 10am–6pm
November–March
Mon–Sun: 11am–5pm

217 Collezione Giancarlo e Danna Olgiati
Avant-garde art of the twentieth and
twenty-first centuries on Lake Lugano

Initially devoted to the German Expressionist avant garde, attorney Giancarlo Olgati shifted his attention to the contemporary art scene in the early 1960s while still a young collector. In so doing, he discovered the artists of the Nouveaux Réalisme, whose work he began to collect systematically in the second half of the 1970s. Since 1985, his wife, Danna Olgiati, a gallerist specialized in Italian Futurism, has assisted his building up of the collection, which also includes positions of Spatialism, Arte Povera, and the latest tendencies of neo-abstraction. In 2012 the Olgiatis gave the city a part of their collection on permanent loan, which is now stored and presented in temporary exhibitions in an underground area in Lugano's Central Park. The space's name, "-1," mirrors its location; since 2015, it is managed by the new cultural center LAC Lugano Arte e Cultura.

Collectors:
Giancarlo & Danna Olgiati

Address:
Riva Caccia 1
6900 Lugano
Switzerland
Tel +41 58 8667214
mediazione@lugano.ch
www.collezioneolgiati.ch

Opening Hours:
Fri–Sun: 11am–6pm

S

218 Kunst(Zeug)Haus

*An extensive private collection of Swiss contemporary
art of the last thirty years*

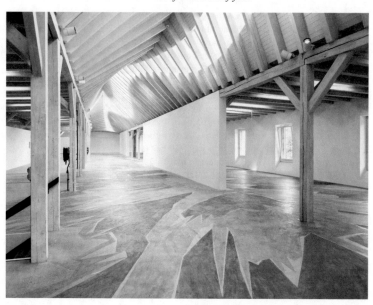

Collectors:
Peter & Elisabeth Bosshard

Address:
Schönbodenstrasse 1
8640 Rapperswil-Jona
Switzerland
Tel +41 55 2202080
info@kunstzeughaus.ch
www.kunstzeughaus.ch

Opening Hours:
Wed–Fri: 2–6pm
Sat–Sun: 11am–6pm

Zurich-based lawyer Peter Bosshard and his wife, Elisabeth,
started collecting art in the 1970s. They had just completed
a two-year stay in New York City and returned to Switzer-
land, where they began a decades-long engagement with
the contemporary art scene. Today, the Bosshards support
artists and art projects, in addition to having accumulated
roughly 5 000 works of their own. In May 2008 they opened
an art center in a former arsenal in the city of Rapperswil-
Jona. Zurich architects Isa Stürm and Urs Wolf meticulous-
ly transformed the long and bulky building into a spacious
2 600 square meters, providing enough room for three to
four exhibits each year. Aside from established Swiss art
stars like Silvia Bächli, Fischli/Weiss, or Roman Signer,
younger positions such as Mario Sala or Yves Netzhammer
have also found a comfortable home.

219 Fondation Beyeler
*World-famous art in a building by Renzo Piano
outside of Basel*

His standards were always high. Ernst Beyeler, who died in 2010, turned his gallery in Basel into one of the most important addresses of the international art market. Together with his wife, Hildy Beyeler, he built an impressive collection of modernist, Abstract Expressionist, and Pop Art works. Paintings by Pablo Picasso, Mark Rothko, and Andy Warhol have all found a home here. In 1997, the collectors opened the Fondation Beyeler in their hometown of Riehen, on the outskirts of Basel. The elongated Renzo Piano building blends perfectly into the landscape. Every year the foundation stages three large exhibitions of modern or contemporary art. In 2008, Sam Keller, a former director of Art Basel and a hyperconnected art-world figure, became the foundation's director, lending a sense of continuity and inventiveness to the collection. If you think the Museum of Modern Art (MOMA) in New York City is too far to travel, a visit here might be just as good.

Collectors:
Ernst & Hildy Beyeler

Address:
Baselstrasse 101
4125 Riehen, Basel
Switzerland
Tel +41 61 6459700
info@fondationbeyeler.ch
www.fondationbeyeler.ch

Opening Hours:
Wed: 10am–8pm
Thurs–Tues: 10am–6pm

220 Sammlung Ruedi Bechtler—
Kunst im Castell
*Contemporary art of the highest quality
in a truly cool hotel*

There are simply too many so-called art hotels showcasing works by unknown regional artists usually purchased in a frenzy right before the hotel's grand opening. Hotel Castell, in Zuoz, in the Engadin region, however, goes about things differently. Both inside and outside the building, the visitor bumps into works by Pipilotti Rist, Tadashi Kawamata, Roman Signer, or Lawrence Weiner—most of them created specifically for the place. Hotel owner Ruedi Bechtler is an artist in his own right, and sensible enough not to feed his guests standard artistic fare. In 1955, his father, Walter A. Bechtler, started one of the largest Swiss art foundations, whose mission is to make contemporary art accessible. As its current president, Ruedi Bechtler is is deeply devoted to this goal. One of the hotel's highlights, James Turrell's *Skyspace*, offers the opportunity for a contemplative experience both night and day.

Collector:
Ruedi Bechtler

Address:
Via Castell 300
7524 Zuoz
Switzerland
Tel +41 81 8515253
info@hotelcastell.ch
www.hotelcastell.ch

Open visitation during hotel hours. Guided tours every Thursday at 5pm.

Basel's flagship event is Art Basel, undisputedly the most important art fair in the world. Held each year in mid-June, the elite of international collectors meet here or at one of the half-dozen side fairs taking place simultaneously. Approximately 300 participating galleries at the main fair offer the most exquisite, most sought-after contemporary artworks of the twentieth and twenty-first century. Given this spectacle, visitors are apt to overlook the city's expansive range of top-class art institutions: The Kunstmuseum Basel, with its collection ranging from Lucas Cranach the Elder to Wolfgang Tillmans, has, since spring 2016, a new building for temporary exhibitions, designed by Basel architects Christ & Gantenbein and financed primarily by private capital. Specializing in young avant-garde positions, Kunsthalle Basel attracts visitors with its dependably fascinating program. Opened in 2014, the Haus der elektronischen Künste (HEK) is a center of excellence for "all art forms that express themselves through new technologies and media, and reflect upon them." Likewise forging new paths is the neighboring Schaulager, a hybrid combination of museum, art depot, and research facility, located in a polygonal building designed by the Basel architect super-duo Herzog & de Meuron, where art stars like Matthew Barney or Francis Alÿs are fêted with monographic exhibitions. Just outside the Basel city gates in Riehen, the Fondation Beyeler scores big not only with its Renzo Piano architecture, which is perfectly suited to the surrounding landscape, but also with exhibitions of classical modernism, postwar art, and established contemporaries like Marlene Dumas, Roni Horn, or Gerhard Richter. Interesting exhibitions of international and Swiss contemporary artists can also be found at Stampa gallery. The Kunsthaus Baselland, in Muttenz, renowned for its discourse-friendly program, and the Vitra Design Museum, in Weil am Rhein, housed in a deconstructivist building designed by Frank O. Gehry, are additional worthwhile destinations outside the city.

Nicole Büsing & Heiko Klaas

Collectors:
Sevda & Can Elgiz

Address:
Meydan Sokak
Beybi Giz Plaza
Maslak
34398 Istanbul
Turkey
Tel +90 212 2902525
info@elgizmuseumistanbul.org
www.elgizmuseum.org

Opening Hours:
Wed–Fri: 10am–5pm
Sat: 10am–4pm
Tues: by appointment only

221 Elgiz Museum of Contemporary Art
Prominent Turkish and international contemporary art

Long before contemporary Turkish art came into the spotlight, Sevda and Can Elgiz knew its inherent worth. The couple has been eagerly collecting since the early 1980s, even knocking down walls of their own home to fit the artworks inside, as they told the American magazine *Art + Auction*. Initially they focused on Turkish artists; at the end of the 1990s they began to acquire works by international artists. The private Elgiz Museum—opened in 2001 as one of the first institutions for contemporary art in Turkey—now holds works by influential Turkish artists like Ömer Uluç and Güngör Taner, as well as those by international names like Tracey Emin and Barbara Kruger. In 2012, the museum was supplemented by 1 500 square meters of open-air, rooftop exhibition space.

T

222 Özil Collection
East and West, past and present in the heart of Istanbul

Istanbul is where East meets West. Art dealer and collector Dağhan Özil has been leveraging this knowledge since 1986, when he began exploring the interaction between Western and Turkish artists in his gallery. Özil's private collection, which he opened to the public in 2007, also reflects this interest: exhibitions at his gallery spaces, where parts of his collection are on permanent display, highlight the legacy of the Islamic past and today's understanding of international art. At the private collection, roughly 500 pieces of Islamic ceramics and bronzes share space with around 250 works of renowned contemporary artists including Gerhard Richter, Tony Cragg, Gavin Turk, Gotthard Graubner, Jannis Kounellis, Wim Delvoye, Markus Lüpertz, and Panamarenko.

T

Collector:
Dağhan Özil

Address:
Ömer Avni Mahallesi
Sarayarkası Sokak No:10
Gümüşsuyu Beyoğlu
34430 Istanbul
Turkey
Tel +90 212 2276852
info@ozilcollection.com
www.ozilcollection.com

By appointment only.

The development of Istanbul's art scene in can be described in one word: speedy. Within the span of just a few years, Turkish contemporary art has moved into the international spotlight, and despite low support from the state, the metropolis has established itself as a major international art center. This is due foremost to the private sector, with corporations and banks generously subsidizing the city's art institutions. One example is a platform for contemporary art, Akbank Sanat Beyoğlu, founded in 1993, which is sponsored by a financial institution. So is Istanbul Modern, a private museum of modern and contemporary art established in 2004 by an industry group in a former warehouse. Both institutions are located in the Beyoğlu district, considered the most important local art-scene address. Here you'll find a smattering of galleries, such as Pi Artworks, Galerist, or Galeri Nev Istanbul. Additional art institutions reflecting the contemporary art scene in Istanbul are DirimArt and Rampa. Located in a former bank in the Galata district, the nonprofit center SALT is undoubtedly one of the city's most significant art initiatives, which also maintains a second venue close to Taksim Square. Not far from this you'll find Collectorspace, where businessman Haro Cümbüşyan invites other collectors to exhibit a work from their collection. Also worth a visit is Arter, an institution initiated in 2010 by the Vehbi Koç Foundation (VKF) of the well-known Koç family of entrepreneurs. For 2017, plans are also underway for a museum to permanently house their own collection. The Istanbul Biennial, launched in 1987, continues to make a decisive contribution to the development of the Istanbul art scene. Today, it's one of the most important art biennials, alongside Venice, São Paulo, and Sydney. It is held from mid-September to mid-November and starts at the same time as the annual art fair Contemporary Istanbul.

Silvia Anna Barrilà

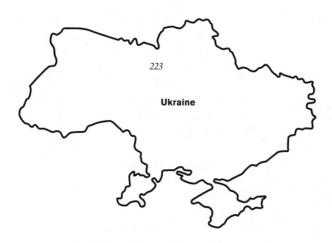

223

Ukraine

223 Pinchuk Art Centre
*Blue-chip contemporary in the first private museum
in the former USSR*

Collector:
Victor Pinchuk

Address:
1/3-2, "A" Block
Velyka Vasylkivska/Baseyna vul.
01004 Kiev
Ukraine
Tel +38 44 5900858
info@pinchukartcentre.org
www.pinchukartcentre.org

Opening Hours:
Tues–Sun: 12–9pm

Within the span of a few years, Ukrainian billionaire Victor Pinchuk has asserted himself as one of the most powerful collectors on the international scene. He bought *Hanging Heart (Magenta/Gold)*, by Jeff Koons, for a reported 23.6 million dollars, and *99 Cent II Diptychon*, by Andreas Gursky, for a reported 3.3 million dollars, setting a record price for both artists. Pinchuk has purchased other million-dollar artworks by the likes of blue-chip stars Peter Doig and Takashi Murakami. He reveals it all at his very popular **U** Pinchuk Art Centre, founded in 2006, a colossal six-story building that was the first private museum opened in the former USSR; nearly a million visitors have already passed through its doors. "There is only one queue in the country," Pinchuk told *The New Yorker* in 2009: "ours."

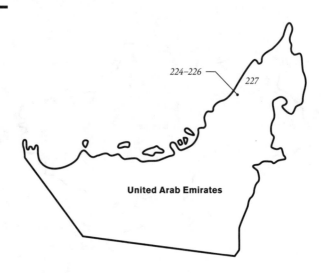

224–226 *227*

United Arab Emirates

224 The Farjam Collection
A voyage from ancient Islamic art to contemporary
Middle Eastern and Western art

Farhad Farjam, a Dubai-based Iranian industrialist, started his collection when he was still a student in New York in the 1970s. He bought the first piece of his collection of Persian miniatures for 2 000 dollars, the cost of a semester's tuition. This resulted in, well, a lost semester. "It was a dramatic story for me that I never forget," he recalled during a panel at Art Dubai in 2010. Today Farjam owns one of the most important collections of privately held Islamic art in the world, an undertaking he considers a social responsibility. Over the years Farjam has turned to modern and contemporary art from the Middle East and the West. The Farjam Collection today includes artists like Mohammad Ehsai and Nja Mahdaoui, as well as Western icons Andy Warhol and Jean-Michel Basquiat. The collection forms the core of the eponymous foundation, which has committed itself to the promotion of intercultural dialogue.

U

Collector:
Farhad Farjam

Address:
DIFC Gate Village 4
Dubai
United Arab Emirates
Tel +971 4 3230303
info@farjamfoundation.org
www.farjamfoundation.org

Opening Hours:
Sun–Thurs: 10am–8pm
And by appointment.

Dubai may not be for everyone: an artificial giant created almost overnight, embedded in a surreal desert landscape. Nevertheless, a highly interesting art scene has taken root and developed at a blistering pace. One of its hubs is the Gate Village at the Dubai International Financial Centre (DIFC), where, alongside large financial corporations, you can find galleries like Cuadro Fine Art Gallery, Ayyam Gallery, and ArtSpace Dubai. Christie's is also located here, which transformed Dubai into a regional center for the international secondary art market by launching its first Middle Eastern auction of international modern and contemporary art in 2006. Another focal point for the art scene is Alserkal Avenue in the industrial area of Al Quoz—a hub for creativity where you´ll find installations in public spaces, cafes, and studios, in addition to galleries like The Third Line, Green Art Gallery, Gallery Isabelle van den Eynde, and Leila Heller Gallery, from New York. March is the best time to discover Dubai's art scene, when Art Dubai is held at the Madinat Jumeirah—a fair that has played a key role in the development of the scene since 2007. Happening concurrently with Art Dubai are other events like Design Days Dubai, a fair devoted to collectors of design, and Sikka Art Fair. The latter presents young art from around the Emirates in the historical district of Al Fahidi. While Dubai is more representative of the art market, neighboring Emirates make their marks with large-scale exhibitions and new institutions. The Sharhaj Biennial is held every two years in Sharhaj, and, in Doha, Abu Dhabi, and around the entire region, enormous resources are currently being invested in new museum buildings. Large institutions are taking shape here, including the National Museum of Qatar or the Louvre Abu Dhabi, both designed by star architect Jean Nouvel. Once the construction of these museums is completed, there will be even more reasons to explore this colorful region.

Silvia Anna Barrilà

Collector:
Jean-Paul Najar

Address:
Unit E 45, Alserkal Avenue
Street 8, Al Quoz 1
PO Box 928040
Dubai
United Arab Emirates
www.jpnajarfoundation.com

Opening Hours:
Sun–Tues: 11am–7pm
Sat: 1–5pm

225 Jean-Paul Najar Foundation
European-American Post-Minimalist Art in a Bauhaus-inspired building

Situated on Alserkal Avenue in the heart of Dubai´s art quarter, the Jean-Paul Najar Foundation opened its gates to the public in 2016. Najar—an economist, photographer, and sculptor who spent most of his life in Paris—began collecting art in the mid-1960s, engaging in dialogues with many artists of that time. A pivotal figure for Conceptual and Minimal Art, he curated various exhibitions and published in-depth texts on the artists he was collecting. His exceptional assemblage includes works by James Bishop, Gordon Matta-Clark, Suzanne Harris, Marcia Hafif, and Linda Francis, among others. To create a private museum for her father's collection, Deborah Najar Jossa convinced her father-in-law and legendary architect, Mario Jossa, to come out of retirement to design the Bauhaus-inspired building. The foundation aims to ensure and expand on Najar's legacy through a mix of new acquisitions, educational programs, and temporary exhibitions.

Collector:
Ramin Salsali

Address:
Complex/Unit 14, Alserkal Avenue
Street 8, Al Quoz 1
Dubai
United Arab Emirates
Tel +971 4 3809600
spm@salsalipm.com
www.salsalipm.com

Opening Hours:
Sat: 1–5pm
Sun–Thurs: 11am–6pm
And by appointment.

226 Salsali Private Museum
A platform for collectors in Dubai's hub of creativity

Located in the industrial area Al Quoz 1—one of Dubai's designated hubs of arts and creativity—the Salsali Private Museum, which opened in 2011, is not just an exhibition space for Ramin Salsali's collection of contemporary art. It is also a platform for collectors who want to meet and exchange ideas, or to exhibit their own collections. "An art collection is an art in itself," Salsali says. "It should reveal to its audience a story more significant than any individual viewpoint." An Iranian consultant for the petrochemical **U** industry, Salsali started collecting when he was a twenty-one-year-old student in Germany. Today he owns over 300 works by Middle Eastern artists such as Reza Derakshani, Mona Hatoum, and Shirin Neshat, which sit alongside international stars like Arman, Niki de Saint Phalle, Jonathan Meese, André Butzer, Fischli/Weiss, Meret Oppenheim, and Daniel Richter.

227 Barjeel Art Foundation
*Modern and contemporary art from four corners
of the Arab world*

The term "Arab world" comprises a vast territory spanning from the Middle East to North Africa, subsuming the Levant, Maghreb, Egypt, the Gulf Arab, and Iraq—places strongly characterized by their own history and culture. This internal diversity of the Arab world's countries lies at the basis of Sultan Sooud Al-Qassemi's art collection, which includes over 500 works by both modern and contemporary Arab artists, such as Shakir Hassan Al Said, Khaled Hafez, and Lara Baladi. Sultan Al-Qassemi spent over a decade amassing his collection, which was opened to the public in 2010, on the second floor of the Maraya Art Centre, in Al Qasba, the entertainment hub of Sharjah. "What's the point in art," he asked in the local daily newspaper *The National*, "if it is not shared?"

Collector:
Sultan Sooud Al-Qassemi

Address:
Maraya Art Centre
Al Qasba
Sharjah
United Arab Emirates
Tel +971 6 5566555
info@barjeelartfoundation.com
www.barjeelartfoundation.com

Opening hours vary depending on exhibition. Please check the website for the most current information.

234
228
United States of America

254
236
247, 248
240, 241
255

237 251
229
252
230 250
239
249

256
235

253 238
231–233 242–246

228 Clarinda Carnegie Art Museum (CCAM)
*A double feature of contemporary art
in the heart of America*

Collectors:
Robert & Karen Duncan

Address:
300 N 16th Street
Clarinda, IA 51632
United States of America
www.clarindacarnegieartmuseum.com

Opening Hours:
Wed, Sun: 1–4pm

Over eighteen months, in 2013 and 2014, Robert and Karen Duncan opened not one but two exhibition spaces in the American heartland. The couple has spent the past thirty years building a collection of over 2 000 works, by a varied cast of artists such as Bruce Nauman, Bernar Venet, and George Segal. Female artists are particularly well represented with major works by Louise Bourgeois, Georgia O´Keeffe, and Kiki Smith. While the Duncans periodically open their home by-appointment, they decided to open up **U** their holdings even further. Wanting to give back to their hometown of Clarinda they purchased the city's former Carnegie Library, completely restored and refurbished it, and then turned it into an art museum for works from their collection. It follows Assemblage, an exhibition space opened in 2013 in Lincoln, Nebraska, together with fellow collectors Marc and Kathryn LeBaron, providing access on a by-appointment basis.

229 Transformer Station
*International photographic art and
a unique collaboration*

Fred and Laura Ruth Bidwell exhibit their collection in an erstwhile transformer station six months out of the year. Then they leave the exhibition rooms to the watchful eyes of the Cleveland Museum of Art, which uses the atmosphere of the old industrial building for exhibitions suited to the cool ambiance. This unique collaboration was decided before the Transformer Station's February 2013 opening, because both the Bidwells and the museum pursue the same goal of bringing smartly curated contemporary art exhibits to Cleveland. The collector couple's emphasis is on photography, having purchased works by Jessica Backhaus, Hiroshi Sugimoto, Philip-Lorca diCorcia, and Martin Parr. They also offer a perfect link to the curatorial mission of the museum by presenting historical positions like Walker Evans and Lee Friedlander.

Collectors:
Laura Ruth & Fred Bidwell

Address:
1460 West 29th Street
Cleveland, OH 44113
United States of America
Tel +1 216 938 5429
info@transformerstation.org
www.transformerstation.org

Opening Hours:
Wed, Fri: 12–5pm
Thurs: 12–8pm
Sat–Sun: 10am–5pm

230 Pizzuti Collection
Meritorious Midwestern assemblage of the now

The Pizzuti Collection is one of the newest entrants onto the American private museum circuit—one of the most dynamic, too. Real-estate mogul Ron Pizzuti assembled the estimated 2 000-work-strong collection over the past four decades, starting with Karel Appel's *Circus People*, in 1974. The print hung in the collection's inaugural exhibition, in September 2013. Spread over a three-story building, which formerly served as the headquarters of an insurance company, the Pizzuti Collection rotates at least once per year. It features a wide range of artists from the collection, from established names like Carroll Dunham and David Hammons to emerging exponents like Florian Meisenberg. Pizzuti is particularly keen on works by Cuban artists, a passion that began after a trip to the country in 2009. He also recently launched a sculpture garden on the premises with works by Tom Friedman, Thomas Houseago, and Jason Middlebrook, among others.

Collectors:
Ron & Ann Pizzuti

Address:
632 Park Street
Columbus, OH 43215
United States of America
Tel +1 614 280 4004
info@pizzuticollection.org
www.pizzuticollection.org

Opening Hours:
Tues–Sat: 11am–5pm
And by appointment.

231 The Goss-Michael Foundation
*A must-see for everyone who loves
the Young British Artists*

Collectors:
Kenny Goss & George Michael

Address:
Dallas,
United States of America
Tel +1 214 696 0555
info@g-mf.org
www.g-mf.org

Please check the website
for the most current information
on opening hours.

The strong contingent of Young British Artists in Dallas, Texas, is due to the longstanding alliance between art dealer Kenny Goss and the pop singer George Michael. Both have great sympathy for Damien Hirst's marinated cadavers that deal with death and ephemerality, and for Tracy Emin's eroticized installations. Sarah Lucas's feminist statements also make an appearance in the collection. Since 2007 you can catch a glimpse of the overall criteria of the Goss-Michael Foundation, where the two enthusiasts have assembled roughly 500 works, including those by Gilbert & George, Op Art queen Bridget Riley, or provocateurs Jake & Dinos Chapman. Many works are from the 1990s, which were formative years, says the collector duo, for an entire artistic generation.

232 Nasher Sculpture Center
*A private collection of masterpieces every museum
dreams of owning*

Collectors:
Patsy & Raymond Nasher

Address:
2001 Flora Street
Dallas, TX 75201
United States of America
Tel +1 214 242 5100
www.nashersculpturecenter.org

Opening Hours:
Tues–Sun: 11am–5pm

Patsy and Raymond Nasher began obeying one command in the 1950s, and they have stayed true to it ever since: only collect sculpture. More specifically, by modernist artists like Henry Moore, August Rodin, Pablo Picasso, and Raymond Duchamp-Villon. These works are accompanied by masterpieces by Alexander Calder, Richard Serra, and Claes Oldenburg. Every single object in this collection is museum-worthy; taken as a whole, they show the development of an entire epoch. Since 2003 the Nasher **U** Sculpture Center has presented its holdings in exciting contrasts and supplemented by matching new acquisitions. Built by architect and Pritzker-Prize winner Renzo Piano, the pavilion-like structure, situated at the end of a park in Dallas's arts district, allows for a perspective that sets the robust outdoor sculptures in a relationship with the fragile objects inside.

233 The Warehouse
Two major United States collections in dialogue

Cindy and Howard Rachofsky open their Rachofsky House, designed by Richard Meier, for events devoted to their charitable interests. But art lovers can find parts of the collection with works by Gerhard Richter, Lucio Fontana, Sigmar Polke, Piero Manzoni, Mario Merz, Kazuo Shiraga, and Atsuko Tanaka at a second address. Since 2013 Cindy and Howard Rachofsky have shared a large industrial building called The Warehouse—divided into sixteen galleries—with fellow collector Amy Faulconer, who, together with her now deceased husband, also assembled an impressive collection with works by artists such as Anselm Kiefer, Anish Kapoor, Bridget Riley, Cecily Brown, Jaume Plensa, Kara Walker, and James Turrell. The result is an exciting dialogue of exhibits and, because collaborating collectors are a rarity elsewhere, a truly innovative experiment.

Collectors:
Cindy & Howard Rachofsky
Amy & Vernon Faulconer

Address:
14105 Inwood Road
Dallas, TX 75244
United States of America
Tel +1 214 442 2875
www.thewarehousedallas.org

By appointment only.

234 The Dikeou Collection
Siblings collect artists they find to be inspiring

Artist Devon Dikeou and her brother Pany are less interested in establishing themselves than in making known the colleagues they deem important. Among them are established names like Momoyo Torimitsu, Vik Muniz, and Wade Guyton. Above all, the collection suggests a preference for subtle comedy, which can be found in the works of Dan Asher, Jonathan Horowitz, Johannes VanDerBeek, or Margaret Lee. The Dikeou's exhibition space, in Denver, matches their taste in art: an odd bricolage of styles in **U** the form of an historical office building from 1902 that has retained its retro charm. For the most recent acquisitions the collection has now expanded to include work by painter Joshua Abelow and installations by Devon Dikeou. Another novelty lies a few blocks away—Dikeou Pop-Up: Colfax, which is a second address and features the work of Rainer Ganahl, Lizzi Bougatsos, Anicka Yi, among others—as well as an enormous archive of vinyl records.

Collectors:
Devon & Pany Dikeou

Addresses:
1615 California Street, Suite 515
Denver, CO 80202
United States of America
Tel +1 303 623 3001

Dikeou Pop-Up:
Colfax
312 East Colfax Avenue
Denver, CO 80203
United States of America

info@dikeoucollection.org
www.dikeoucollection.org

Opening Hours:
Wed–Fri: 11am–5pm
And by appointment.

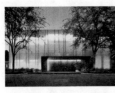

Collectors:
Francie Bishop Good &
David Horvitz

Address:
117 Northeast 2nd Street
Fort Lauderdale, FL 33301
United States of America
Tel +1 954 828 9151
admin@girlsclubcollection.org
www.girlsclubcollection.org

Please check the website
for the most current information
on opening hours.

235 Girls' Club
*The name is the mission: to promote and
rediscover female artists*

With glamorous names like Beatriz Milhazes, Elizabeth
Peyton, or the American concept art-icon Barbara Kruger,
you'll get noticed fast in the art business. But Francie Bi-
shop Good and David Horvitz could name dozens of female
artists who have been unjustly overlooked, which is why
the American collector pair founded the Girls' Club in
2006. Here in this private foundation—comprised of spa-
cious exhibition halls tucked behind a shimmering façade,
designed by the fabulous architect Margi Nothard—the
collectors show their holdings of women's art: the elabo-
rate, cartoony paintings of Sandy Winters, or the stunning
photography of Tracey Baran, who documented the inhab-
itants of a small New York town before her untimely death
at age thirty-three, in 2008.

Collectors:
Nancy & Steve Oliver

Address:
22205 River Road
Geyserville, CA 95441
United States of America
Tel +1 510 412 9090-210
www.oliverranchfoundation.org

Opening Hours:
Fri–Sun: Only guided tours
with prior registration. Group
tours upon request.

236 Oliver Ranch Foundation
A sculpture park where art responds to nature

Driving through the countryside of San Francisco to
visit the region's vineyards is no longer a hidden secret.
But Nancy and Steve Oliver's sculpture park still is. In the
mid-1980s the two decided to complement the picturesque
landscape with art. The first sculpture was *Shepherd's Muse*,
by Judith Shea, an allusion to sheep farming, the collectors'
shared hobby. This was followed by sculptures by Miroslaw
Balka, Fred Sandback, Richard Serra, Bill Fontana, and
Bruce Nauman. The fixed principle of the Oliver Ranch
Foundation is that art must directly respond to nature. **U**
Each work is created in dialogue with the artist. The reali-
zation of a work often takes several years, as was the case
with Ann Hamilton's accessible *Tower*, the centerpiece of
the Olivers' collection. Visitors can take a seat on one of
two curiously constructed staircases, while performances
and plays are presented on the other.

237 The Brant Foundation Art Study Center
Important American art from the 1960s to the present

He sits at the source and is one of the first to know who the artists of tomorrow will be: Peter M. Brant—the owner of Brant Publications, chairman and CEO of a large paper manufacturing concern, and a coproducer of movies about important artists of the twentieth century, such as Jean-Michel Basquiat and Jackson Pollock. Over the decades, Brant has amassed one of the world's largest and most distinguished collections of American contemporary artists, including Andy Warhol, Julian Schnabel, and Keith Haring. His focus on American art stems from his concern with the American sense of life, which he finds in every work anew. The spectrum runs from the positive attitude of Jeff Koons to the provocative criticism of performer-sculptor Paul McCarthy. Appropriately, since 2009, a large part of the collection has been exhibited in something quite traditionally American: a former barn.

Collector:
Peter M. Brant

Address:
941 North Street
Greenwich, CT 06831
United States of America
Tel +1 203 869 0611
info@brantfoundation.org
www.brantfoundation.org

Opening Hours:
Mon–Fri: 10am–4pm
By appointment only.

238 The Menil Collection
*An amazing collection with the format
of a metropolitan museum*

The legacy of Dominique und John de Menil is not only the imposing private museum with numerous individual galleries for works by Mark Rothko, Cy Twombly, or Byzantine art. The couple began their collection in the 1940s and have amassed invaluable works of art over the decades: Fernand Léger, Henri Matisse, or Pablo Picasso mark the entry point of this incredible collection, and Jean-Michel Basquiat, Eric Fischl, Cindy Sherman, and Robert Gober belong to the list of later additions. Between the two groups hang the heroes of American postwar painting: Barnett Newman, Willem de Kooning, or Jasper Johns. Dominique de Menil, who passed away in 1997, had survived her husband for more than twenty years. She founded their museum in 1987. Mid-2017 marks the opening of the Menil Drawing Institute (MDI), the first independent institution in the country dedicated exclusively to the presentation and research of contemporary drawing.

U

Collectors:
Dominique & John de Menil

Address:
1533 Sul Ross Street
Houston, TX 77006
United States of America
Tel +1 713 525 9400
info@menil.org
www.menil.org

Opening Hours:
Wed–Sun: 11am–7pm

239 Fisher Landau Center for Art
International stars from the 1960s on, in one of
New York's most important collections

Collector:
Emily Fisher Landau

Address:
38-27 30th Street
Long Island City, NY 11101
United States of America
Tel +1 718 937 0727
info@flcart.org
www.flcart.org

Opening Hours:
Thurs–Mon: 12–5pm

It all started with a robbery: over half a century ago, a few thieves relieved Emily Fisher Landau of her jewelry. The insurance company reimbursed the victim, who then wondered just what exactly she should do with her fresh funds. She decided on art, eventually becoming one of the most important collectors and patrons in all of New York City. Pablo Picasso, Fernand Léger, Piet Mondrian, and Jasper Johns all hang in Fisher Landau's spacious Manhattan townhouse—big, but not big enough for the entire 1 300-work collection. So in 1991 the Fisher Landau Center of Art was opened in a remodeled factory. Its focus is on works after 1960, works Fisher Landau bought directly from the artists at the start of their careers, the timely result of good instinct, good advisers, or both: Donald Judd, Jenny Holzer, Ed Ruscha, Kiki Smith, Cy Twombly, and Sherrie Levine are all here.

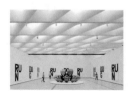

240 The Broad
A compendium of contemporary art in downtown L.A.

Collectors:
Eli & Edythe Broad

Address:
221 S. Grand Avenue
Los Angeles, CA 90012
United States of America
curator@thebroad.org
www.thebroad.org

Opening Hours:
Tues–Wed: 11am–5pm
Thurs–Fri: 11am–8pm
Sat: 10am–8pm
Sun: 10am–6pm
Closed on Thanksgiving and
Christmas Day.

Eli and Edythe Broad's philanthropic efforts in the arts are so extensive it can be hard to keep them straight. Their gifts have earned them names on two museums—the Broad Contemporary Art Museum at the Los Angeles County Museum of Art (LACMA) and the Eli and Edythe Broad Art Museum at Michigan State University (Broad MSU). But the collectors opened a more private affair in 2015, called, simply, The Broad. It's the first of the three institutions to focus solely on the couple's private collection and that of The Broad Art Foundation, which they founded in 1984. Together, the over 2 000 works by more than 200 artists, among them Jeff Koons, Kara Walker, and William Kentridge, represent a veritable compendium of the very best contemporary art. Located in downtown L.A., in a building designed by Diller Scofidio + Renfro, The Broad sports two floors of exhibition space and a vast vault that houses the couple's immense catalogue of works.

U

241 Frederick R. Weisman Art Foundation
The Who's Who of Modernism, from Surrealism to Pop

It's as if Billie Milam and Frederick R. Weisman were still living in their mansion. Paintings by Abstract Expressionists like Willem de Kooning or Mark Rothko hang together with Pop Art works over the fireplace and sectional sofas. Yet the collector couple had purchased the 1920s house only as an exhibition space. Weisman, the son of Russian immigrants, and a passionate art buyer, established a foundation in 1982 to preserve his esteemed collection after his death. Now, guided tours through the villa and adjacent gallery showcase the work that was most important to him: European Modernism from Paul Cézanne and Pablo Picasso, Surrealists like Max Ernst, and postwar art by Alberto Giacometti, Alexander Calder, or Robert Rauschenberg. Way too much art for a mansion, and all of it museum worthy, which why the forward-looking collector founded several American museums before his death, in 1994.

Collectors:
Frederick R. &
Billie Milam Weisman

Address:
265 North Carolwood Drive
Los Angeles, CA 90077
United States of America
Tel +1 310 277 5321
tours@weismanfoundation.org
www.weismanfoundation.org

Opening Hours:
Mon–Fri: 10:30am and 2pm
Only guided tours with prior
registration.

242 CIFO—Cisneros Fontanals
Art Foundation
*Latin American art evades pigeonholing in this
expansive collection*

Anyone who equates Latin American art with colorful, mythical painting will be pleasantly challenged by Ella Fontals Cisnero's collection. Forty years of continuous collecting offers stellar insight into the abstract, geometric language of Jesús Rafael Soto or Lygia Clark. The centerpiece is a work by Julio Le Parc, whose hulking sculpture at Documenta 3, the *Continuel-Mobile*, **U** was comprised of flexible metal discs that scattered light about the room. It was stored in boxes for decades, but now it fits perfectly in a former department store that was transformed into an exhibition hall by the prize-winning architect Rene Gonzalez in 2005. Photography, video, and installation art form the 1 400-work collection, each given equal treatment. There's also an increasing amount of contemporary art—by Francis Alÿs or Ernesto Neto, for example—unrestrained by either geography or theme.

Collector:
Ella Fontanals-Cisneros

Address:
1018 North Miami Avenue
Miami, FL 33136
United States of America
Tel +1 305 455 3380
info@cifo.org
www.cifo.org

Opening Hours:
Thurs–Fri: 12–6pm
Sat–Sun: 10am–4pm

Los Angeles's chief cultural contribution may still be on the silver screen, but the city's art scene is booming too. Artists are moving to the city in droves, both from America's other major art center, New York, and from more artist-friendly metropolises like Berlin. L.A. has no small advantage in attracting them: its rents are still relatively cheap (unlike New York) and its populace is wealthy (unlike Berlin) with a growing cadre who are passionate about contemporary art. The Southland's institutions are flourishing. Its newest addition, The Broad, opened to the public in September 2015 and houses the Broad Art Foundation's collection, assembled by real-estate magnate Eli Broad and his wife Edythe. But it's hardly the only game in town. Just a few steps away from L.A.'s arts and culture locus of Grand Avenue is the Museum of Contemporary Art, Los Angeles, and one of three MOCA venues in the city. MOCA's largest space, The Geffen Contemporary, is just minutes away as well. Head half an hour west by car (traffic allowing) and you'll hit the Los Angeles County Museum of Art (LACMA), the largest of the city's art institutions. But L.A. has much more than museums to offer. Fairs like Art Los Angeles Contemporary (ALAC) and LA Art Show in January bring additional collectors to the city each year. And over the past years, outposts of some of the world's most influential galleries have opened in the city. In September 2015, New York dealer Michele Maccarone opened a multi-use complex in a former warehouse downtown. The following February, Berlin and London's Sprüth Magers opened a gallery across from LACMA, and one month later, Hauser & Wirth teamed up with esteemed, former MOCA chief curator Paul Schimmel to open Hauser Wirth & Schimmel, in a 9 000-square-meter former flour mill downtown. And, that's not to mention L.A. stalwarts like Regen Projects and exciting young spaces like Night Gallery, François Ghebaly Gallery, and Freedman Fitzpatrick, which are peppered across the city's many neighborhoods. As the saying goes, if you want to see what's next in North American art, *go west, young man.*

Alexander Forbes

243 De la Cruz Collection—
Contemporary Art Space
*Emerging artists meet solid positions like Neo Rauch
or Thomas Houseago*

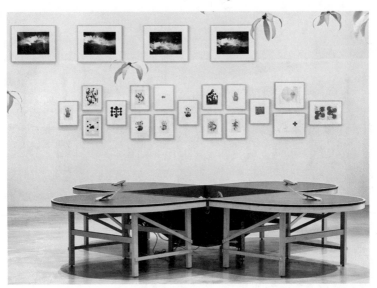

Collectors:
Rosa & Carlos de la Cruz

Address:
23 Northeast 41st Street
Miami, FL 33137
United States of America
Tel +1 305 576 6112
info@delacruzcollection.org
www.delacruzcollection.org

Opening Hours:
Tues–Sat: 10am–4pm

Whenever Rosa and Carlos de la Cruz show up, art dealers get nervous. The American couple is part of the so-called group of "super-collectors," people who might never think their holdings are quite large enough: there's always room for one more work, preferably a large one by Thomas Houseago, Daniel Richter, or Neo Rauch. The couple is quickly enthused over new movements and acquires them promptly for their museum, opened in 2009. This is how the work of the up-and-coming artist Dana Schutz or Jacob Kassay made it into the collection. With purchases of Manfred Pernice or Martin Creed, the de la Cruzes evidence their receptivity to complex theoretical works. Each year the exhibition is changed for Art Basel Miami Beach. Additionally, the museum offers an extensive program of lectures and workshops, all free of charge.

U

244 The Margulies Collection
at the Warehouse
*Big-name photographers and sculptors
in curious combination*

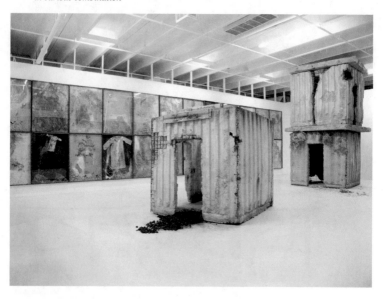

Old and new photography, from Helen Levitt to Cindy Sherman; videos and installations by Sara Barker, Bill Viola, or minimalistic light artist Iván Navarro count among the interests of the real-estate tycoon Martin Z. Margulies—a special niche not for everyone. His collection, which has been overseen by curator Katherine Hinds since the 1980s, is situated in a former warehouse. There you also find must-haves for any international collection: Richard Serra, Donald Judd, Dan Flavin, Jannis Kounellis, Michelangelo Pistoletto. Margulies combines these with Surrealist sculptures by Joan Miró, objects by Franz West, or a large-scale installation work by Anselm Kiefer—artists separated chronologically by just a few decades but also by entire artistic epochs. Such fissures, however, excite the collector and uniquely mark his rotating exhibits.

Collector:
Martin Z. Margulies

Address:
591 Northwest 27th Street
Miami, FL 33127
United States of America
Tel +1 305 576 1051
mcollection@bellsouth.net
www.marguglieswarehouse.com

Opening Hours:
October–April
Wed–Sat: 11am–4pm

U

For many in the art world, Miami represents an annual December pilgrimage to Art Basel Miami Beach and its numerous satellite fairs. The fourteen-year-old art fair—now arguably on equal footing with its European progenitor in Switzerland—certainly has more than enough dazzle to sate the visual and conceptual appetites of even the most enduring lover of art and serves as the backdrop to a marathon of afterhours delights each evening. But for that very reason, so much of what Miami has to offer can easily fall by the wayside. Principal among recent additions to the city is the Pérez Art Museum Miami (PAMM), which opened its doors to the public under its new name in 2013, following a major gift from real estate mogul Jorge M. Pérez. The museum, which is housed in a gem of a building created by Swiss architectural duo Herzog & de Meuron, scored a major coup in 2015 when it recruited Franklin Sirmans from Los Angeles County Museum of Art (LACMA), a curator known for his advocacy of greater diversity in the art world—a mission which no doubt syncs up well with PAMM´s efforts to strengthen the importance of Latin American art. The PAMM is part of the Miami Art Museums Alliance (MAMA), initiated to increase the profile of the city's relatively nascent but ever-improving cadre of institutions in the fifty-one weeks of the year when Art Basel isn't in town. Miami also leads America in its number of publicly accessible, private collections, all of which are well worth a look. But, the ever-more-popular field of street art is where Miami truly shines—especially in Wynwood. In opposition to other cities that have clamped down on street art in recent years, late real-estate magnate Tony Goldman essentially legalized it in the neighborhood, when he began redeveloping its warehouses in 2009, attracting landmark works by Shepard Fairey, Os Gemeos, Ryan McGinnes, and AVAF, among others.

Alexander Forbes

245 Craig Robins Collection
A collection where art meets design

Collector:
Craig Robins

Address:
3841 Northeast 2nd Avenue,
Suite 400
Miami, FL 33137
United States of America
Tel +1 305 531 8700
tiffany@dacra.com
www.dacra.com

Opening Hours:
Mon–Fri: 9am–5pm
By appointment only.

If anyone knows how art and design should be displayed together, it's Craig Robins. The real-estate agent founded Design Miami in 2005 as a companion to Art Basel Miami Beach and thereby managed to make a discredited Art Déco district chic and expensive once again. His collection, housed in his office building, brings together both fine art and fine design with consistency: paintings by Thomas Scheibitz, Kai Althoff, or Marlene Dumas meet classical furniture by Jean Prouvé, Charlotte Perriand, or Ron Arad, a contemporary design icon. Robins arranges the works with an eye toward form and content. It's not surprising that Cosima von Bonin or Mike Kelley are on the list of his favorite artists: both have extended their range to create sculptures that integrate furniture, plush, and even ambient music.

246 Rubell Family Collection/
Contemporary Arts Foundation
The most resonant names in Western art

Collectors:
Mera & Donald Rubell

Address:
95 Northwest 29th Street
Miami, FL 33127
United States of America
Tel +1 305 573 6090
info@rfc.museum
www.rfc.museum

Opening hours vary depending on exhibition. Please check the website for the most current information.

They are America's super-collectors, with museum-sized spaces, sponsors for exhibition projects, and a consistent and clear philosophy: for four decades Mera and Donald Rubell have only purchased art that speaks to both of them. They have agreed so far on over 1 500 works, including those by Bruce Nauman, Jeff Koons, Lawrence Weiner, Gerhard Richter, Richard Prince, and Keith Haring. Since 1993 a part of their collection has been shown in a remodeled warehouse and adjacent sculpture garden. Another **U** highlight is German photography, from August Sander to the Düsseldorf Becher School, including Thomas Ruff and Andreas Gursky. The Rubells know that their market power can influence the artists' careers—even if they collect solely out of passion.

247 The Hess Art Collection, Napa
Museum highlights from Europe and America
in the gentle hills of Napa Valley

He sold the family brewery. He successfully began a Swiss mineral water brand and sold it to Coca-Cola. From that day on, Donald M. Hess, the son of Swiss-American parents, was able to devote his time to his two true passions: wine and art. Hess owns vineyards and art collections in the Argentine Andes and the South African cape region. Prior to this, in 1978, he invested in California's Napa Valley. At Mount Veeder, it's not just about sampling the wine; the two-hour drive from San Francisco is worth making for other reasons: integrated into the rustic 1903 building is one-quarter of Hess's 1 000-work art collection, spread over two spacious stories. Works by Francis Bacon, Franz Gertsch, Anselm Kiefer, and Per Kirkeby are true jewels: nowhere else in California can you see them in such quality and density.

Collector:
Donald M. Hess

Address:
4411 Redwood Road
Napa, CA 94558
United States of America
Tel +1 707 255 1144
info@hesscollection.com
www.hesscollection.com/art

Opening Hours:
Mon–Sun: 10am–5:30pm

Additional exhibition locations:
Salta, Argentina, p. 013
Klapmuts, South Africa, p. 182

248 Di Rosa
Nature and art in almost equal standing

Since 1997 the collection of Veronica and Rene di Rosa has invited visitors to descend upon their vineyards and sprawling natural preserve. Everything here seems to be focused on the local: the large outside sculptures as well as the works housed in four elongated buildings were all made by regional artists. The painterly landscape is just as important to the collectors as the creatures that reside there. Artists like Mark di Suvero, Bruce Nauman, and Larry Sultan, or the painter Raymond Saunders have all spent time in California, which is why they fit seamlessly into the di Rosa portfolio, as do artists less internationally known, including Mildred Howard or Joan Brown. Today the collection boasts over 1 800 works that can be visited year-round, in guided tours of no more than twenty-five people.

Collectors:
Rene & Veronica di Rosa

Address:
5200 Sonoma Highway
Napa, CA 94559
United States of America
Tel +1 707 226 5991
tours@dirosaart.org
www.dirosaart.org

Opening Hours:
Wed–Sun: 10am–4pm
Only guided tours with prior online registration.

U

The New York art scene is thriving like never before. With this growth comes a shifting and expanding geographic landscape for the city's dealers, artists, and museums. A majority of the city's most important galleries showing established and blue-chip artists remain in Chelsea. Meanwhile, the more classical environs of the Upper East Side have attracted an increasing number of major dealers who occupy spaces in townhomes. Cologne and Berlin veteran Daniel Buchholz opened his first New York space in July 2015, placing it a stone's throw away from the Metropolitan Museum of Art, and longtime Chelsea inhabitant Barbara Gladstone quietly launched an additional space uptown in December 2015. While a select number of spaces uptown like Venus Over Manhattan and Half Gallery offer up a roster of emerging artists, the most exciting crop of young talents tends to sprout up on the Lower East Side. From artist-run galleries like 247365, Essex Flowers, and Mathew (with its main space in Berlin), to dynamic young dealers like Bridget Donahue and 56 Henry. Brooklyn remains home to the greatest number of New York's artists—and increasingly prominent galleries such as Clearing and The Journal Gallery. Brooklyn's most southern points have also continued to expand their offerings of contemporary art as well. Nonprofit exhibition space and residency, Pioneer Works, proceeds to put on impressive programming in Red Hook. The Bruce High Quality Foundation artist collective (BHQF) and its Bruce High Quality Foundation University (BHQFU) moved from the East Village to Gowanus in 2016. But it's not just the galleries that are moving. The Whitney Museum of American Art inaugurated its new Meatpacking District location in spring 2015. Meanwhile, the Breuer Building—the Whitney's home for nearly fifty years— opened in March 2016 under the temporary guardianship of the Metropolitan Museum of Art, giving new wings to the museum's contemporary art department. The only real challenge to seeing unparalleled art in New York? Keeping up with where to go next.

Alexander Forbes

249 The Walther Collection—
Project Space New York
*African and Asian photo art in dialogue
with Western classics*

Collector:
Artur Walther

Address:
526 West 26th Street, Suite 718
New York, NY 10001
United States of America
Tel +1 212 352 0683
contact@walthercollection.com
www.walthercollection.com

Opening Hours:
Wed–Sat: 12–6pm
And by appointment.

Additional exhibition locations:
Neu-Ulm, Germany, p. 095

Having a second space in New York City makes sense, particularly for globally connected collectors like Artur Walther, founder of the Neu-Ulm-based Walther Collection, a high-quality German venue opened in 2010 that specializes in contemporary and classic photography. For Walther, who has long lived on the Hudson, establishing an address in New York City was entirely logical. Here, he sits on the committee of both the Whitney Museum of American Art and the International Center of Photography (ICP), and the city is also where he makes numerous international contacts, which benefit his German location as well. Since 2011, the Walther Collection has been located in a 160-square-meter space inside a historical landmark, the West Chelsea Art Building—ten floors of galleries and artists' studios. The collection's cosmopolitan perspective includes African and Asian works, and its rotating three-month schedule offers both new discoveries and modern masters.

U

250 West Collection
Key names in international art meet new voices

Financial services professional Al West is a man of action. He doesn't wait for gallerists or curators to recommend emerging voices to him; he lures them in himself. In 2011, for example, he and his daughter, Paige West, asked artists to apply for the West Collection Art Prize. Everyone who downloaded the app, looked at the art, then gave an evaluation and became part of the extended jury. This kind of participation is continued in the public spaces of West's business, SEI Investments. Approximately 1 200 works are installed in SEI's main building and can be viewed by appointment. The collection has grown since 1996, now encompassing nearly 3 000 works, including those by Donald Judd, Richard Artschwager, Martin Boyce, and Candice Breitz. Many of the works are loaned to museums or curated traveling exhibitions.

Collectors:
Paige & Al West

Address:
1 Freedom Valley Drive
Oaks, PA 19456
United States of America
Tel +1 610 883 7368
lee@westcollection.org
www.westcollection.org

By appointment only.

251 Buckhorn Sculpture Park
Magic sculpture garden in Upstate New York

Nestled on six hectares in the scenic town of Pound Ridge, New York, is the Buckhorn Sculpture Park and the private home of collector couple Sherry and Joel Mallin. It features gardens, woodlands, a lake, an orchard, and over seventy outdoor sculptures each discreetly and creatively placed to be viewed as individual works of art in extraordinary settings. Some of the artists featured include Richard Serra, Sol LeWitt, Joel Shapiro, Andy Goldsworthy, Ursula von Rydingsvard, Anish Kapoor, and Dan Graham. The collection also includes pieces by young sculptors whose work is showcased for the first time. In 2001, a 930-square-meter facility known as the Art Barn was completed in order to highlight an ever-changing collection of installations, paintings, photography, videos, and sculptures. Works by masters such as Chuck Close, Yayoi Kusama, and Sean Scully are installed alongside works by mid-career artists and young, emerging talent.

Collectors:
Sherry & Joel Mallin

Address:
60 Pound Ridge Road
Pound Ridge, NY 10576
United States of America
sherryhmaf@gmail.com

By appointment only.

U

252 Hall Art Foundation
*Impressive presentations of art in an
eighteenth-century building*

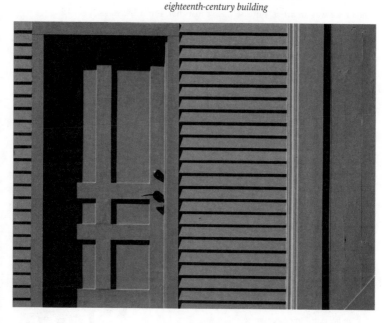

Collectors:
Christine & Andrew Hall

Address:
551 VT Route 106
Reading, VT 05062
United States of America
Tel +1 802 952 1056
info@hallartfoundation.org
www.hallartfoundation.org

Opening Hours:
May–November
Wed, Sat, Sun by appointment
only.

Christine and Andrew Hall are not only long-standing
collectors of art by Georg Baselitz. In 2006 the American
commodity trader and his wife also bought the artist's
former castle, near Hildesheim, Germany, to house works
from their collection. More recently they bought and
renovated Lexington Farm, in Vermont, an eighteenth-
century structure that is now part of the Hall Art Founda-
tion, where they show parts of their extensive collection.
But unlike many of their peers, whose collected names
read like a Who's Who of the international art scene, the
Halls have decided to concentrate on a few positions and
prefer to collect them in depth. Here one finds notable
Neo-Expressionist solo shows by the likes of A. R. Penck
and Georg Baselitz, among other monographic exhibitions,
including Neil Jenney's figurative paintings and Edward
Burtynsky's photographs.

U

253 Linda Pace Foundation
The legacy of a patroness who promoted young art

Linda Pace was an artist. But she wasn't just that. From 1993 onwards she organized a scholarship and exhibition program for artists in the Texan city of San Antonio. The artists often went on to have fantastic careers. Artist Isaac Julien, whose films can be found in Pace's collection— alongside art by Susan Philipsz, Arturo Herrera, Mona Hatoum, Jesse Amado, and Gabriel Orozco—all called Pace an "artist-collector." The passionate patroness procured roughly 500 works of art before she died, in 2007. Pace placed a part of her sculpture collection in a park dedicated to her young deceased son. The publicly accessible terrain is adjacent to a building of the foundation—Space— where works from the collection are presented in temporary exhibitions. The foundation continues to purchase works by emerging artists in order to continue Linda Pace's legacy. Ruby City, a carmine red new building, will offer even more exhibition space starting in 2018.

Collector:
Linda Pace

Address:
111 Camp Street
San Antonio, TX 78204
United States of America
Tel +1 210 226 6663
info@pacefound.org
www.lindapacefoundation.org

Opening Hours:
Wed–Sat: 12–5pm
And by appointment.

254 Pier 24 Photography
*Photography shines at this outsized venue
in heart of San Francisco*

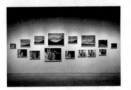

Collectors have long had a tenuous relationship to photography. It's a fickle medium: one difficult to preserve and with a relatively recently established market. But that hasn't dissuaded collector Andrew Pilara, who is fairly new to the pursuit: his Pilara Foundation, located on Pier 24, purchased its first photograph just over a decade ago. So entranced was Pilara with Diane Arbus's 2003 San Francisco Museum of Modern Art (SFMOMA) retrospective that he immediately embarked on assembling a collection, which now boasts over 4 000 photographs. The collection's works are practically an A-to-Z of the medium's greats: from classics like Ansel Adams and Irving Penn to contemporary stars like Doug Aitken, Philip-Lorca diCorcia, and Jeff Wall. The works are stored and displayed on a rotating basis in what is perhaps America's largest photo-centric exhibition hall: a 2 600-square-meter space under the Bay Bridge.

Collectors:
Andrew & Mary Pilara

Address:
Pier 24 The Embarcadero
San Francisco, CA 94105
United States of America
Tel +1 415 512 7424
info@pier24.org
www.pier24.org

Opening Hours:
Mon–Fri: 9am–5:15pm
By appointment only.

U

255 Thoma Foundation

*Two intimate art spaces that encourage dialogue
between work and viewer*

Collectors:
Carl & Marilynn Thoma

Addresses:
Art House Santa Fe:
231 Delgado Street
Santa Fe, NM 87501
United States of America

Orange Door:
Chicago, Illinois
United States of America

www.thomafoundation.org

Opening Hours:
Santa Fe:
Thurs–Sat: 10am–5pm

Chicago:
By appointment only.

Since 1975 Carl and Marilynn Thoma have amassed a diverse array of over 500 works, often in highly specialized areas that require a deep level of personal investment. Ranging from digital and software art, to Japanese bamboo sculptures, Color Field paintings, and one of the world's largest concentrations of Spanish Colonial paintings, the Thomas' continually growing collection is impressive. Opened to the public in 2014, the Thoma Foundation presides over two different sites: Orange Door in Chicago and the Art House in Santa Fe. The Art House, located in the historic Canyon Road arts district, is a traditional adobe house that has been converted into an art space. The focus here is on contemporary works from the collection, including digital art, light installations, and Color Field works. Orange Door, open by appointment only, is housed in an old warehouse space and showcases work from the entire collection.

256 Whitespace

*International art stars in a former warehouse in
Palm Beach*

Collector:
Elayne Mordes

Address:
2805 N. Australian Avenue
West Palm Beach, FL 33407
United States of America
Tel +1 561 842 4131
whitespace@mordes.com
www.whitespacecollection.com

Opening Hours:
November–April
Sat–Sun: 1–4pm
And by appointment.

The collector couple Elayne and Marvin Mordes has assembled works by established artist-teams like Teresa Hubbard & Alexander Birchler, or Elmgreen & Dragset. Their collection also includes international names like Jonathan Meese, Thomas Houseago, Mat Collishaw, Christian Boltanski, and Anish Kapoor. The couple's treasures, comprised primarily of sculptures and installations, are housed in an unassuming warehouse in Palm Beach that was previously used for the manufacturing of one of the **U** city's most in-demand products: dentures. Marvin Mordes was a longtime board member at the Hirshhorn Museum in Washington. Since his death, his wife continues to fulfill the couple's mission: sharing knowledge and art with others, and opening Whitespace's rooms upon request for groups, private events, and, on Saturdays and Sundays, for all interested art lovers.

A project like this can never be complete. Almost every month, collectors worldwide open new showrooms or make their private collections available to the public in a variety of ways. If you know of any private collection of contemporary art that is publicly accessible and not listed here, we would be delighted to hear about it. We would be equally pleased to hear of any plans you might have for opening your own collection to interested art lovers. Doing so will help us keep the *BMW Art Guide by Independent Collectors* up to date.

Please write to us at: bmwartguide@independent-collectors.com

Silvia Anna Barrilà is a freelance journalist based in Milan and Berlin who specializes in the art market. Since 2008 she has written for the Italian financial newspaper *Il Sole 24 Ore (ArtEconomy24)*, as well as for *Icon, Panorama, Architectural Digest,* and for other international media, including *Damn*. She is co-founder of Contemporary Art Galleries, a blog about international art galleries.

For this guide she wrote about collections in southern and eastern Europe: Greece, Hungary, Italy, Poland, Russia, Turkey, and Ukraine. She also covered several countries in Asia—Bangladesh, China, India, and Japan—as well as a few collections in Germany, the Netherlands, Qatar, South Africa, Spain, Switzerland, and the United Arab Emirates.

The journalist couple **Nicole Büsing** and **Heiko Klaas**, based in Hamburg and Berlin, have written freelance art journalism and art criticism since 1997 for a variety of national and international art magazines and newspapers including *Monopol, Artmapp, Artist Kunstmagazin, Dare, Zeitkunst, Kunstmarkt Media, Photonews,* and *Next Level*. They also write catalogue essays for artists and institutions.

For this guide they focused on collections from Europe and South America—Argentina, Austria, Belgium, Brazil, Denmark, Finland, France, Germany, Iceland, Israel, Luxembourg, Mexico, the Netherlands, Norway, Portugal, Puerto Rico, Spain, and Switzerland—as well as several collections in Japan, South Africa, and the United States.

Alexander Forbes is a New York-based art writer and critic, who, since 2015, has served as news editor for Artsy, directing the magazine's content strategy. Prior to that he was based in Berlin, initially founding the online publication *Berlin Art Journal,* and later serving as the German bureau chief for the Louise Blouin Media publications *Artinfo, Modern Painters,* and *Art + Auction* in German-speaking Europe. He also served as the European editor for *Artnet News*.

For this guide he focused on collections in the United States, as well as on several collections in Canada, Finland, France, Germany, Great Britain, Italy, Israel, Norway, and Romania.

Jeni Fulton is a writer and editor based in Berlin. Since 2014 she has served as art and commissioning editor for *Sleek Magazine* and contributes to *Frieze.com, Spike Art Quarterly, Randian,* and *Apollo,* among others. She holds a degree in philosophy from the University of Cambridge, and completed her PhD at the Institute for Cultural Theory and History at the Humboldt-Universität zu Berlin in 2016.

Her focus in this guide was on several collections in China, Lebanon, Mexico, Romania, Serbia, South Korea, and the United Arab Emirates.

Freelance art critic **Christiane Meixner**, based in Berlin, has served as editor of *Der Tagesspiegel*'s Art & Market section since 2008; since 2013 she has worked as an editor for *Weltkunst*. Additionally, Meixner writes for a variety of magazines and newspapers, including *Monopol, Frankfurter Rundschau, Kunstforum,* and *Zeit Online*.

Her focus in this guide was on English-speaking countries: Australia, Canada, and New Zealand—as well as several collections in Great Britain and the United States.

Anne Reimers lives in London. Since 2006 she has been a freelance arts journalist for the *Frankfurter Allgemeine Zeitung*, reporting on auctions, art fairs, and exhibitions in the British capital. An art historian, Reimers has taught cultural theory for nearly a decade and is currently senior lecturer for visual culture and fashion theory at the University for the Creative Arts (UCA), in Rochester.

Her focus in this guide was on collections in Great Britain, as well as on several collections in Australia, Belgium, France, Germany, Norway, and the United States.

City

City

Collection

Collection

** new in the Guide*

Collection

Collection

Collection

Collection

* new in the Guide

Collector

Collector

Collector

Collector

Collector

Collector

p. 010 Courtesy: MALBA–Fundación Costantini **p. 013** James Turrell, *Unseen Blue*, 2002, © James Turrell; photo: Florian Holzherr **p. 014** MONA / Leigh Carmichael, Courtesy: MONA Museum of Old and New Art **p. 016** POLIT-SHEER-FORM OFFICE, *Library*, 2008, Courtesy: the artist and White Rabbit **p. 020** Heimo Zobernig and Ferdinand Schmatz, *Eybesfeld*, 1990; photo: Michael Schuster **p. 021** © Museum Liaunig; photo: Lisa Rastl **p. 022** Ernesto Neto, *A Gente se encontra aqui hoje, amanhã em outro lugar. Enquanto isso Deus é Deusa. Santa gravidade*, 2003, Courtesy: Thyssen-Bornemisza Art Contemporary Collection, Vienna; photo: Jens Ziehe **p. 027** photo: Alexandre van Battel **p. 031** Haroon Mirza, *Digital Switchover*, 2012, © Haroon Mirza / hrm199 Ltd., Vanhaerents Art Collection, Brussels **p. 033** Aeneas Wilder, *Untitled #140*, 2008, Courtesy: Verbeke Foundation **p. 034** photo: Philippe de Gobert **p. 035** Yayoi Kusama, *Narcissus Garden*, 2009; photo: Pedro Motta **p. 037** left: Douglas Coupland, *Spectra*, 2011, Courtesy: Dr Kenneth Montague / The Wedge Collection and Daniel Faria Gallery, Toronto; right: Lynette Yiadom-Boakye, *Any Number of Preoccupations*, 2010, Courtesy: Dr Kenneth Montague / The Wedge Collection and Jack Shainman Gallery, New York; photo: John Cullen **p. 038** Martin Creed, *Work No. 329*, 2004, © Martin Creed, © photo: Site Photography, Courtesy: Rennie Collection, Vancouver **p. 040** from left to right: Kacey Wong, *World Building*, 2008; Tang Kwok Hin, *The Lonely Island*, 2013; Dennis Oppenheim, *Crystal Garden*, 2007; Jasper Fung, *I am Not Playing Violin*, 2012; William Lim, *54:10: Artist's Table*, 2011; Duan Jian Yu, *Guangzhou Local Chicken*, 2003; Adrian Wong, *Untitled (Wall) VII*, 2012; Lam Tung Pang, *The Huge Mountain*, 2011; Krijn de Koning, *Modular for Building*, 2009; photo: Nirut Benjabanpot **p. 043** Sifang Art Museum, 2013, architect: Steven Holl; photo: Xia Zhi **p. 044** (top) from left to right: Zhang Enli, *Sky*, 2010; Zhang Enli, *The Yellow and Green Pipes*, 2012; Wilhelm Sasnal, *Engine*, 2010; Ólafur Eliasson, *Colour Experiment No. 22 (fibonacci outside spiral)*, 2010; © Qiao Zhibing Collection, photo: JJYPHOTO **p. 044** (bottom) Adel Abdessemed, *Telle mère tel fils*, 2008; Courtesy: Yuz Museum, photo: JJYPHOTO **p. 048** Henry Moore, *Reclining Figure on Pedestal*, 1960, Courtesy: Henry Moore Foundation; photo: Rauno Träskelin **p. 053** (top) Louise Bourgeois, *Crouching Spider*, 2003; © Easton Foundation, New York; photo: Andrew Pattman **p. 053** (bottom) from left to right: Véronique Joumard, *Solarium*, 2006; Peter Downsbrough, *le Silo*, 2011; François Morellet, *Lamentable*, 2006; Richard Serra, *Basic source*, 1987; photo: André Morin **p. 054** François Morellet, *Red Beaming Pi 300*, 2002; Courtesy: the artist and Galerie Jean Brolly; photo: Denis Prisset **p. 055** Gao Weigang, *No Way!*, 2013; Courtesy: the artist and DSL Collection **p. 056** Céleste Boursier-Mougenot, *From Here to Ear*, 2009; Courtesy: Collection Antoine de Galbert; photo: Jana Ebert, me Collectors Room Berlin / Olbricht Foundation **p. 061** Tatiana Trouvé, *Untitled*, 2014; photo: Maya Claussen **p. 062** © Museum Frieder Burda, Baden-Baden; photo: Klaus Frahm / Artur Images **p. 064** © NOSHE **p. 068** photo: Ludger Paffrath **p. 069** St Agnes 2012; photo: Ludger Paffrath **p. 070** exhibition view: Rolf-Gunter Dienst, *Über das Schreiben und das Sehen*, 27.06.–04.08.2012; photo: Jan Brockhaus **p. 075** Hreinn Fri finnsson, *Notions of Time - Hreinn Fri finnsson & Roman Signer*, 2015; Courtesy: Safn Berlin; photo: Henrik Strömberg **p. 077** Avery Singer, *The Studio Visit*, 2013; Courtesy: Sammlung Springmeier; photo: Patricia Parinejad **p. 078** Alicja Kwade, *Grosses C*, 2004–2006, Courtesy: the artist and König Galerie **p. 082** (top) photo: Stefan Wolf Lucks **p. 082** (bottom) Richard Long, *Cornish Slate Circle*, 1983; Richard Long, *A walk of thirteen days in the Swiss Alps*, 2000; Richard Long, *Stones along the way*, 1998; © Stiftung DKM; photo: Werner J. Hannappel **p. 084** from left to right: Hans-Peter Feldmann, *Untitled (Portraits after Holbein)*, 1977; Andreas Schmitten, *Die Sammlung*, 2013; photo: Maria Litwa **p. 085** foreground: Lori Hersberger, *Ghost Rider*, 2004/2013; background: Paul Schwer, *Neuschnee*, 2013; photo: Bernhard Strauss **p. 086** from left to right: Kurt Kocherscheidt, *Untitled*, 1989, *Untitled*, 1990, *Die reisende Birne*, 1990, *The Boys from Kolchis*, 1991, *Das schwarze Meer I*, 1991; photo: Bernhard Strauss **p. 087** from left to right: Wolfgang Tilmans, *Man Pissing on Chair*, 2000; Ed Ruscha, *Parking Lots*, 1967–1972, © Ed Ruscha; Martha Rosler, *Bringing the War Home*, 1967–1999; photo: Egbert

Haneke, Hamburg **p. 090** Bruce Nauman, *Human Nature / Knows Doesn't Know*, 1983/1986; Zhan Wang, *Marmorfindling*, 2009; Frank Stella, *Lo Sciocco Senza Paura*, 1987; photo: Maik Mayer, Leipzig **p. 095** The Walther Collection; photo: Walter Vorjohann **p. 096** Brigitte Kowanz, *Eidyllion*, 2010; photo: Marianne Obst **p. 097** Erwin Heerich, *Turm, Begehbare Skulptur*, 1989; photo: Tomas Riehle / Artur Images **p. 098** Stiftung für konkrete Kunst; photo: Ralf Gottschlich **p. 100** Sylvie Fleury, *First Spaceship on Venus (14)*, 1996; © Sylvie Fleury; photo: Frank Kleinbach **p. 103** © Sammlung Grässlin, St. Georgen; photo: Wolfgang Günzel **p. 105** foreground: Donald Judd, *Untitled, Four Brass Boxes*, 1973; left: Dan Flavin, *Untitled (to Bob and Pat Rohm)*, 1969; right: Giulio Paolini, *Mimesi*, 1976; Archiv Sammlung FER Collection; photo: Maria Schlumberger-Rentschler **p. 106** Jaume Plensa, *Mariana W's World*, 2012; Cragg Foundation; photo: Michael Richter **p. 108** Charles Jencks, *Cells of Life*, 2005; Courtesy: Jupiter Artland **p. 109** Roe Ethridge, *Gisele on the Phone*, 2013; Courtesy: the artist and Cranford Collection, London; photo: Mark Griffiths **p. 113** exhibition view Sam Falls; Courtesy: the artist and Zabludowicz Collection; photo: Stuart Whipps **p. 114** from left to right: Urs Fischer, *Thank You Fuck You*, 2007, *Death of a Moment*, 2007, *Chair for a Ghost*. Thomas, 2003, *Untitled (Door)*, 2006, *Spinoza Rhapsody*, 2006; photo: © Stefan Altenburger **p. 117** Exterior view of the Vorres Museum **p. 121** Sheba Chhachhi, *The Water Diviner*, 2008; photo: Lucida, Photographers' Collective **p. 124** left: Yehudit Levin, *Pieta*, 1982, right: Yehudit Levin, *The Bather*, 1982; photo: Avi Amsalem **p. 128** photo: Jürgen Eheim **p. 130** foreground, right: Wolfgang Laib, *Untitled*, 1998; foreground, left: Jason Martin, *MOOR*, 2006; background, right: Richard Long, *Porfido del Trentino Circle*,1991; background, left: Thomas Ruff, *jpeg sak01*, 2005; Foto: Federico Baronello **p. 131** Ugo Rondinone, *Where Do We Go From Here?*, 1999; Courtesy: Il Giardino dei Lauri **p. 133** Ólafur Eliasson, *Meteor shower bike*, 2010; photo: Victor Munoz **p. 137** Fondazione Prada, Mailand, architect: OMA; Courtesy: Fondazione Prada, photo: Bas Princen 2015 **p. 139** Jason Dodge, *A permanently open window*, 2013; © Jason Dodge, Courtesy: Collezione Maramotti, Reggio Emilia; photo: Dario Lasagni **p. 140** Ahmet Öğüt, *River Crossing Puzzle*, 2010; Courtesy: Giuliani Collection; photo: Gilda Aloisi **p. 142** Goshka Macuga, *Plus Ultra*, 2009; Courtesy: the artist and Kate MacGarry, London **p. 144** Palazzo Grassi / Punta della Dogana; photo: Andrea Jemolo **p. 147** Jonas Burgert, *Mondjäger (Moon hunters)*, 2005; photo: Roberto Manzotti **p. 149** Nawa Kouhei, *PixCell-Lion*, 2015; © Kouhei Nawa; © Takahashi Collection; photo: Kioku Keizo **p. 151** Katja Novitskova, *Approximation (Quokka)*, 2014 and *Growth Potential (stand alone, zigzag)*, 2014; Courtesy: the artist and Gallery Kraupa-Tuskany Zeidler / Berlin **p. 153** Iván Ignacio Navarro, *Shortcut*, 2005 **p. 159** Wolfgang Nestler, *Geschlossene Scheune*, 1997; Wiliam Sweetlove, *The sheep and the red statue*; Horst Keining, The posters; photo: Richard Fieten Fotografie, 2008 **p. 161** Courtesy: BMW Group Netherlands; photo: Menno Ridderhof **p. 163** Courtesy: KaviarFactory **p. 164** Marc Quinn, *All Of Nature Flows through Us*, 2011, © Marc Quinn, Courtesy: Mary Boone Gallery and Kistefos-Museet / Vegard Kleven; photo: Kistefos-Museet / Vegard Kleven **p. 169** Mateusz Sadowski, *Half a banana*, 2014; Courtesy: Michał Borowik Collection **p. 171** Benoît-Marie Moriceau + Nicolas Milhé, *The Future is but the Obsolete in Reverse. (Exhibition view Leal Rios Foundation)*, 2013; © Leal Rios Foundation Collection and the artists; photo: João Biscainho **p. 173** Courtesy: MARe–Muzeul de Arta Recenta; photo: Youssef Thome Architects and Associates **p. 174** Paul Neagu, *Unnamed (Eshaton)*, 1997 **p. 180** Fung Ming Chip, *To Be & Not To Be*, 2012; photo: Jeremy San **p. 187** A view of the Can Framis Museum, 2009; photo: Pere Pratdesaba **p. 188** Joseph Kosuth, *Five Adjectives*, 1965; photo: Luis Asín, Courtesy: Fundación Helga de Alvear, Cáceres **p. 191** Maya Lin, *11 Minute Line*, 2004; Courtesy: the artist; photo: Anders Norrsell **p. 192** photo: Roland Scotti **p. 194** Tatiana Trouvé, *I tempi doppi*, 2013; photo: Collezione Giancarlo e Danna Olgiati, Lugano **p. 195** Karim Noureldin, *Area*, 2014; photo: Martin Stollenwerk, Zurich **p. 199** Nuray Sevindik, *Breaking Off*, 2005; photo: Kayhan Kaygusuz **p. 200** Kashan Keramiken, ca. 1100; Courtesy: Galeri Artist, Istanbul **p. 207** interior view of the Jean-Paul Najar Foundation, Design Mario Jossa; © 2016, Jean-Paul Najar Foundation; photo:

BMW Art Guide by Independent Collectors

Editors
BMW Group, Munich
Independent Collectors, Berlin

Conception & Implementation
Independent Collectors, Berlin
Dorten studios, Berlin

Project Directors
Hedwig Solis Weinstein, BMW Group
Stephanie Schild
Karoline Pfeiffer & Christina Werner,
Independent Collectors
Dorten studios
Sonja Altmeppen, Hatje Cantz Verlag

Executive Editor
Sylvia Dominique Volz, Berlin

Authors
Silvia Anna Barrilà, Berlin/Milan
Nicole Büsing & Heiko Klaas, Hamburg/Berlin
Alexander Forbes, New York
Jeni Fulton, Berlin
Christiane Meixner, Berlin
Anne Reimers, London

Additional Texts
Independent Collectors

Translation & Copyediting
R. Jay Magill & Tanja Maka, Berlin
Erik Smith, Berlin

Graphic Design
Dorten studios

Image Rights
Jacek Slaski

Typefaces
Arial by Robin Nicholas & Patricia Saunders,
The Monotype Corporation, Woburn
Akzidenz Grotesk BQ by Hermann Berthold,
H. Berthold AG, Berlin
LeMondeLivre by Jean-François Porchez,
Porchez Typofonderie, Clamart

Reproductions
PX1, Berlin
Wagnerchic Digital Artwork, Stuttgart

Production
Franziska Lang, Hatje Cantz Verlag

Printing
Offsetdruckerei Karl Grammlich GmbH,
Pliezhausen

Paper
Invercote G, 180 g/m^2
Fly 06, extraweiss, 90 g/m^2

Binding
Josef Spinner Grossbuchbinderei,
Ottersweier

© 2016 BMW Group, Munich;
Hatje Cantz Verlag, Berlin;
Independent Collectors, Berlin, and authors

Published by
Hatje Cantz Verlag
Mommsenstrasse 27
10629 Berlin
Germany
Tel +49 30 346 4678-00
Fax +49 30 346 4678-29
www.hatjecantz.com
A Ganske Publishing Group Company

Hatje Cantz books are available internationally
at selected bookstores. For more
information about our distribution partners,
please visit www.hatjecantz.com

ISBN 978-3-7757-4144-6 (English)
ISBN 978-3-7757-4145-3 (German)

Printed in Germany

Additional Contributors
Amy Binding, Thomas Girst

Art is a gift. When we look at a work, are pulled into and interact with it, we silently thank all the artists that fascinate, inspire, and sometimes even change us. With this publication, BMW and Independent Collectors wish to thank everyone who lives with art and who has opened their spaces to like-minded enthusiasts from around the world. Our heartfelt thanks go to all the collectors who appear in this edition of the *BMW Art Guide by Independent Collectors*. Your support and confidence in our project have made this book possible. Our deepest gratitude also goes to our committed team of authors and editors, and to the many contributors to the Independent Collectors and BMW network. You never turned away from the challenge. Thank you.